AFRICAN RENAISSANCE

CONTENTS

ILLUSTRATIONS

CATALOG

INTRODUCTION

The [contemporary African] artist is chiefly concerned with establishing a new identity, with gathering the broken pieces of a tradition and building them—often self-consciously—into a new kind of collage in which the *African renaissance* is proclaimed.

—Ulli Beier[1]

n visual culture, is there an African renaissance? Is it not a contradiction to speak of "Africa" and "renaissance" in a complementary way, because one is equatorial and the other Western? What are the implications of bringing both words together, to suggest some form of cultural hybridity or schizophrenia? In the context of African art, the term *renaissance* means much more than a "rebirth." Now almost a cliché, the word *renaissance* means rebirth in the context of Italian art and refers to a generally understood period and idea, however difficult to define.[2] In African art the term *renaissance* may include, in addition to the concept of rebirth, issues of resistance and loss, revival, rehabilitation, revision, relocation, reparation, and reinvention of ancient African artistic forms within a global context. Using the Yoruba artistic culture as an analogy, this book tells the "lost and found" story of African art as it replenishes and redefines itself after surviving a long, blistering season of lesion, loss, and ruin.

The twentieth century brought drastic changes to African cultures, resulting in the death or lethargy of several indigenous artistic traditions. Many master sculptors passed away without passing on their skills to succeeding generations. The once preserved names of the greatest artists of the times are largely lost, except for a very few nomenclatures to which we cling tenaciously. In Yoruba art these transformations were complicated by two centuries of civil wars, slavery, and colonization—the themes of which dominated Yoruba sculpture on the eve of the transition from autonomy to colonial rule under British subjugation.

As the ash of the old culture forms around its dying fires, a new flame is slowly rising from the core of a burned gem, taking the form of what is now known as contemporary African art. A large number of artists who claim Yoruba ancestry, who work within and outside Yorubaland, now produce works in contemporary media including painting, sculpture, installation, video, and performances. They use materials available to contemporary artists all over the world including traditional materials such as oil, acrylic, and ink on paper. Some experiment with printmaking and fiber arts. A few have exhibited at prestigious museums such as the Museum of Modern Art, the Smithsonian Institution, and the British Museum; and their impact is being felt at important international biennials and triennials in Europe, Africa, and the Americas. They have created a Yoruba Renaissance, built on pillars glimpsed from the ruins of their own "Rome." These atavistic ruins refer to the old Yoruba sculpture, textile, ceramic, and painting traditions that succumbed under the pressures of precolonial civil wars, slavery, and colonization.

By focusing on the confluence between contemporary African art and the old tradition, this book celebrates that Renaissance. Although the intersection between these two artistic traditions is located in the twentieth century, the new millennium continues to build upon the foundations of the last century. This volume is based on an exhibition that juxtaposes the best from the two traditions by presenting works by the greatest Yoruba sculptors with the best examples of contemporary Yoruba art. The mythological sculptures of Yoruba masters such as Ọlọwẹ and Oọṣamuko are drawn from the collections of the Denver Art Museum, as well as two private collections. The work of Moyọ Ogundipẹ illustrates the best examples of the emergent new tradition of contemporary African art. The exhibition focuses on the new forms by Ogundipẹ and their reinterpretations of Oọṣamuko's and Ọlọwẹ's ancient icons and myths, although Ogundipẹ is exploring Western materials and using contemporary themes. This publication elaborates on that theme of Renaissance by placing the experience within a concrete historical format.

Ten large paintings, five prints, and three drawings by Ogundipẹ are displayed with thirty monumental pieces from the ancient Yoruba tradition. The Denver Art Museum already owns Ogundipẹ's highly praised work, *Soliloquy: Life's Fragile Fictions,* as well as the less-known *Serenade: Centaur and Water Spirits.* Six pieces from the Heitler Collections will add depth to the body of the old works on display.

This book is in part a catalog to accompany the exhibition. In addition to containing images of the displayed works, the book provides a larger context for the show. It examines the exhibited Yoruba art pieces within the canon of Yoruba art making while studying Ogundipẹ's work as a part of the larger

body of contemporary Yoruba artistic experimentations. All the pieces in this exhibition were made since the twentieth century, indicating that it is an art best interpreted not only within the internal aesthetics of Yoruba culture alone but also within the larger global cultural context of international politics, colonization, independence, and its aftermath. This book therefore takes that crucial historical landmark of the twentieth century—colonization—as a metaphor for structuring the interpretation of twentieth-century Yoruba images. Colonization and the events that led to it culminated in the death or lethargy of the old culture. The end of colonization also saw the beginning of the rebirth of the ancient culture, revisioned as a new culture. The use of colonization as a metaphor for a cultural renaissance does not imply that colonization is the most important cultural experience Africa has faced. It simply means it is one of the most important cultural experiences Africa has had in recent years. Colonization, particularly how and why it has shaped the development of art and the lives of artists in the process of changing African cultural values, is an important cultural theme throughout this book.

The images are grouped into four broadly overlapping periods. The first period, the imposition period (1900–1945), coincides with the heyday of colonization in Nigeria, and it describes the era when colonial rule and aesthetics were imposed on Yoruba people by their British colonial masters. The discouragement of indigenous Yoruba art and values, and the concurrent encouragement of Western art and cultural values, led to a decline in colonized people's esteem for their own indigenous culture. This period saw a drastic reduction in the practice of indigenous Yoruba architecture and an immediate rise in the adoption of Western styles of architecture. The period witnessed the death of the last renowned masters of the old tradition, personified by Ọlọ̀wẹ̀ (c. 1870–1938), and the birth of the new masters, personified by Aina Ọnabolu (1882–1963). To counteract the effects of indigenous Yoruba values, which the colonial government regarded as backward and injurious, Britain imposed a colonial culture, based on what the British called "indirect rule," on Yoruba indigenes. Marking the onset of colonialism, the imposition period constituted the time when Yoruba indigenes first encountered rudiments of European art education in the classroom.

The following era, the opposition period (1945–1960), marks a phase when Yoruba artists pitched their creativity as a weapon against colonial subjugation, as some form of political nationalist aesthetics. The period also rekindled an interest in the rebirth of indigenous African cultures. The quintessential artist of the period, Akinọla Lạṣekan, was joined by others, notably Justus Akeredolu, to create an art that opposed the colonizers' interests and values and stimulated a renaissance of Yoruba cultural values. The result was the development of an art and aesthetics that blended strong political statements with experimental designs in painting, sculpture, printmaking, and ceramics. These artists succeeded in using their art as part of the efforts that ended colonial rule in Yorubaland and once again saw the indigenes in the control of their own destiny.

After political independence was attained in 1960, a turbulent five-year period led to the military coup of 1966, during which the Nigerian army took over the affairs of the people. The Nigerian independence and subsequent military putsch led to a different political and aesthetic era, here referred

to as the exposition period, from 1960 to 1990. It was a promising but utterly disappointing and depressing period during which people lost their civil rights after the military suspended the constitution. The significant art of the period marked the pains and joys of living during an era that was free of colonial opposition but not of military rule. It was a time when Yoruba artists made nonoppositional, proactive artistic statements as free expositions to celebrate the richness of their cultures. It was a period in which a few artists, such as Odutokun, used their art as a tool of social criticism or an exposition of prevalent sociopolitical realities. Other artists such as Twins Seven-Seven, Tayọ Adenaike, and Agbo Fọlarin saw an opportunity to celebrate the revival of the African culture. These artists made a cultural exposition of Yoruba myths as an expression of their new-found political and aesthetic autonomy rather than in opposition to any European or Western aesthetic or art, as in the preceding period.

From 1990 to the present a steady migration has occurred from Yorubaland to the political centers of the West, mainly Britain and the United States, by artists fleeing the economic and political depression that followed three decades of destructive military rule. This period, here described as the emigration period, has witnessed what has been called a "brain drain." It is becoming clear that the country's most highly educated elites have abandoned the country. But what is less obvious is that the culture is also witnessing a massive relocation to the West of the greatest Yoruba artists and art historians, including Moyọ Ogundipẹ and art historian Rowland Abiọdun. Other notable Yoruba artists are also flowering in the West including Rotimi Fani-Kayọde, Yinka Shonibarẹ, and, recently, Ọlaniyi Ọlabayọ. As these individuals relocate to the West, they carry seeds of Africa with which they build a rebirth or renaissance of African culture through their writings and their arts.

To accommodate that content, this book is structured in six chapters, in addition to this introduction and a conclusion. The first chapter attempts to dig into the memory of time, to exhume the fame, honor, and name that belonged to Yoruba sculptors prior to colonization. Entitled "Lost and Found: Excavation of Ancient Yoruba Artistic Traditions," the chapter elaborates on the death of the old Yoruba sculptors and the disappearance of their names from scholarly discourse. This cultural demise or lethargy affecting the ancient artistic traditions has caused a sort of collective amnesia among the people today. That memory loss is combated by the ongoing intellectual struggle to dig into the historical mind of the people and rekindle their recollection. Therefore, one of the most enduring struggles in African art is to recognize as art the work made by African artists and to begin to recollect and acknowledge the names and identities of lost artists rather than regard African art as anonymous. Chapter 1 reveals the efforts Africanist art historians are making to excavate Yoruba art from under the debris of colonial amnesia so it can fully enjoy the benefits of its renaissance.

The second chapter, "Imposition Period: Suppression of Ancient Artistic Traditions (1900–1945)," investigates the works of artists who actively practiced during the heyday of colonial imposition, from 1900 to 1945. This chapter explores the tension generated between the works of Yoruba masters, such as Ọlọwẹ Isẹ and Oosamuko who were working in the old tradition, and the work of an emergent artist such as Ọnabolu, who used the new materials and

methods imposed and adopted in colonial art education classes. Ọlọwẹ Isẹ and Ooṣamuko are survivors of an indigenous sculptural tradition that succumbed to the imposition of Western art and art education championed by Aina Ọnabolu. The chapter focuses on the cultural resilience found in the works of Ooṣamuko, Ọlọwẹ, and Bamgboye—indigenous artists whose fame and works have proved enduring long after the end of colonization. In contrast is the work of Ọnabolu, a colonized Yoruba artist who accepted and helped to impose Western materials and methods. The chapter examines his art to investigate his countercolonial strategies and his pioneering efforts to develop an indigenous nationalist aesthetic.

Chapter 3, "Opposition Period: Revival of Ancient Customs and Traditions (1945–1960)," examines the art of a period that witnessed the first intellectual countercolonial aesthetic activism by Yoruba artists, at the end of World War II. The chapter focuses on the works of two Yoruba artists, Akinọla Laṣekan and Justus Akeredolu, who pioneered the movement to revive and rehabilitate African values and present African individual and cultural identities as positive, progressive, and humanistic. These artists developed spectacular and fascinating cartoons, portraits, and landscape forms from their hybrid aesthetics, based on the creative conjugation of Yoruba and Western ideas.

Chapter 4, "Exposition Period: Revision of Ancient Artistic Traditions (1965–1990)," examines the proactive art created by a people now free of colonial rule, grappling with the failures of democracy while celebrating the attainment of political and cultural freedom. The most visible art of the period submerges itself in mythology, almost as an escape from the sordid realities of civil insecurity, economic deprivation, and political subjugation under military rule. The works of artists such as Twins Seven-Seven, Muraina Oyelami, and Jimoh Buraimoh are examined as expositions of new forms of Yoruba myths and oral traditions. Gani Odutokun stands as an example of a painter committed to using his work as an exposition of the evils and pains the Nigerian people endured under the yoke of military rule. During this period many artists used new materials and forms to recreate design motifs and mythological contents adapted from ancient Yoruba visual forms.

In Chapter 5, "Emigration Period: Relocation of African Artists (1990–present)," I examine the works of Yoruba artists who have emigrated from Yorubaland into Western metropolitan centers. Although it concentrates on the paintings of Moyọ Ogundipẹ as an example of the new works being created by artists coming from Yorubaland to the West, the chapter broadly examines the images made by many of these "émigrés" in terms of their continuities and breaks with the Yoruba traditions of image making, mythology, and aesthetic values. Because all of these artists have relocated to the West, their works resonate with a sense of nostalgia that has caused many to use images drawn from indigenous Yoruba art, myths, and values. Ogundipẹ draws freely on Yoruba sculpture, textiles, and mural painting traditions in his art while using mythological sources and art materials to create a hybrid art that exists only at the margins of Western contemporary art.

Chapter 6, "Transatlantic Renaissance: Reclamation, Retention, and Returning From Diaspora," examines the use of Yoruba images in the Americas, from Brazil through the Caribbean to Canada. The chapter explores the works of Israel Garcia, an immigrant from Cuba, and Michael Harris of the United

States to show how their arts come together with the works of Moyọ Ogundipẹ, a new immigrant into the Western diaspora, to form part of a larger Yoruba commonwealth of aesthetics and images. All of these diasporic Yoruba artists eloquently reinvent and proclaim a bold and spiritual world—evolving precariously out of the chaos created by the collapse of the old world order—as well as the emergence of a new order free of cold-war politics. The images of these artists become a visual metaphor for a brave renaissance world of quasi-divine aesthetics, powered by secular digital technology and located perilously on an alien landscape.

AFRICAN RENAISSANCE

1
LOST AND FOUND
Excavation of Ancient Yoruba Artistic Traditions

One of the most abiding Yoruba values is change. Life itself, to the Yorubas, is a marathon journey for a people who conceptualize themselves as perpetual pilgrims on this planet, on a homeward trip to *ọrun,* or the spiritual world.[1] *Ìrìn àjò la wà, orí gbé wa délé* (we are on a journey, may our heads lead us home) is a saying around which we can interpret Yoruba art. Yoruba images are veritable road signs the individual *orí* must navigate spiritually alone, albeit in the physical company of others in the community of travelers. As the child cries *Mo wòrú è/ Mo wòrú è* (I am done for/ Woe is me) when he or she enters the world, that child expresses a sense of confusion as a new traveler confronted with a vast landscape with no apparent direction. It is the duty of the community to assure the new traveler that not only is he or she not physically alone but that a series of road maps exists, made by great and talented ancestors who as individuals have beaten a track for succeeding generations.

These road maps are in the visual cultural forms of Yoruba art, diligently produced by named Yoruba artists.

But because Yoruba used to be an oral culture, the names of many Yoruba artists perished with their works during the wars, slavery, and colonization that ravaged Yorubaland between the eighteenth and twentieth centuries.[2] It is within this metaphor of loss and recovery that we must now interpret Yoruba art at the beginning of the twenty-first century, especially in Western societies.

The metaphor of loss and recovery is particularly applicable in the United States because of the intensity of cultural ferment—both positive and negative—in the megastate. Since I moved to the United States from Nigeria several years ago, I have received lots of junk mail, including an item that arrives virtually every week with the inscription "Have you seen me?" It always bears the face of some missing person staring innocently at me. Puzzled, I always ask myself, "Why are these people lost?" I ask a similar question whenever I visit museums to view displays of African artworks. The objects always seem to ask "Have you seen us?" In other words, the problem of the missing person in the United States has become for me a paradigm or a model for exploring the issue of the missing artist in African art. The challenge for me is where to locate these lost African artists.

What do I mean by the "missing" or "lost" artist in African art? Observant museum visitors will notice a major difference between the display of African art objects and the display of Western art objects. Crucial to the display of works from the West is an emphasis on the identity of the artist as an individual. Museum displays of works by Western artists therefore emphasize such details as the name of artist, title of work, date of completion, and perhaps the artist's country of origin. In African art displays, these details are often missing. If anyone is named it is often the donor, lender, or collector rather than the artist.[3] Instead, there is usually mention of the ethnic group that "made" the work or from which the work was collected. The missing artist seems to be of no importance. The reference to the ethnic group is supposed to indicate that African art is communal rather than individualistic.

Indeed, some Africanist art historians think the attempt to search for the individual artist is merely an imposition from the outside, more or less an aberration within Africa itself. Issues of the artist's identity are not important in African art. The intention and motivation of the artist are not crucial as in Western art. They say one thing is clear: you could not call the maker of objects in Africa an *artist* in the Western sense because the concept of individuality is missing. What we are left with is the faceless craftsperson who is without significant recognition in his or her own society. The artist's work is not a window into the mind of an individual, as in Western art; the image is merely part of a larger ethnographic data through which the dogmas and superstitions of a people may be read and analyzed. In African art history is frozen, time is banished, individuality is discouraged, and community or ancestral values are represented. We therefore do not talk of style in African art and do not seek the development of ideas as an evolving pattern. African art history, like the artist, is frozen in time, as if dead.

Yet according to Africanist curator Susan Vogel, "African art history painstakingly assembles the oeuvre of individual African artists while recognizing that this exercise is not one that would normally have been practiced or have

been meaningful in the African societies where these people worked."[4] Vogel came to this conclusion because "over the past fifty years . . . a large number of thorough, highly motivated, and qualified researchers have sought information on artists, and most report the same lacuna, while succeeding in collecting other kinds of data about artists (their working techniques, practices, training) and about objects (their names, meaning, uses, symbolisms, etc.)."[5] To exonerate researchers for their inability to collect names from their "fieldworks," she argues that "because cultures preserve the knowledge they value, any information that has so consistently eluded researchers should be taken to indicate an area of little or no cultural relevance to the people under study."[6]

In an article titled "Is Primitive Art Art?" published in the *Journal of Aesthetic Education* in 1991, philosopher Gene Blocker seems somewhat more specific in his evaluation of the artist in African art. He argues

> I do not mean that they fail to have the visible marks and features which
> qualify objects in my society to be artworks or that they are not good
> enough to be worthy of art. I simply mean that the people who make and
> use such objects do not themselves regard them in ways that are suffi-
> ciently similar to the ways in which native English speakers indicate they
> regard them by calling them "works of art." My refusal to call them
> works of art casts reflection more on the traditions and institutions of the
> people than it does on the objects themselves.[7]

What Blocker is saying is that the works are good enough to be art but that the society has not recognized the makers as artists because the societies have no recognition of art. We may in fact have masterpieces, but we have no masters. This somewhat contradicts Vogel's position that "in their own societies, African artists are known and even famous, but their names are rarely preserved in connection with specific works of art they have made."[8]

One may too quickly dismiss Blocker and Vogel as ethnocentric scholars simply because they are Westerners. But as recently as 1995, in a book titled *The Aesthetics of African Art* (Uppsala: Uppsala University, 1995), Mohammed Abusabib (an African) calls African art primitive and describes African artists as primitive artists. The Nigerian-born literary critic Isidore Okpewho, in his book *The Epic in Africa,* insists that because African art is functional, it is "difficult to see the artist other than [as] a slave to history."[9]

The present book will reexamine some of these assumptions by showing how the location of the individual artist in the discussion of African art challenges these stereotypes. The African continent is so large that it is not possible to speak in general terms without committing errors of abstraction. At first, Western scholars and political leaders swore that black Africans were incapable of making realistic sculpture. Later, these same elites changed their opinions when Leo Frobenious and others, at the turn of the twentieth century, found out that an ancient form of naturalism—predating Renaissance art in Europe—existed in Africa. The discovery of vividly naturalistic terra-cotta and brass figures at Ile Ife, the mythological origin of the Yoruba people, clearly reveals that Yoruba art defies many of the generalizations often applied to African art. According to Africanist philosopher Olabiyi Yai, "In the context of a culture like that of the Yoruba, which places premium on individuality to

the extent of deifying it as *ori* . . . the concept of an anonymous sculpture is a *non sequitur.*"[10]

Using the works of three artists (Ọlọwẹ Isẹ, Dada Arowoogun, and Akinọla Laṣekan) as a point of reference, I will explore Yoruba art in general to demonstrate its depth and diversity. I will also investigate how individuality is not only recognized but celebrated and cherished in Yoruba culture. Readers will see how style may be measured when they compare and contrast the works of these artists. Finally, readers will see the connection between the works of these artists and concrete historical realities transcending issues of mythology, magic, superstition, or functionality with which African art is so often associated.

Like a bridge over two significant historical periods, the works of Ọlọwẹ Isẹ and Dada Arowoogun link the nineteenth and twentieth centuries. The two artists' lives spanned the late nineteenth century to the mid-twentieth century. Ọlọwẹ Isẹ was born around 1870 and died in 1938, whereas Arowoogun lived from about 1880 to 1956. When one considers that the nineteenth century witnessed the phasing out of slavery and the twentieth century witnessed the colonization and decolonization of Africa, one can appreciate the full historical significance of the period during which both artists lived and created their sculptural masterpieces.[11] Indeed, their lives spanned a period before and after the creation of Nigeria as a nation-state. It was a momentous time when the Yoruba ethnic group to which both sculptors belonged became a mere region in southwestern Nigeria.

The works of Ọlọwẹ and Arowoogun also become a bridge between the so-called traditional African art and contemporary African art because they shared the same subject matter with contemporary Nigerian artists such as Akinọla Laṣekan, a renowned Yoruba artist and one of the first African art professors. Laṣekan's *Kírìjì* (Fig. 1.1), which he painted in oil in 1957, explores the same subject as Arowoogun's door sculpture from about 1916, *Kírìjì* (Fig. 1.2). Both artists explored the protracted civil war that lasted several hundred years in Yorubaland, leading to the colonization of the region. But the similarities between the work of Laṣekan and that of Arowoogun seem to end within the realm of content and do not extend into the realm of form or composition.

Whereas Laṣekan's work is oil on hardboard, Arowoogun's work is crafted in Iroko wood, a traditional material favored by Yoruba wood sculptors. Arowoogun's work is also much older than Laṣekan's painting. Laṣekan is not influenced by the physical compositional structures of Arowoogun's work. Laṣekan's work incorporates Western devices such as linear and aerial perspectives, allowing his figures to loom large and vivid at the foreground while tapering off into the fogged background. Arowoogun uses no Western techniques. He incorporates the indigenous conventions available in Yoruba art where figures are arranged on the same shallow picture plane without any significant sense of depth. But what is perhaps more remarkable is that Laṣekan's work demonstrates how the so-called contemporary Yoruba artist may share the same subject with the so-called traditional artist, thereby breaking down the boundaries theorists often erect between the two idioms.

Unlike Laṣekan's painting, Arowoogun's work consists of several registers, each sufficient to stand by itself as a complete work. The thematic conti-

nuity and the structural devices of the grid are used to hold all the registers together in Arowoogun's work. Laṣekan focuses on the strategies of cavalry warfare mounted by the northern elements of Yorubaland against the southern elements that were largely without a cavalry. Whereas Laṣekan is depicting a single moment, using a single frame, Arowoogun is depicting several moments, using several frames within a larger, more comprehensive picture. The war general, depicted on horseback in the works of both artists, is shown in the midst of battle, maneuvering his forces. These battles were the first skirmishes involving the use of firearms such as hand rifles and field cannons. The petrifying boom of cannon artillery fire produced the sound "Kírìjì," from which the civil war took its name and from which both Laṣekan and Arowoogun derived the titles of their works, *Kírìjì*. This thematic similarity provides a unity between Laṣekan's and Arowoogun's work while also forming their point of departure in the realm of form.

Arowoogun's work is a simple composition of ten views arranged in two symmetrical columns, each consisting of five framed registers. On each of the ten registers, Arowoogun painstakingly represents events and scenes he associated with the Kírìjì war, the final decade of which he witnessed as a Yoruba child growing up in a country devastated by warfare. He depicts the callous activities of the equestrian war generals, their system of enslavement, and the advent of European consumerism into Yoruba culture. Let us take a moment

1.1 Akinọla Laṣekan, *Kírìjì*, oil on board, private collection

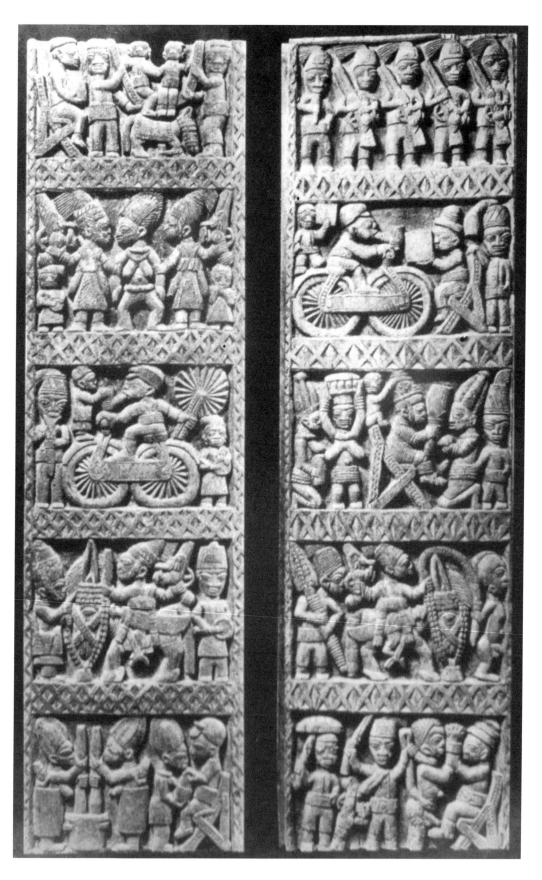

1.2 Dada Arowoogun, *Kírìjì*, wood, Fowler Museum

to study the details of some of the registers meticulously sculpted by this fastidious artist.

First, let us consider the imaging of the principal actors in the war, namely, the warriors who did the fighting, the rulers whom they served, the Europeans who supplied them with arms and ammunition, and the women and children who were the victims. Let us start by looking at some of the registers celebrating the prowess of the warriors.

The first register celebrates the equestrian general, dressed in his elaborate war costume while brandishing a handgun with one hand. With the other hand he masterfully maneuvers his horse. He is framed by a drummer playing the Yoruba talking drum and a praise singer chanting praise songs in celebration of the general's prowess. This register is the visual transcription of what the Yoruba call "*oríkì*," or praise poetry, often chanted in exaltation of indigenous heroes and dignitaries.[12] The warrior displays some of the indigenous and foreign weapons employed during the Kírìjì war, namely firearms, swords, and magical charms. A Yoruba proverb expresses the ambivalence of the horse in warfare. It states: "*Ẹṣin tá a fi í jagun, náà la á fi í ságun*" (The same horse used in prosecuting a battle, may also be used for escaping from the battle). The proverb has a story to explain it. As they approach the battleground, a young private looks at his commander's magnificent horse and asks "General?" The commander says, "None of your stupid questions now; this is enemy territory." The private assures him that this time the question is important. "Sir, what is the function of this horse? To enable you to run down our enemies, or to enable you to escape from the war front if things are not going so well?" The general ponders the question and says, "It all depends." "On what?" the soldier asks. "Oh, on whether you are still alive, in which case you will see me using the horse to pursue the enemies, or whether you are dead, in which case you will not see me using the horse to escape." "It all depends, sir," replies the private. "On what?" asks the general. "Oh," replies the private, "on whether I am pretending to fight or pretending to be dead."

Another register representing warriors consists of a column of foot soldiers, marching with their rifles into battle. They line up in a strategic formation as they seem to advance toward the war front. The diagonal slanting of their weapons reinforces the vertical thrust of their disciplined bodies, and the sensation of motion is generated by the rhythm of the tassels flying on their stylish hats.

Arowoogun's imaging of the Yoruba king, the ruler (*ọba*), is particularly lavish because it is located in the register with the largest number of human figures—six. Thus he projects the identity of the ruler as an individual who is always surrounded by his people, who is never alone, someone "clothed" by people. Surrounded by his many wives, the king is seated on a straight-back throne introduced by the British to Yorubaland during the early nineteenth century. He is wearing his official costume, including a robe, a beaded crown, and beaded shoes. His feet are resting on a stool decorated with beads. He is carrying a fly whisk, which he shakes at a wife kneeling in front of him as she presents him with a bowl of condiments. Behind her is an unarmed palace guard, called *Kúdẹ̀ẹ̀fù* in Yoruba. Behind the king is a court jester, and one of his wives enters with a load of presents. All the queens are shown in the nude

as a symbol of fecundity but also because tradition demands that they must remain naked while he is eating.

Let us now examine how Arowoogun images exemplify the advent of Europeans into Yoruba politics and culture by exploring two of the door registers. The first depicts two European merchants riding a bicycle on their way to visit another European. Their costumes, particularly their stylish hats, identify them as Europeans. One is smoking a pipe, and the other is holding an open book from which he reads. The host is also reading a book, and behind him stands an unarmed attendant wearing an elaborate hat. The bicycle is presented here as a luxury item, which indeed it was at that time.

How does Arowoogun depict the victims of the war, the male and female captives who were enslaved and shipped off to the Americas? They are usually depicted in the nude, as this register indicates. An equestrian general, brandishing a handgun, ties a nude captive to his horse, leading the distraught victim away in a victory parade. Behind the general marches a foot soldier carrying a huge spear in both hands.

The same captive, who is for sale, is led to a European slave dealer, seated on the straight-backed chair at the extreme right of this register. The European holds one of the captive's hands as he examines him to assess his monetary value. One of the soldiers is armed with a rifle and holds the leash attached to the captive's neck and waist, and the other soldier casually holds an umbrella over his head.

The final register we will examine on this door depicts two soldiers who seem to disagree about the ownership of a pretty woman they have taken in during battle. The entirely symmetrical composition shows the two warriors with their weapons drawn as they argue over the possession of this woman, each drawing her nearer to himself. Two musicians occupy the space below the guns, with the one on the left playing a talking drum while the one on the right is blowing a flute.

Almost a decade later Arowoogun completed another work, *Àtahun Àtejò* (Fig. 1.3), on the same Kírìjì war theme using similar forms. In this work his style has evolved further, and particularly noticeable is the less angular structure of his compositions. They are more smoothly finished, roundly formed, and deeply sculpted into the wood panel. The composition is also far more elaborate, demonstrating a confidence in handling the carving adze not seen in his previous work.

One register of this work deserves attention. This register may appear somewhat puzzling, largely because it is so allegorical and different from the others. It involves two animals, a snake and a turtle, locked in a deadly battle as the snake tries to devour the turtle. This image refers to a Yoruba proverb that goes "*Ebi ń pejò, ahun ń yan: àtahun àtejò eran jíję*" (The snake is hungry, but the turtle nonchalantly struts about: both snake and turtle will soon become someone else's supper). The snake and the turtle become a metaphor for the warring parties of the Yoruba elements who engaged each other in the internecine civil war. The snake obviously is unable to swallow the turtle, try as it might. There will be a deadlock, as the result of the war proved. A third party—the British government—would soon benefit from this deadlock, however, and would colonize all the warring Yoruba parties because they

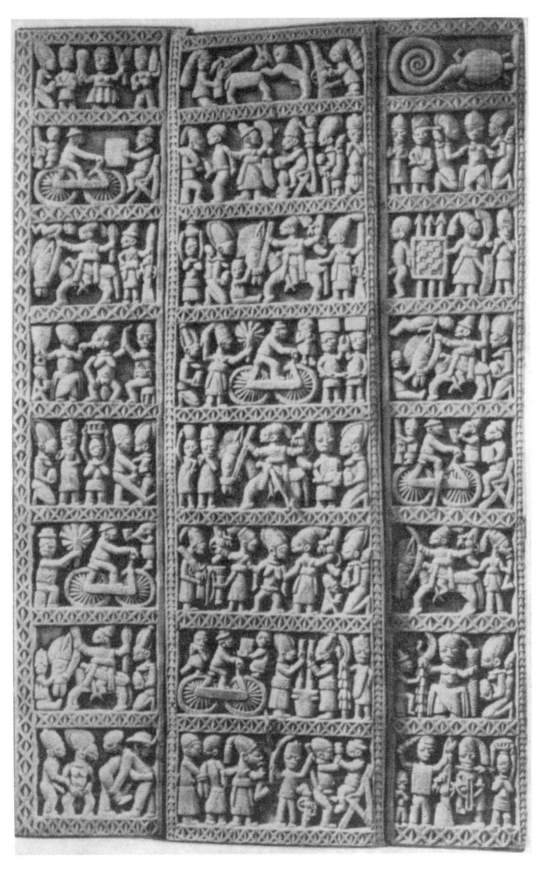

1.3 Dada Arowoogun, *Àtahun Àtejò*, wood, British Museum

were weary and weakened by the endless battles. With little resistance, the Yoruba elements succumbed to British rule.[13]

It is this issue of colonization, as the consequence of the Kírìjì war, that Ọlọwẹ Isẹ depicts in his own door panel, the *Ògògà Palace Gate* (Fig. 1.4). Ọlọwẹ's work demonstrates that when the snake and the turtle are fighting, they become easy prey for the vigilant hunter.

Ọlọwẹ Isẹ's work (before 1924) seems to combine elements from both Laṣekan and Arowoogun. Focusing on the aftermath of the Kírìjì war, with which both Laṣekan and Arowoogun are grappling, Ọlọwẹ's work depicts a single moment, as does Laṣekan's painting, but uses several registers, as in Arowoogun's sculpture. The single moment depicted by Ọlọwẹ is the tour of Yorubaland by two British traveling commissioners, Captain Ambrose and Major Reeves Tucker. Here, Ọlọwẹ is depicting a period of transition when the British began to establish control over Yorubaland. In vivid detail Ọlọwẹ shows the exchange of baton from the Yoruba indigenous political system to the British colonial system. Specifically, Ọlọwẹ made this work for the king of Ikẹrrẹ, known as Ògògà Ikẹrrẹ, as a commemorative art marking the visit of Commissioners Ambrose and Tucker to Ikẹrrẹ between 1897 and 1904, a few years after the British imposed a peace accord on all the warring parties. The work, held in the collections of the British Museum, was acquired in 1924 to be placed in the British Empire Exhibition at Wembley.[14]

The entire sculpture shows a single moment, structured by the artist into ten registers rendered within a single frame. Because the work was intended to be the entrance into a palace shrine, it has two arms that could be thrown open. The left side of the door is slightly narrower than the right, even though each arm contains five registers, one stacked on top of the other. The door's narrower left arm features images of the king and his entire royal household, including chiefs, wives, warriors, and slaves. The right arm of the door displays the august visitors and their entourage of carriers and armed guards. Whereas the left side—the host's side—contains both male and female figures, the right side—the visitor's side—only contains male figures.

Let us examine a few registers in this sculptural complex. The two largest registers, which from the top form the second row of images, depict the king and Captain Ambrose as they meet face to face. The king, with his most senior wife, known as Olorì, standing behind him, is seated on the straight-back chair welcoming the British commissioner. He actually manages a smile, perhaps in response to the smile of the British commissioner. But the king is not fooled. He must remember the Yoruba proverb "*Ìfẹ́ a fẹ́ adìyẹ kò dénú*" (One's love for a poultry fowl is only skin deep). The proverb also comes with a story to explain it.

Mrs. Farmer's daughter, Miss Farmer, was getting married, and Mrs. Farmer wanted to make chicken stew for some visitors. She looks at her chicken and smiles. The chicken also studies Mrs. Farmer and smiles. The chicken says, "Just say it, Mrs. Farmer. My time has come, hasn't it?" Mrs. Farmer replies, "Oh, why must we put it so crudely, so blatantly, so insensitively. Look, all these months I have fed and housed you; it is clear that I love you. This is the deal: you have a choice here. Would you prefer me to slit your throat or wring your neck?" The chicken answers, "There you go again, Mrs. Farmer, worrying to death about me. What does it matter whether you slit my throat or wring my neck, as long as you do it lovingly?"

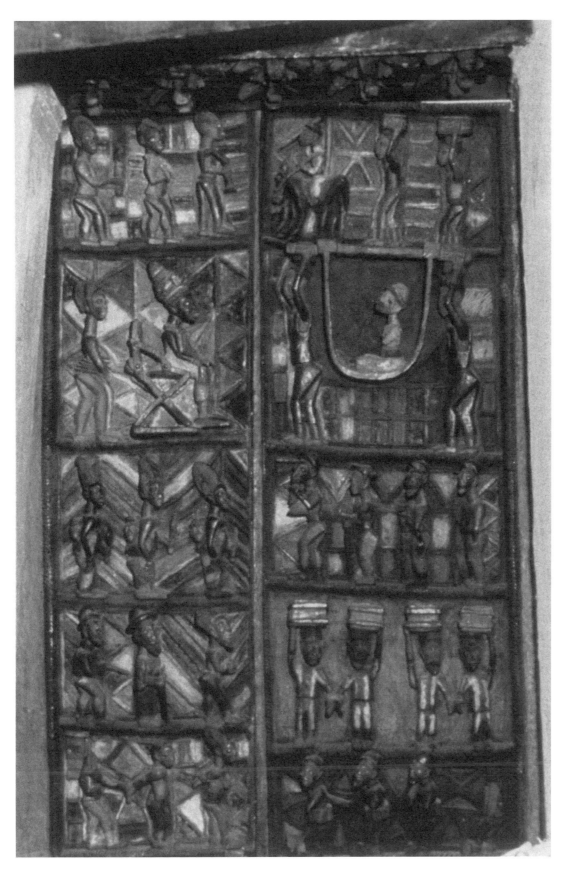

1.4 Ọlọwẹ Iṣẹ, *Ògògà Palace Gate*, wood, British Museum

In Ọlọwẹ's work the king is the chicken and the commissioner is Mrs. Farmer who has come to do the inevitable. The colonization of the land is akin to wringing the neck of the king because his power is about to be taken from him, and he is about to be turned into a mere figurehead. The visitor, Captain Ambrose, seated in a litter carried by two uniformed constables, is wearing a cap and has a heavy mustache. Both men seem rather anxious, with the king wearing a nervous smile while Ambrose's mustache seems to twitch with anticipation.

The register directly above them, on the visitor's side, depicts Major Tucker on horseback, followed by two uniformed carriers. On the other side are three male chiefs. Each is carrying his official paraphernalia while managing an archaic smile, standing with the right foot placed forward. The register directly below the king represents three more queens lined up to receive Ambrose. Unlike the nude queen directly behind the king, all three wives are dressed in a wrapper, each with a baby strapped to her back. They wear intricately decorated hairdos, each woman carrying a hand mirror with which she admires herself.

The register directly below Captain Ambrose shows a unit of the newly formed Native Constabulary wearing their flashy uniforms. The officer in front is playing a flute. The one directly behind him is giving a salute, and the last two are standing at ease—one hand holding the baton, the other in akimbo.

The register below the bevy of queens represents a group of royal guards and warriors. They all wear different attire and identical long beards. Their hats are dramatic and conspicuous, adding to their distinguished appearance. On the other side of the door, looking rather miserable, are four carriers in the service of the traveling commissioners. Even though they are not slaves, they are tied together to prevent them from making off with the commissioners' property.

When we examine the works of these two sculptors, it seems Yoruba art breaks down all the stereotypes about African sculpture as made by unknown, uncelebrated craftspersons without recognition as artists among their own peoples.[15] The active, creative, and celebrated lives enjoyed by Ọlọwẹ and Arowoogun and other Yoruba sculptors, and the remarkable images these artists carved, ensured that they were remembered among their own peoples even after their deaths for their contributions to the making of art.[16]

Also clear is that the two sculptors work in two different styles. Arowoogun's style favors a relatively shallow relief sculpture with an even surface. Ọlọwẹ's style is much more complex, in which the surfaces are uneven and the relief so high that some of the figures actually break off the panel, becoming almost freestanding. Unlike Arowoogun, Ọlọwẹ uses color and energizes the background of the figures with various combinations of lines and geometric shapes. Some registers are also left blank to contrast sharply with others that have busy backgrounds, thus relieving the eyes while emphasizing the textures of the designed backgrounds. Arowoogun always leaves his backgrounds blank to allow his figures to stand out clearly against the even grounds.

It is in comparison with the two works by Arowoogun and Ọlọwẹ that we can examine a pair of door panels (Fig. 1.5) in the collection of the Denver Art Museum. The artist who made these door panels remains unknown. Using a more schematic approach to the equation of the human form, the unknown sculptor reduces the figure to its most rudimentary essence, beyond which

the meaning of the figure might be lost as a readable sign. A fluid movement of lines flows throughout the body of the sculpture as the biomorphic figures are reshaped to generate a tide of rhythm, using a style much favored in the northern parts of Yorubaland, from Ila to Old Ọyọ.

Our discussion of Ọlọwẹ's and Arowoogun's works (and those of many other artists not mentioned here) demonstrates that much of the stereotyping of African art objects as essentially religious, ahistorical, static, and not made by artists is not applicable to Yoruba art. I conclude with an excerpt from the *oríkì* of Ìyàndá Òpó, a recently deceased Akinmorin-Ọyọ sculptor, as chanted by his granddaughter during Ìyàndá's funeral. The epic poetry refers to a competition between Ìyàndá and Kidẹro, a local sculptor who challenged Ìyàndá to a carving competition. A day was named for the competition, and the entire village gathered to see who was the better sculptor. The poet continues:

Ìyàndá Òpó agbẹgilére
Àjànàkú apagidà
Ó fúngi lójú
Ó lẹ́hinjú mejì o
Ó fúngi nimú
Ó níhòomú mejì o
Ó fúngi lẹ́nu
Ó létè mejì o
Ó fúngi lókó
Ó tún de ní fìlà o
Ó sọgi dèniyàn
Ó tún fun láya méjì o

[Iyanda Opo the master sculptor
The elephant (that is expert) who transforms wood
The wood had eyes
Complete with two pupils
The wood had a nose
Complete with two nostrils
The wood had a mouth
Complete with two lips
The wood had a phallus
Complete with a round cap.
The wood is now a gentleman
Complete with two loving wives]

[Then the challenger was asked to present his own sculpture:]
Kídẹró alásẹjù fẹnugbẹgi
Gbẹnugbẹnu ò jọ gbẹnàgbẹnà
Ó fúngi lójú
Kò lẹ́hinjú mejì o
Ó fúngi nímú
Kò níhòomú mejì o
Ó fúngi lẹ́nu
Kò létè mejì o
Ó fúngi lókó
Kò de ní fìlà o
Ó sọgi dèniyàn
Kò fun láya méjì o

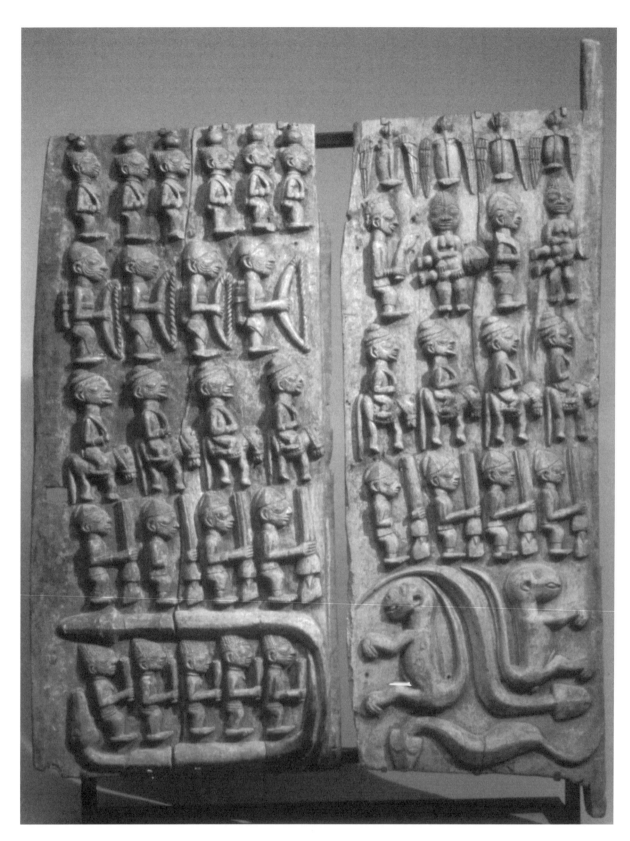

1.5 Unknown Yoruba artist, *Door Panels,* wood, Denver Art Museum

[Kideṛo, the pretender carver
He carves only with his mouth and not with his adze
The wood had eyes
Incomplete without two pupils
The wood had a nose
Incomplete without two nostrils
The wood had a mouth
Incomplete without two lips
The wood had a phallus
Incomplete without a round cap
The wood is a gentleman
Incomplete without any spouse]

The verdict? The king made Ìyàndá the royal sculptor. Kideṛo, the pretender, was asked to return to the woods and not visit the town until he learned to carve with more than his mouth. In other words, the idea that African art is bereft of individuality, that African artists are neither recognized nor celebrated as talented individuals, is a generalization that no longer holds. Some museums are beginning to recognize the individuality of Yoruba artists, judging from two major exhibitions in the United States during the late 1990s. Alisa La Gama, curator of African art at the Metropolitan Museum, organized an exhibition entitled "The Master Hand," almost at the same time Roslyn Walker of the National Museum for African Art, Smithsonian Institution, Washington, D.C., was holding a solo exhibition of Ọlọwẹ's work. These artists were lost the moment they died, but thanks to curators such as Walker and La Gama they are being found, studied, and celebrated in exhibitions and elaborative catalogs.

Different challenges face different aspects and areas of African art at different times. A difficult challenge faces the present generation of researchers and curators of Yoruba art as they begin to proceed beyond the illusion of missing African artists by locating those artists and relocating them in their proper places next to their works in museums. Art historians also face the task of formulating new theoretical frameworks for interpreting Yoruba art if art history is to continue to play significant leadership roles in African art. The theoretical framework outlined here is a model specific to the Yoruba colonial and postcolonial experience. At the same time, it is adaptable to fit any colonial/postcolonial visual culture after necessary adjustments of dates, contexts, and themes.

2
IMPOSITION PERIOD
Suppression of Ancient Artistic Traditions (1900-1945)

The works themselves, whatever we may presuppose of the antiquity of the traditions they represent, are works of a period in which colonial authority is imposed and, at the same time, contested.

—JOHN PICTON

It is important to realize that the main burden of imposing European rule on Africans was also borne by Africans. . . . The European commanders' conquest would have been much less easily acceptable had their soldiers also been European. In fact the rank and file in the colonial armies were Africans. . . . Once Europeans had forcefully imposed their rule on the continent, they continued to rely on Africans to help them govern.

—J. D. FAGE

Bí ikú ilé ò pá ba pa ni, ti òde kò lè pa ni (If the internal forces do not conspire to kill an individual, he or she could not succumb to any external causes).

—YORUBA PROVERB

lọwẹ Isẹ's *Ògògà Palace Gate* and Arowoogun's *Àtahun Àtejò*, explored in Chapter 1, clearly support this opinion of the Africanist historian J. D. Fage, as well as those of other scholars who have studied the dynamics and mechanisms of colonial impositions. Consider the following adaptation of Fage's words: "The main burden of imposing European art education on Africans was also borne by Africans. The learning of European art and technique would have been less easily acceptable had their teachers also been European. The art teachers were Africans. Once Europeans had forcefully imposed their aesthetic tastes on the continent, they continued to rely on Africans to help them propagate it."[1] The presence of very few Europeans on Ọlọwẹ's and Arowoogun's panels indicates that only a few Europeans actually participated in the imposition of the colonial culture on the Yoruba people. In what seems like a study in self-imposition, the British simply managed to persuade the

indigenes to subject themselves to the colonial economy through the cultivation of cash crops such as cocoa and groundnuts. They also persuaded the indigenes to subject themselves to the colonial religion, Christianity. In a related development, Africans "soon learned that Western education was the gateway to success in colonial society."[2] Thus they subjected themselves to colonial education in general and to colonial art education in particular. One energetic and talented artist who played a major role in the imposition of the colonial form of art education on Yoruba indigenes was not a European but a Yoruba man named Aina Ọnabolu. Just as the kings, chiefs, and other rulers formed an elite that facilitated the imposition of colonial culture on Yoruba people, so did an educated Yoruba elite help to impose the colonial form of art education on Yoruba indigenes.

Ọnabolu, who gloried in his ability to paint European-type portraits, sought to introduce the skill to fellow Yoruba indigenes because he was persuaded that the European style, rather than the ancient artistic traditions of Arowoogun and Ọlọwẹ that Ọnabolu had inherited, was the way of the future. Ọnabolu therefore taught in several schools in the colonial educational system in Lagos in his efforts to help spread the Western form of art education. He made disparaging comments about the indigenous forms of art making, which he considered primitive and inferior to the European perspectives, proportions, oils, and canvases. He focused on painting portraits of the elites of Lagos to show his own newly acquired oil-painting skills and also to display the newly acquired European tastes of his clients, who were often affluent and influential indigenes in the colonial system. According to art historian Nkiru Nzegwu,

> Like many Africans of the period who strategically deployed European upper-class mannerisms and legal principles to fight the battle of racial difference, Ọnabolu did the same with his chosen style of representation without forgetting who he was. . . . There is no question that a central part of Ọnabolu's objective as an artist was to use his art as a critical tool to visually confront and challenge the racist rhetoric of colonialists.[3]

Doubtlessly, the exposure to Western forms of education gave Ọnabolu enormous opportunities. But that exposure also had some negative effects in terms of how he interpreted his culture. In the words of Victor Khapoya, "Missionary education then had dual consequences for the Africans: it gave them skills with which to articulate their demands and question the legitimacy of colonial authorities; it also turned out to be a powerful medium of African acculturation of Western Christian (and political) values."[4] The acquisition of Western values also affected the indigene's aesthetic tastes and preferences because in his sometimes unrelenting quest and critical desire for Western aesthetic properties and values, Ọnabolu did not fully appreciate the creative value of indigenous African sculptures in Yorubaland or the murals painted by the indigenous women. Without intending to do so, Ọnabolu unwittingly contributed to the assault against indigenous forms of art making, as inherited from the ancient tradition of the people. Unfortunately, he merely meant to try to establish a totally different form of art education in Yoruba country for the benefit of the indigenes.

Aina Ọnabolu (1882–1963) was born in Ijẹbu Ode near Lagos during a crucial historical period when the British were consolidating their control over that seaport and its vicinity. According to Kevin Shillington, "Until the 1880s, the only official British possession of what was to become Nigeria was the small coastal colony of Lagos. By the time of the Berlin Conference of 1884–1885, however, the British had obtained a virtual trading monopoly over palm-oil export from the Niger delta and the lower Niger."[5] Ọnabolu therefore grew up in the metropolitan center of a colonized land, subject to the full vagaries of colonial cultural excesses while also poised to benefit from the opportunities created by the colonial presence. One such opportunity was access to colonial or missionary education, which opened the door to the European world otherwise inaccessible to the African. Ọnabolu attended St. Saviour's Primary School in Ijẹbu Ode, where he encountered pictorial realism in the form of photographs and drawings in religious books and school texts. While copying these drawings he taught himself to draw and soon became a teacher in the colonial system, struggling to include art education in the school curriculum. To justify his claim to competence in the European form of art education, he went to Britain for two years to study painting, returning with a diploma that gave him much credibility within the colonial school system. He felt pleased by his ability to rise to the upper echelons of Lagos colonial society, where most of his clientele were Africans, even though he was also a member of the Lagos Dining Club, where he met and painted the portraits of many Europeans. He felt less satisfied by his inability to reach a large number of Yoruba indigenes with his newly acquired skill of making and teaching realistic art.[6]

The Barrister (Fig. 2.1) by Ọnabolu characterizes his approach to portrait painting. In terms of composition there are usually two grounds—the foreground, containing the figure, and a background. Usually a shallow space, the background sometimes contains the suggestion of a decorated room configuration. *The Barrister* has that form of dual layering, consisting of a distinctive foreground superimposed on a complementary background to produce the scenic complex of an inhabitable space, humanized by the identity of a specific individual. In this instance that individual is also a professional type, a lawyer, regarded as part of the elite class of colonial society. A rare curiosity, the black African lawyer depicted in this picture was the center of the indigenous community, where the extremely complicated constitutions of the British legal system were imposed on the indigenes. Since no British lawyers were available in the colonies to argue the case of the villagers and ordinary citizens, the few Yoruba lawyers who were trained in London law schools were considered perhaps as important as the traditional rulers in the communities. In many instances even the natural rulers sought out these lawyers, especially because of the virulence of land dispute cases that followed the imposition of the colonial legal system. Since the indigenous Yoruba lawyers could speak both Yoruba and English fluently, they became the intermediaries between the old customary laws and the new British constitutional laws. When Ọnabolu painted *The Barrister* around 1920, no Yoruba woman had been called to the British bar, so it was reasonable that he could only conceptualize the lawyer as a male figure in a black robe.

At the same time, an informed viewer would realize that Ọnabolu's work falls within a Western naive portrait-painting tradition that proliferated in

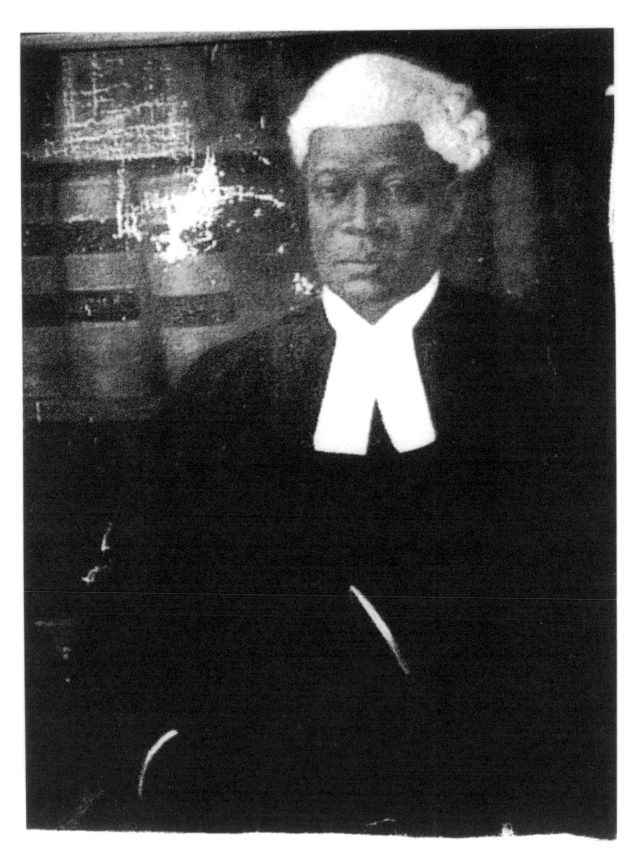

2.1 Aina Ọnabolu, *The Barrister,* oil on board, Nigerian National Gallery

Europe and was exported to the United States as the limner tradition. It was fairly popular in colonial America, where portrait painting was also the major art form because the settlers were trying to invent a metaphoric identity for themselves through the visual arts. In a similar vein, Ọnabolu was trying to forge a positive image for Nigerians, who were battling the cultural and identity complications of a colonial situation. Since the attorney was one of the bravest and most heroic icons of colonial culture, many Yoruba indigenes dreamed of becoming lawyers. Actual attorneys were worshiped and were often the subject of popular songs people composed in admiration of their intellectual and legal skills. In some songs local lawyers were called *"Akọ niwaju adajọ,"* meaning "the courageous hero who engages the jury." Because colonized individuals feared the complicated British legal system, they viewed as role models the lawyers who could understand and interpret those laws. It seemed much more important that the sitter shown in Ọnabolu's painting be a lawyer than that he be a particular person with specific idiosyncrasies. The sitter's identity is therefore defined by the court paraphernalia, particularly the dark robe, the white wig, and the rows of legal documents arranged carefully on the invisible shelf behind him.

The problem with the limner tradition within which Ọnabolu worked is that it is designed to project Caucasian pigmentation. Light-skinned figures are therefore situated in dark environments, producing a contrast that intensifies the figures' legibility. Ọnabolu's attorney, on the contrary, is dark skinned. The limner formula of a dark background does not provide the necessary striking contrast against dark skin, which makes legibility difficult in *The Barrister* and other portraits of Africans painted by Ọnabolu. The African American limner portrait painter Joshua Johnston faced a similar problem that can be seen in his painting of a black man entitled *Unidentified Gentleman* (Fig. 2.2), painted about a hundred years before Ọnabolu's portraits. When Ọnabolu or Johnston painted Caucasian clients, they did not have this problem, and those portraits seem more successful. Ọnabolu's rendering of human anatomy also seemed patterned after the uneven draftsmanship of the limner tradition, as seen in the left hand of the attorney, which hangs rather awkwardly over the arms of the ornate Victorian chair with displayed fingers that seem boneless and flabby.

At the same time Ọnabolu was working, several Yoruba artists trained in the indigenous art schools were also active, and many were at the pinnacle of their artistic achievement. Artists such as Obembe Alaaye, Ọlọwẹ Isẹ, Oọsamuko, Bamgbose Arowoogun, and others whose names are lost sculpted images in wood and metals, designed fabrics, painted murals, constructed installations, and staged performances. The names and works of a number of these artists have survived colonial rule, and a brief account of their lives and activities is presented here to acknowledge their contribution to the development of Yoruba art during a period of colonial imposition, when it was not fashionable to continue to work in their indigenous idioms.

Perhaps the most renowned master of indigenous Yoruba art is Ọlọwẹ Isẹ (c. 1875–1930), a perfect example of the Yoruba artist who became lost in his own lifetime and was found long after his death. By the early 1920s the British had consolidated a large empire in Africa into which they had successfully incorporated all of Yoruba country, an area covering thousands of square miles.

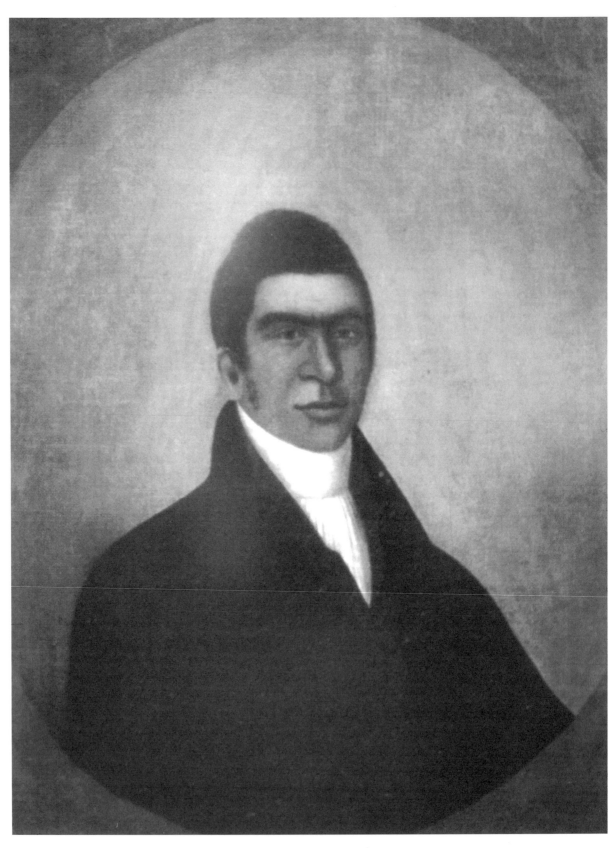

2.2 Joshua Johnston, *Unidentified Gentleman,* oil on board, Bowdoin College Museum of Art

A British Empire Exhibition was organized in 1924, and a Nigerian pavilion, including a Yoruba component, was displayed. The Yoruba component was carved by an anonymous village sculptor whose name the collectors did not bother to ask, even though the work was considered "the finest piece of West African carving that had ever reached England."[7]

Perhaps that would have been the end of the story for this great Yoruba sculptor, whose name and work would have disappeared into the bottomless pit of colonial amnesia, had a totally unconnected incident not happened in Ikẹrrẹ several years later. A colonial officer in Nigeria, Phillip Allison, lost his dog, which Ọlọwẹ Isẹ, a local sculptor, found and returned. Allison noted that Ọlọwẹ, the same local sculptor who had made the palace door displayed in the Wembley British Empire exhibition, also found his lost dog. A few years later Ọlọwẹ died, but Allison, with the assistance of other expatriates interested in Ọlọwẹ's work, helped to build a body of work attributed to Ọlọwẹ—which was not particularly difficult because that work is so stylistically distinctive. If Allison's dog had not gotten lost and Ọlọwẹ had not helped recover the dog, Allison would not have been in a position to revive Ọlọwẹ's name, and his art would have been lost forever in the jungle of colonial ignorance.

The Ọlọwẹ piece *Jagunjagun,* or *Warrior* (Fig. 2.3), is a house post especially sculpted to celebrate the prowess and pride of the equestrian general in Yoruba culture. To fully understand the potency Ọlọwẹ infused into the body of the horseman, it is pertinent to understand that as a child Ọlọwẹ witnessed the equestrian general's military activities. Ọlọwẹ therefore projects the general as a powerful and intimidating figure who inspires awe and fear in all and sundry. This piece has inspired many Africanist art historians and artists, including the painter Moyọ Ogundipẹ, whose discussion of the work appears in Chapter 5. But one of the most remarkable aspects of the composition is the gender relationship Ọlọwẹ explores, particularly the relativity of its importance to the equestrian figure. The power and glory of the equestrian warrior depend largely on the extent to which he is supported by the nude women who carry him aloft. The contrasts here are remarkable, as Ọlọwẹ explores the relationships between male and female, equestrian and pedestrian, attired and nude, single and multiple figures, and so on. In the pillar-shaped composition Ọlọwẹ cleverly stacks the rather heavy body of the horseman on the rather slender figures of the nude women, thereby playing upon the visual tensions of weight distribution, balance, and stability. These same principles energize the works of his contemporaries, including Ooṣamuko.

Along with Arowoogun and Bamgboye, Ooṣamuko is one of the most gifted artists in recent history to handle the theme of Ẹpa configurations. The three artists all sculpted Ẹpa masks with fascinating female figures exuding authoritative communal leadership, boundless fertility, and feminine power. Arowoogun and Ooṣamuko sculpted the female in a kneeling position, whereas Bamgboye sculpted her as an equestrienne. In these sculptures the woman is clearly the most important figure, largely because of the way she is positioned exactly at the center of the composition and also because she is the largest figure in the entire complex of images atop the helmet mask.

The Ẹpa figure (Fig. 2.4) by Ooṣamuko is part of a larger ensemble of performance images used in the celebration of the annual Ẹpa festival, held in the southeastern part of Yorubaland known as Ekiti. The Ẹpa is a special

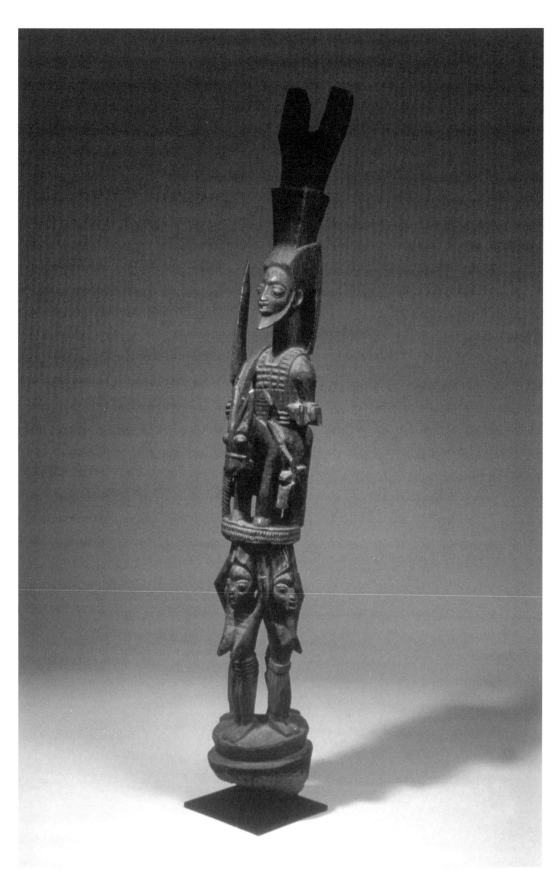

2.3 Ọlọwẹ Isẹ, *Jagunjagun* (Housepost), wood, Denver Art Museum

type of masquerade performed in few parts of Yorubaland.[8] The Ọyọ, Ifẹ, Ẹgba, Ijẹbu, Ondo, and Ọwọ peoples do not have the Ẹpa masquerade. Found only among the Ekiti, a people of the hilly, thickly forested yam belt, the performance is an integral part of planting and harvesting calendars. Other parts of Yorubaland have their own forms of masquerade, which are generally absent among the Ekiti people.

These Ẹpa masks commemorate the abiding and triumphant spirit of a people who celebrate their victory over the evil powers and principalities that seek to constantly destabilize the rhythms of everyday life. The appearance of the Ẹpa mask demonstrates that the people have once again completed a fruitful and prosperous season and are eagerly looking forward to beginning a new cycle. In gratitude to the selfless heroes who saw the society through the trials and triumphs of the previous season, and in celebration of these role models whom the people will be looking to for leadership during succeeding seasons, members of the community stage the Ẹpa mask performances. During the performance, people in the community demonstrate their gratitude to the pillars of the society—those who metaphorically support the society, as the òpó house post supports the house. The Ẹpa masks therefore visually celebrate the pride in the communal heroes with meticulously sculpted wood carvings, finished with detailed painting.

Ekiti communal heroes are categorized in a few types—hunter/warrior, herbalist/priest, mother/beauty, and ruler/king. These types are rendered in visual images as different forms of Ẹpa masquerade. During the Ẹpa festival the masks appear in public to dance and perform, one by one, for the enjoyment of everybody in the community. The dances acknowledge and portray the importance of the type of social hero approximately equated in the composition of the mask. The portrayals of characters on the Ẹpa masks must be described as "approximate equations" because the sculptors do not attempt to "represent" reality but instead try to approximate life with images, thereby transferring life into images and images into life. They bring life into images by depicting social heroes (e.g., warriors, mothers, herbalists). They bring images to life by wearing the sculptural pieces in performance dance dramas involving entire communities. Every resident participates in the annual Ẹpa masquerades, an outdoor event staged just before the rainy season. A hierarchy of participation exists in Ẹpa masquerading. The insiders make all the decisions about who carves the sculptures for the masquerade, when the dances will be held, who will carry the masks, and all such important decisions. And the outsiders have no direct connection with the actual masquerade performance beyond serving as spectators. That role is important, however, because the entire performance is staged for the pleasure of the spectators, who value the entertainment aspect of the festival. Without the spectators, the dancers would not be moved to take spectacular steps, and the drummers would not be inspired to create intricate and provocative rhythms. As outsiders, the spectators are in a position to offer impartial criticism of the artistic and spiritual experience without malice or favor.

Between the insiders who make the decisions and the outsiders who see the result of those decisions is a group of participants who serve as executives. They include the artists who carve the objects, the dancers who perform the masks, the cooks who prepare the dishes, and those who keep the paraphernalia,

sing praise songs, manage the performance proceedings, protect spectators and performers, and serve as links between the decision makers and the spectators. They are the "in-betweeners," and they have information about forthcoming Ẹpa performances, which are presented within a cloak of secrecy. The in-betweeners often leak the dates of the performances to the public, which begins to look forward to the colors, sculptures, songs, and dances of Ẹpa masquerades and the magnificent display of the indigenous art forms that constitute a week of lavish aesthetic and spiritual experiences. In the context of dancing, singing, and drumming, figural sculptures carved by artists such as Ooṣamuko are paraded around the streets of the community, joyfully received by all.

Ooṣamuko, an enigmatic personality about whom relatively little is known, left a small body of exquisitely shaped images, including the Ẹpa sculpture with the kneeling female figure (Fig. 2.4). This sculpture is a robust-looking piece carved in wood and finished with polychromatic painting. Most imposing is the figure of the kneeling woman, which is used to unify the form of the pictorial composition as well as the content of the story behind the composition. Ooṣamuko's Ẹpa sculpture consists of a double-decker structure, the lower tier comprising a highly stylized head with large eyes, a gaping mouth, and no nose. On top of the head is a flat platform that serves as a partition between the lower and upper decks of the sculpture. Flat and built like a stage, the upper deck is worn almost as a hat over the head of the lower deck. The images of the upper deck are dominated by the figure of the kneeling woman, whose powerful body supports two smaller female frames flanking her spiritually powerful presence on both sides. All the figures shown in the composition are female. The central figure is kneeling, whereas the two flanking figures are standing upright, loaded with some goods belonging to the central figure. The sheer size of the kneeling figure makes her dominant within the body of the entire composition, as the two standing females are no more than one-eighth her size.

The expanse of the kneeling woman enables Ooṣamuko to focus on the details of her body. A wrapper is draped around her lower body, leaving her upper body bare, which allows Ooṣamuko to explore her nudity. The elaborate headgear decorating her impressive coiffure is remarkable. The headpiece resembles a crown in its complexity, adding a compelling apex to the commanding figure of the kneeling woman, whose extended hands protectively support the two standing figures. In the middle of her forehead is a diamond-shaped decoration, around which are arranged rectangular shapes, also indicative of decorative jewels. Her entire face seems determined—her jaw grimly set, her nose flaring, her lips clipped with urgency. Since her body leans forward from the waist, her face is pushed forward, further emphasizing her prominent eyes, with lids provocatively raised to give her a bewitching stare. Long ear decorations are prominently embedded in her earlobes, visually connecting the chin with the shoulders and yielding a delightful geometric design that further enhances the decorative appeal of the topmost part of the sculpture. The theme of ornamentation is reinforced by the arrangement of two layers of circular discs around the woman's neck, gently positioned to rest on her finely crafted shoulders and to depict beaded decorations worn by important women.

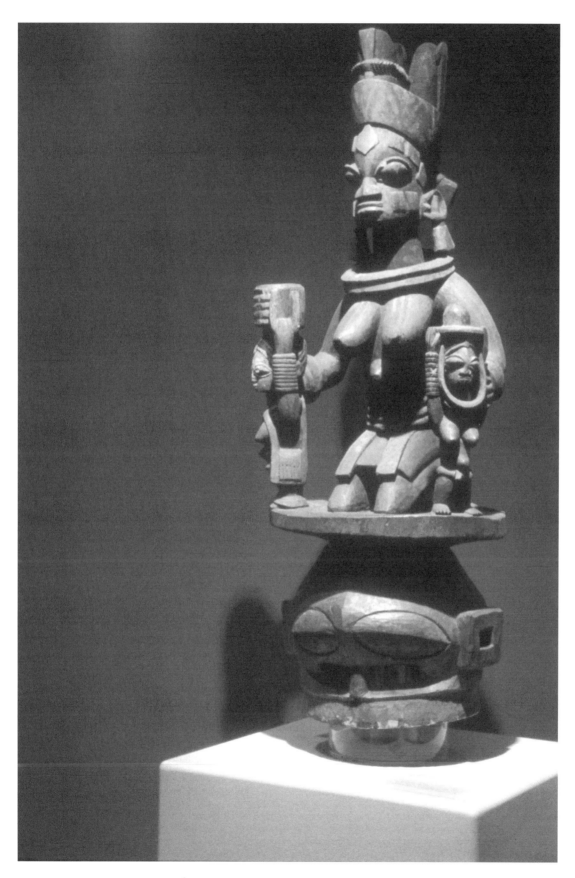

2.4 Ooṣamuko of Osi, *Èpa With Kneeling Woman*, wood, pigment, Denver Art Museum

Just below the lower line of beads, her breasts rise magnificently and provocatively in a gesture that is both erotic and maternal. The cylindrical fullness of the breasts indicates nurturing, which Ooṣamuko further visually suggests in his cylindrical modeling of the woman's belly. Once again, Ooṣamuko introduces decorative motifs as a means of generating rhythms around the woman's waist area. He adds two layers of horizontal lines around her neck to balance the four parallel lines of circular beads around her waist, emphasizing her pronounced belly button. The woman's arms run parallel to her breasts and embrace the two smaller figures, just as visually nurturing as the breasts are anatomically nurturing. Her legs are carefully modeled to accentuate and contain the thrust of her body, in a tense position that clearly portrays her seriousness of purpose. The two nude maidens who stand in front of her lend an atmosphere of sisterhood to the image. An urgent sense of encounter is conveyed between the three figures and the viewer, through whom the figures coolly stare.

The entire composition is in the structure of a pyramid, with the apex at the summit of the woman's headgear. The skull-like head above the woman is also shaped as a pyramidal structure, elegantly bearing the weight of the larger pyramid formed by the spectacle of the woman's figure. By constructing these intricate architectonic structures, Ooṣamuko demonstrates his understanding of abstract visual relationships beyond the narrative arrangements of figures. In contrast, the artist Bamgboye relies on the heavy arrangement of figures to convey a narrative and ritual to his composition, as his Ẹpa piece demonstrates (Fig. 2.5).

As complex and diverse as the figures are on Bamgboye's Ẹpa mask, the image of the central woman remains the boldest and most magnificent figure, balanced as it is on horseback. In all, there are twenty-four human figures including infants strapped to their mothers' backs, drummers, priests, servants, and attendants. Two decks of human figures are arranged around the central female figure and her horse, depicting the members of her entourage, in the middle of which she rides triumphantly. The upper part of the composition has a rhythmic connection to the female figure on horseback, whereas the lower part of the composition coincides with the size of the figure of the ridden horse. The upper deck consists of several figures, in varying degrees of interaction and aloofness. Two men flank the woman on horseback, a talking drummer to the right and a servant to the left. The talking drummer is wearing a shirt (bùbá) and pants (kèmbẹ̀) with stripes. Like other figures in the composition, he is staring straight ahead. As in other figures, the head of the drummer is about a third the size of the entire adult body. This places a great deal of emphasis on the head, which stands out prominently on the figures. Second, the head becomes a unit of rhythm in a triadic rather than quadratic composition; the triadic unit deploys the head as a one-out-of-three model of figural structure rather than the design often found in Western art, where the head is about an eighth or a seventh of the entire adult body. Although he enhances and stylizes the natural human body with a triadic composition, Bamgboye emphasizes the rhythm in the entire body by making the head the most important element of the composition. Despite this idealistic rendition of the human figure, Bamgboye is able to convey a story that presents his characters in a realistic cultural context. This approach to sculpting makes his work seem ethnographic, as if he were doing a demographic study of the

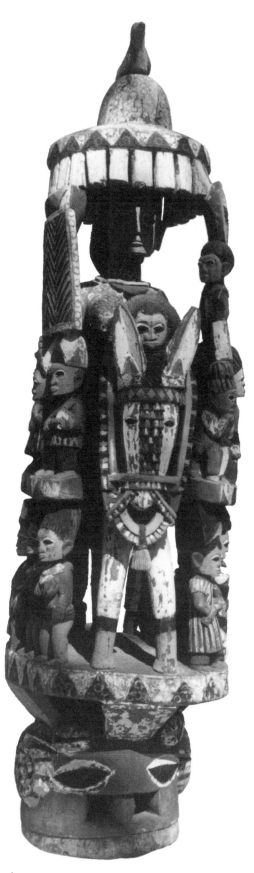

2.5 Bamgboye, *Ẹpa With Equestrienne*, wood, pigment, Heitler's Collection

community. Bamgboye shares this penchant for ethnographic details with Lamidi Fakẹyẹ, a sculptor who is still living.

Lamidi Fakẹyẹ's portrait of the Yoruba diviner, *Babaláwo* (Fig. 2.6), is a vivid ethnographic study of that spiritual figure in West African culture. Central to understanding Yoruba cosmology and its interpretation, the *babaláwo* is the all-seeing eye who is able to recall the past while incorporating an all-encompassing view of the present yet maintaining a commanding sweep of the future. Geographically mapping the terrain, the *babaláwo* is located at the heart of Yoruba life, a veritable compass for positioning other key cultural icons, such as the king (*ọba*) and general (*jagunjagun*). Fakẹyẹ equates the *babaláwo* icon with the most powerful figures in Yoruba culture.

Fakẹyẹ's *Babaláwo* is a projection of a Yoruba diviner in his complete regalia, showing his official position as a seer. The personality of the *babaláwo* embodies calmness, which his face portrays. Although he is silent, with his face forming a benign mien, his lips capture a cool smile of self-assurance and responsibility. The silence of his mouth contains hundreds of poems and chanted narratives he has memorized as part of his calling as an Ifá priest. Imbued with a transfixing look, his spiritual essence radiates from his distant eyes as his gaze falls directly into mythological space, transcending the world of ordinary visibility. Those eyes feed a timeless vision with a boundless vista, erasing the lines between the sphere of the living and the realms of the immortal. The gaze of the *babaláwo* reveals glimpses of eternity, which Fakẹyẹ captures in the reverent shaping of the wooden figure.

The visual power of the *babaláwo* figure resides largely in his head, which constitutes a third of the size of the whole body. The allocation of so much space to the head of the *babaláwo* gives Fakẹyẹ ample room to demonstrate his skill as a talented sculptor. Much of the space becomes a room for him to play with intricate patterns and rhythms. Fakẹyẹ also seizes the opportunity to provide a detailed ethnographic record of a Yoruba diviner, showing the style of coiffure and professional accouterments.

The *babaláwo* sports an outlandish coiffure that instantly grabs the viewer's attention. The elegance of the hairstyle lies in its clean demarcation into two contrasting and complementary parts, one bald, the other bushy. The bald side is enhanced with a long woven lock into which is incorporated a medicinal gourd (*àdó*). Fakẹyẹ says it was common for the wearers to save the hair on the bald side until it got bushy and then shift the design around to the other side. Fakẹyẹ has preserved a flamboyant and elaborate coiffure, demonstrating that Yoruba male hairstyles were numerous, original, and provocative rather than simply conservative. Even the *babaláwo*'s finely groomed beard has a dramatic flare with a fan-line configuration, bringing emphasis and attention to the lower part of the priest's head.

The *babaláwo* has his divination bag, known as *àpò jèrùgbé*, suspended from his neck, jauntily thrown to the back and hanging between his broad shoulder blades. Inside the *àpò jèrùgbé* can be found the basic divination implements the *babaláwo* needs to consult the Ifá divinity on behalf of his clients. The divination paraphernalia in the *àpò jèrùgbé* slung by the *babaláwo* might include *ọpẹlẹ*, the divination chain; *ìróké*, the divination tapper; and *opón*, the divination tray. The sacrificial offerings the *babaláwo* collected on his round would also be placed in the divination bag.

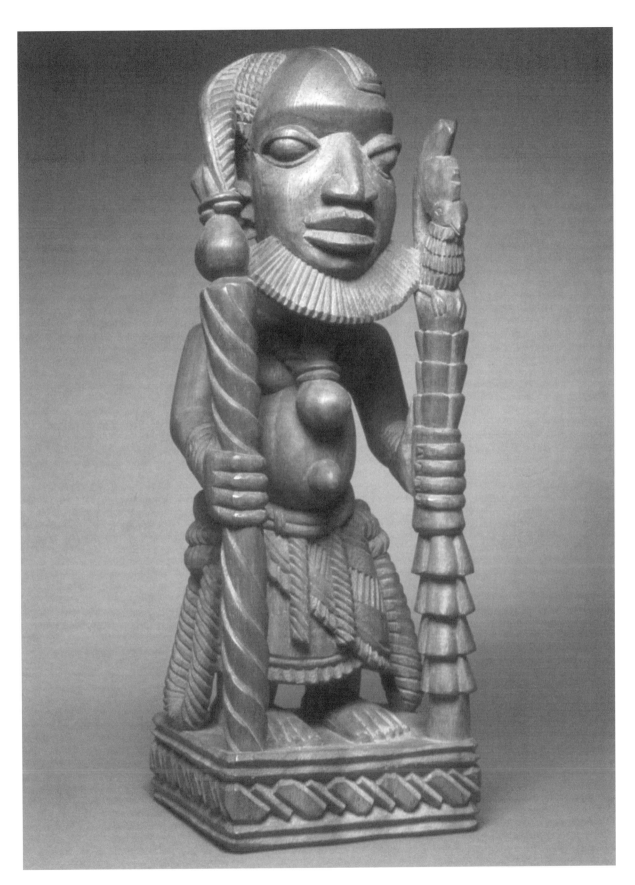

2.6 Lamidi Fakẹyẹ, *Babaláwo*, wood, Denver Art Museum

To give balance to the composition an *ado* rests on the *babaláwo*'s chest, visually enriching his mythographic icons and paraphernalia. The upper part of the *babaláwo* is marked by naked skin, and the lower part of his body is enclosed in an elaborate *bàǹtẹ́*, which he wears to portray his prominence in society. Diagonal ornamentations, rendered in low relief, are embedded in the *bàǹtẹ́* to enliven the surface decorations. Giving the loin garment a more elaborate appearance, the girdles of the *bàǹtẹ́* hang low and profusely on both sides of the priest's body. Around his waist is a tightly tied leather chord, called *olóndè* or *ìgbàdí,* containing defensive and offensive medicinal preparations to protect the *babaláwo* from physical and spiritual attacks by detractors, enemies, and rivals. Where the *olóndè* straps interlock around the *babaláwo*'s waist, they taper into fine linear movements, only to bulge into a knotty segment at the back, where the *olóndè* rests elegantly on the *babaláwo*'s muscular flanks. The visual effect of the *olóndè* deters would-be assailants, whereas its actual effect in combat is to contain physical attacks.

The two staffs the *babaláwo* holds in his hands perform similar functions of metaphysical offense and defense, in addition to serving as the official paraphernalia of Ifá priesthood. The staffs are variations of the *ọ̀pá ọ̀rẹ̀rẹ̀* or *ọ̀pá ọ̀ṣòòrò* or *òsùn staff* in his right hand and *ọ̀pá ọ̀sanyìn* in his left hand. Fakẹyẹ transforms both types of staff to introduce novelty and innovation, signifying his individuality as a sculptor. According to art historian Rowland Abiọdun, "*Ọ̀pá Ọ̀rẹ̀rẹ̀ or Ọ̀pá Ọ̀ṣòòrò* is an iron staff usually carried vertically in the hand by the babaláwo but it may be stuck in the ground at important gatherings or occasions involving the presence of Ifá priests."[9] The priest does not deploy the iron staff in real scuffles. The mere presence of the metal staff is sufficient protection because it clearly identifies the individual as an Ifá priest. There is a an Ifá verse that states "*Ẹnìkan ò gbọdọ̀ síwọ́ lu babaláwo, tó bá gbọ́fá yanranyanran lótù Ifẹ̀ yì í,*" meaning "No one may raise their hands against a *babaláwo,* who is well versed in the art of Ifá divination here on earth." The Ifá priest is thus protected from physical attack simply because he is holding the metal staff. Abiọdun says the bird motif on top of the staff depicts *ẹyẹ kàn.* In his sculpture Fakẹyẹ transforms that same bird into a cockerel, in part to signify the elegance of the cockerel and at the same time to represent the essence of ordained sacrifice, which is crucial to the practice of Ifa divination. The cockerel is one of the most commonly demanded sacrificial animals; thus the symbol of the bird rides high on the *babaláwo*'s totem pole. Overall, the figure of the *babaláwo* is the embodiment of confidence, courage, and determination to succeed and prosper in the face of adversity. Fakẹyẹ portrays the priest as a vertical (upright) configuration, his standing figure mirrored by the vertical thrust of the two staffs on which his head securely rests. With that attitude the Ifá priests find it easier to win the confidence of their clients, who rely on the priests for deliverance from both physical and spiritual challenges that constantly arise.

Lamidi Fakẹyẹ's *Babaláwo* reminds us of a world that is quickly disappearing, especially when we compare Fakẹyẹ's sculpture with Margaret Drewal's photograph (Fig. 2.7) of a contemporary Yoruba *babaláwo,* Kọlawọle Ọṣitọla of Ijẹbu Ode. Africanist art historian Henry Drewal worked with Ọṣitọla and attests to his greatness as a diviner and priest. From the photograph it is possible to see that Ọṣitọla uses the standard paraphernalia,

2.7 Margaret Drewal, *Oṣitola*, photograph, private collection

particularly the Ọpọ́n Ifá or Ifá tray, with which he demonstrates in the picture. Ọṣitọla wears a costume appropriate for a priest, even though the costume consists of a Western shirt and pants made of a white fabric.[10] The whiteness of the fabric refers to Ọbatala, the divinity of creativity, to whom Ọṣitọla is also devoted, whereas the Western design of the costume refers to Ọṣitọla's exposure to Western education and acceptance of Western culture.

At the same time, Ọṣitọla's acceptance of Western culture clearly does not compel him to discard his indigenous beliefs because he continues to practice actively as a priest, even though he now uses available Western resources such as videos and audio recordings, as well as Western writing, to communicate with his clients, who are scattered all over the world and with whom direct physical contact is often impossible. In using Western media to disseminate his ideas, Ọṣitọla extends the limits of tradition even more than some *babaláwo* who refuse to chant Ifá verses into any form of recording. A respected elderly Ile Ife priest called the practice trying to "can Ifá like a sardine," and he refused to talk while we rolled the tape. Because *babaláwos* such as Ọṣitọla and Bolu Fatunmiṣe are willing to use all available forms of media to project the Ifá divination culture, they must make compromises such as using a Western form of orthography or wearing Western suits or acquiring Western degrees, qualifications, and skills. These diviners hold standard forms of Western education, self-motivated academic qualifications, and learned skills, which some acquired during their incessant training to become priests. The most exemplary Ifá priest is Wande Abimbọla, who not only received a doctorate in cultural history but went on to become president of the famous university in Ile Ife, Nigeria, where dissemination of African languages and literature remains strong.

Some of Abimbọla's critics have accused him of intellectualizing Ifá, whereas others say he only cheapens and falsifies Ifá because he renders an oral tradition in a visual form of writing. Abimbọla does not try to defend himself and allows the importance of his work to speak for itself. Clearly, though, he has self-imposed what he considers beneficial in the Western culture onto the promotion of Ifá, not only in Africa but all over the world. At a time when he sees the need for this divination system to be revived, he has decided to do what he considers most appropriate by borrowing Western tools.

Clearly, all the artists of the imposition period shared concern for cultural authenticity through their depiction of what they considered the salient truths of their colonial culture. The artists who continued to use indigenous materials and methods saw their works as a way of preserving timeless, authentic indigenous images, manners, and values. Such artists, including Bamgboye and Ooṣamuko, depicted what they saw using acceptable iconic standards for rendering images among Yoruba people. In a totally different circumstance, Ọnabolu used his art to record portraits of Nigerians during the era of British colonial imposition. Unwittingly, he thereby became the local agent in the colonial mandate to civilize colonized people.

3
OPPOSITION PERIOD
Revival of Ancient Customs and Traditions (1945-1960)

The West African Negro has . . . never sculpted a statue, painted a picture, produced a piece of literature.

—Sir Hugh Clifford

World War II had just ended in 1945, and the entire world was going through drastic changes resulting from victories and humiliating defeats suffered in Europe, Asia, and America. But Africa remained a colony of Europe. Increasingly frustrated by the inability of Europeans to appreciate African cultural differences, by 1945 the colonized Yoruba people felt the need to look at themselves through their own eyes rather than through the eyes of colonial agents such as Sir Hugh Clifford, who made disparaging statements such as the one quoted at the start of this chapter. Given the bias colonial agents cultivated against the indigenous people and their arts, some Yoruba artists began to rethink their attitudes toward their lives as colonized people and toward their arts as colonial arts. They also began to look at their arts from their own empowering, individual, and communal view rather than from the denigrating perspective of the colonizers. That way of thinking led

to a revival of interest in indigenous Yoruba customs, norms, and practices by many Western-trained Yoruba artists. They began to incorporate aspects of these indigenous cultures into their compositions.

The years 1945 to 1960 can be regarded as a crucial moment in the politics and art history of the Yoruba people, as well as of other ethnic groups in Nigeria and Africa. Those years saw the introduction of new forms of political organization, as well as the adoption and invention of new forms of art into the cultures. Politically, the period covered the end of World War II, the attainment of political independence by Nigeria, and the introduction of democracy as a political system in Nigeria. Artistically, it witnessed the development of political cartoons by Yoruba artists, the introduction of landscape painting, and the expansion of portrait art to include the representation of ordinary folks beyond the images of the elites favored by Ọnabolu, as described in Chapter 2. It was a period when Yoruba artists invented a positive identity for their people, as part of their definition of the Nigerian character, using the mediums of caricature, portraiture, landscape painting, and sculpture.

In part, these artists were responding to racist colonial rhetoric, including that of F. H. Howard, a deputy director of education in colonial Nigeria who wrote that "in the field of art, an African is not capable of reaching even a moderate degree of proficiency."[1] The artists saddled themselves with the responsibility for developing an aesthetics and a repertoire of images that opposed such Western representations of Africa as backward and barbaric. Notable among Yoruba artists who used their work as a form of opposition to colonial rule, aesthetics, and culture are Akinọla Laṣekan and Justus Akeredolu, close friends who both grew up in Ọwọ. In different ways, they represent the creative spirit of a people reacting to negative colonial stereotyping. By reaching deep into the marrows of their minds to respond to the colonial challenge, they came up with different, positive ways of depicting the masses of the people who were moving from the depth of colonization into the light of independence. The artists responded in many ways, ranging from the visual arts to literature and music, as colonized people redefined and reclaimed themselves from the limitations, walls, and boundaries imposed by colonial authorities.

"*Ojú rí ní India*" is a common Yoruba saying whose full significance is often lost in its sheer poetic polyphony. Ordinarily it means "I saw tribulations in India." Others may translate it as "Adventures in India." *Oju Rí Ní India* is actually the title of one of the first literary efforts in the Yoruba language to document the participation by Yoruba people in World War II as soldiers stationed in India, Burma, and North Africa. The narrative explores the life of a Yoruba soldier stationed in India. For the first time, these colonized people had access to the outside world while participating as soldiers in the colonial British Army. Because many had service jobs in the army, they fed and cared for the combatants, who were mostly white.

The Africans could understand the basis for the war, since it was fought to free people from the tyranny of Nazism. What they could not understand were the impunity and ferocity with which human lives and properties were destroyed by members of a European civilization that claimed to hold the only key to the future. When the war was finally over and victory over tyranny had been won, the Africans could not understand why their lands remained

under colonial subjugation by their wartime allies. Had they not helped fight against and defeat Nazi Germany because of these same issues of domination? The discharged African soldiers began to raise a new consciousness among a restive people already wary of British colonization.

By 1945, when the war ended, hundreds of discharged Nigerian soldiers—many of them literate and Christian—dispersed into urban and rural Yoruba communities. They openly spoke against colonization, which was being presented as a British mission to civilize the colonized. These politicized elements joined the ranks of educated Yoruba indigenes—including Rẹmi Fani-Kayọde, Samuel Akintọla, and Obafẹmi Awolowo—in the struggle for independence from British colonization. A comprehensive assault against colonial rule was launched; and politicians, writers, musicians, and artists played equally crucial roles in formulating a liberationist art and aesthetics. Notable among those who played a leading role in defining and articulating the values of the oppositional aesthetics through his art, writing, and teaching was Akinọla Laṣekan.

LAṢEKAN INTENDED TO LEARN THE COLONIZER'S ART and use it to fight colonization in a subtle and aesthetic manner. During the 1940s and 1950s, after tutoring himself and mastering the Western medium of painting, Laṣekan rendered a series of self-portraits and portrayals of other Africans a la Ọnabolu. Going beyond Ọnabolu, however, Laṣekan added landscape painting to his work. The landscapes were usually executed from his recollections and imaginations of Yoruba village scenes, based on his experiences as a young Yoruba boy growing up in the ancient Yoruba city of Ọwọ. Two paintings by Laṣekan, *Market Scene* (Fig. 3.1) and *Nigerian Constable Under Colonial Rule* (Fig. 3.2), both done in the 1950s, exemplify his thematic range and style of oil painting. Both paintings demonstrate his firm understanding of *chiaroscuro,* modeling and draftsmanship. Beyond that, Laṣekan interjects subtle political messages into his paintings without allowing the themes to dominate or overshadow the aesthetic aspects of the compositions.

Laṣekan was born in Ọwọ, a small town in southwestern Nigeria at the beginning of the twentieth century. He received his primary education in Ọwọ at a time when one had to become a Christian to be eligible to attend the missionary-run schools. Ọwọ had a growing population of about 15,000 residents. In those days people were much more mobile, and they constantly moved from their homes to the farms. Many people lived on the farms for most of the week and returned to town just once a week or even once a month to replenish supplies. A growing number of people were becoming permanent residents of towns because of the nature of their work in the emerging colonial economy. These folks included schoolteachers, government officials, ministers of Christian organizations, traders, and artisans such as carpenters, blacksmiths, and masons. The town was growing rapidly. New buildings were being constructed with cement finishings, making them stronger and exotic looking in the local landscape. Many people were also constructing their roofs of corrugated iron sheeting rather than using palm fronds to thatch them.

The Christian church was gradually spreading, and most progressive elites had converted to Christianity or were connected with it directly or indirectly.

3.1 Akinọla Laṣẹkan, *Market Scene*, oil on board, Nigerian National Gallery

Even the die-hard traditionalists who would have nothing to do with Christianity had friends who were Christians and had at some point considered becoming Christians themselves. When some of the traditionalists became very ill and the native doctors were unable to help them, they finally went to the hospital run by Christian missionaries. But as soon as the die-hards were healed, they promptly returned to their old ways. Hospital stays were usually a time to convert people. With exceptionally loving care, the Christian nurses prepared the patient for a spiritual in addition to a physical healing. By the time many people left the missionary-run hospitals, they were converted and were ready to convert others. Somehow a strong connection was made between the physical healing that took place in the hospitals and the spiritual salvation of Christianity, which particularly convinced the new convert of the power of the new religion.

The school system was another area in which the Christian missionaries—who ran most of the schools—gathered converts. The few government-sponsored institutions were based on the same principles and curricula as the missionary-run institutions. At school therefore students constantly heard about Christianity. The successful pupil became a teacher, but the most successful became a pastor or a Catholic priest. Education also prepared people for opportunities in other areas, such as clerical work, justice, and technical services.

3.2 Akinọla Laṣekan, *Nigerian Constable Under Colonial Rule,* oil on canvas, Nigerian National Gallery

But the schools were not trying to make artists out of the indigenes of Ọwọ at the time Laṣekan was born.

At an early age, nevertheless, he was fascinated by the ability of some European artists to copy nature, and he resolved to acquire the required skill. It was an extremely difficult task because he knew of no local or international artist to emulate or use as a role model. He was therefore working totally from his own motivation through a process of trial and error. As he grew up he learned that what he proposed to do was extremely ambitious and that Europeans had said no African could do it.

Challenged, he resolved to demonstrate that an African could make that type of art and even make it better than a white man.[2] He began to copy illustrations of biblical texts and other images rendered in realism. He heard about a correspondence course in England that would improve his skills. He took the course and was introduced to perspective drawing, modeling, and *chiaroscuro* painting. During the late 1930s he decided to go to Lagos, the capital of Nigeria, to open a studio and further develop his talent as an artist.

He went to Lagos when the ferment for political struggle against colonialism was beginning to heat up under the leadership of Nnamdi Azikiwe. Educated in the United States, Azikiwe returned to Nigeria to found the *West African Pilot,* a nationalist newspaper that espoused his anticolonial interests and sentiments. Because Laṣekan was an exceptionally gifted illustrator and a witty fellow, he became the first cartoonist hired by the *West African Pilot,* thereby becoming the first Nigerian cartoonist. By the mid-1940s Laṣekan had established himself as a vital force, working for the leading newspaper in the political struggle to liberate Nigeria from British colonization.

By 1950 he was a household name among the elites who read the *West African Pilot,* which was building a reputation as an anticolonial newspaper. Azikiwe, the enigmatic nationalist politician who later became the first president of independent Nigeria, was the newspaper's intellectual backbone. In his flowery and defiant language, Azikiwe openly challenged the colonial power to defend its moral and intellectual authority to colonize others. Laṣekan, the paper's daredevil cartoonist, had perfected the art of cartoon drawing—something totally new to the intellectual and cultural climate of the colony. Overnight, Laṣekan rose from anonymity to become a political and artistic elite by the sheer virtue of his creative talent and the urgent implications of his political messages.

Because he was aware that he had little Western education, Laṣekan aspired to study in Britain to improve his artistic skills and be exposed to the works of artists from other parts of the world. In 1945, after less than a year at the Hammersmith School of Building, Arts, and Crafts in England, Laṣekan decided he was not learning anything new. He returned to Nigeria to resume his activities as a cartoonist and painter. He remained in Lagos, the seat of the colonial state of Nigeria, until he was appointed a professor in 1960 at the University of Nigeria at Nsukka.

The first half of Laṣekan's life was devoted to political cartoons and the second half to painting and teaching. By the mid-twentieth century he had published four books of cartoons, in addition to continuing his work for the *Pilot.* According to Kojo Fosu, the Africanist art historian,

[Laṣekan's] best works were those executed for the West African Pilot newspaper, for which he worked. He produced provocative cartoons as weapons of political propaganda against colonialism and for promoting national consciousness. These cartoons were simple conventional illustrations with symbolic meanings that were easy for the average reader to understand.[3]

Fosu then analyzed some of the cartoons in the context of the colonial culture within which they were drawn. According to Fosu, one of Laṣekan's cartoons, entitled *Poor Africa,*

Is a satirical cartoon showing five representative European Imperialists. Three of them are in the process of slicing for themselves a portion of the map of Africa placed on a round table. The two representatives of the USSR and USA merely look on approvingly. . . . *The Blackman* shows a giant-sized African male girded in a wrapper from the waist down with feet astride and chasing away diminutive Europeans in a beach scene. The message was clear—time for the imperialists to pack from their colonial paradise to usher in the new political independence.[4]

Laṣekan's two paintings, *Market Scene* and *Nigerian Constable Under Colonial Rule,* were undertaken during a period of intense political activity, when he spent most of his time carving woodblocks under tight schedules for the *Pilot.* During the struggle against British imperialism, Laṣekan was far more famous for his naturalistic cartoons and biting satirical commentaries than for his paintings, which were not in the public eye. His paintings, however, were an extension of his political beliefs and activities. He often depicted the dignity of the colonized Nigerian and the great natural and unspoiled landscapes Westerners sought so eagerly to despoil.

Laṣekan, unlike Ọnabolu, painted ordinary folks. Laṣekan did paint a few dignitaries, but many of his paintings focus on the common person going about his or her way or posing for a portrait. From Laṣekan, therefore, one can glimpse the spirit, energy, and aspirations of a colonized people not at all fractured by their colonial experience. Laṣekan's portraits become a counter-narrative to the negative portraits of the colonized Africans painted by the colonial masters. His *Nigerian Constable Under Colonial Rule* depicts a confident and energetic young man clad in the khaki uniform of the corps of the native constabulary, complete with colorfully tasseled hat bearing her majesty's coat of arms. The fine drawing of the officer's solemn face registers a keen sense of observation and a sensitive handling of the oil painting. Laṣekan's diligent modeling of the eyes brings a subtle glint of liveliness to the officer's face, revealing him to be an intelligent man. If his determined eyes show hints of shyness, his full lips—carefully pressed together—convey a singular strength of character, a relaxed sense of assurance, and a hidden streak of stubbornness, belied by his smooth and pointed chin. On the whole, he seems capable and easy to relate to, dedicated, and honest, which is not how the colonial masters describe Africans.

Laṣekan's *Market Scene* shows a typical market in Yoruba villages during the 1940s and 1950s. In the painting Laṣekan records the people's architecture, town planning, economics, and fashion while provoking a debate on issues of gender through his asymmetrical representation of male and female

figures. A typical village farm scene is usually associated with big trees, intended to be the spirit of the market. The typical Yoruba market often began as a resting place under a big tree at a point where several footpaths met. The opportunity to meet under a tree, protected from the tropical sun, allowed people to interact, exchange goods, and replenish themselves before continuing their journeys. Such points of confluence often became places where traders purposefully brought goods and services for resting travelers, and the places could easily turn into markets and even towns. It is therefore important to note that Laṣekan makes a tree and its leaves so prominent in his market scene. The tree projects a trunk into the center of the painting, serving as a frame within a frame for the composition. It also serves as canopy to shield the traders from the sun. Directly behind the market square is a row of bungalows whose walls are mostly hidden by the bodies of the traders who have arranged their wares at the base of the buildings. All the roofs are thatched with palm fronds, tightly woven to become sun-proof and waterproof.

Perhaps most striking is the fact that even though the market is packed, virtually everybody shown is female. The only male in the composition is pushed to the left side, making this solitary male figure conspicuous and complementary to the large number of female figures massed together on the right side of the composition. Marching forward with a huge load of yam tubers piled high in a basket on his head, the male figure is dressed in a loose shirt, called a *bùbá,* and shorts, his gait unhindered by the weight of the load on his head. In the entire composition he is the only character who engages the viewer's gaze; the other figures in the picture are busy interacting with each other as traders and customers.

Laṣekan shows how Yoruba women in the marketplaces attire and carry themselves. Directly at the right of the composition is a woman with an infant strapped to her back, wearing an elaborate headgear to match the *ìró* (wrapper) and *bùbá* (blouse) costume favored by the women. She straps the infant to her back using an *òjá* (waistband) tied into a knot in front of her belly. In the middle of the composition is an elderly woman, slightly stooped and also wearing the *ìró* and *bùbá* costume, with a headgear. Instead of a baby she carries an *ìborùn,* or shoulder scarf, thrown over her left shoulder. Next to her is a woman standing upright despite the heavy load on her head. She is also dressed in the *ìró* and *bùbá* costume worn by virtually all the women in the market, with her headgear doubling as a cushion for the weight she is carrying.

Laṣekan indicates that in this predominantly agrarian society, the men do not actively participate in market affairs. They are busy on the farms tending crops, and they have left the sale of farm products to the women, who convey everything to markets such as this. Laṣekan also depicts some of the items on display in the local markets, including peppers, cassava, grains, and yam tubers. As Fakẹyẹ does with his *babaláwo* sculpture, Laṣekan is making an accurate ethnographic record of his time. Unlike Fakẹyẹ, however, Laṣekan is using the self-imposed Western medium of oil painting to depict a slowly disappearing African phenomenon, the Yoruba village market, which is being replaced by government-built market warehouses located downtown.

LIKE LAṢEKAN, Justus Akeredolu was also searching for a way to represent the African personality beyond the stereotypes fashioned by the colonizers. Like

Laṣekan, he also accepted the use of Western painting materials such as oil and water colors. Like Laṣekan, he also went to Britain in 1945 to improve his skills as an artist and returned from Hammersmith to Nigeria in less than a year, dissatisfied with the low level of proficiency at the institution.

Unlike Laṣekan, however, Akeredolu refused to be limited by Western art materials and created a distinctive form of art making called thorn sculpture (Fig. 3.3). This self-invented medium not only demonstrated the ingenuity of the colonized African, but it allowed Akeredolu to depict Africans in a manner he found dignified.

Thorn sculpture is fashioned from the thorns that form around the bark of the cotton tree. The thorns exist in various sizes, and thorn sculptors preferred the bigger thorns, which allowed more surface space for carving. The idea of thorn carving occurred to Akeredolu as a child growing up on a farm near Ọwọ. The village of Ọwọ is located in the thickly forested region of Yorubaland, with an abundance of trees of various types. As a child, Akeredolu noticed the barks of the trees, observing their differences and similarities. He was particularly fascinated by the cotton tree and its profusely thorny bark. The fact that the thorns broke neatly off the tree without hurting the plant, promptly grew back after being removed, and could grow to a substantial size intrigued Akeredolu. He studied the plant for a long time, systematically harvesting the thorns to see the plant's reaction. He also realized that the thorns existed in various tones and shades, ranging from pale peach to berry black. Furthermore, he saw that they could be shaped with a sharp knife. Akeredolu first began to make strings of beads from the thorns and then began to carve singular objects such as houses, people, canoes, fruits, and various articles in miniature.

3.3 Justus Akeredolu school, *The Farmer and His Wife,* thorn carving, private collection

3.4 Justus Akeredolu, *Mother and Child,* wood, Nigerian National Gallery

His art went a step further when he learned to glue the thorns together, allowing him to combine colors, textures, and shapes and make more elaborate configurations. The third step came more naturally: as he began positioning the human figures with the houses, fruits, and other objects, a narrative seemed to form around the arrangement, which transformed into a small stage. He then began to make objects out of the thorns with the concept of a narrative in mind and would later arrange the objects into the stories told in his miniature carvings. Everyone in Ọwọ loved his art form and bought his work. People wanted to learn from him, and in the 1930s Akeredolu became a teacher at the Ọwọ Government School. The medium of thorn sculpture became an instant success in Nigeria, and many of his pupils passed his methods on to others who imitated Akeredolu's work. According to Fosu, "Unlike the imitations, the facial expressions of Akeredolu's thorn figures are rendered with outstanding depth of realism."[5] Akeredolu did not limit himself to thorn carving but also actively practiced easel painting and plaque sculpture. In all of these creative activities, Akeredolu favored a style that could be regarded as realistic.

His wood relief, *Mother and Child* (Fig. 3.4), is a fine example of his venture into realism. The work does not represent an elite member of society but focuses on an unnamed person, a typical, ordinary woman with her baby strapped to her back. Here, Akeredolu is doing in sculpture what Laṣekan was doing with painting by creating a benign and intelligent depiction of the colonized Yoruba woman to resist and oppose negative colonial characterizations of colonized subjects. It is remarkable that both Laṣekan and Akeredolu adopted realism as the tool with which to resist, oppose, and fight colonialism. They adopted the very technique the West used to impose colonialism and turned it into a weapon of resistance against that colonialism. In that process they transformed realism from an elitist and imposed medium into an adopted tool of colonial opposition. This antagonistic spirit of resistance set the defiant tone of the opposition period through the time of independence.

4
EXPOSITION PERIOD
Revision of Ancient Artistic Traditions
(1960-1990)

In Africa, the present generation of artists feels, consciously or unconsciously, that the destruction of traditional values has been carried out by others, by foreigners, and the artist sees his own task as one of reconstruction and rehabilitation.

—Ulli Beier

hen Nigeria became independent in 1960, Laṣekan and Akeredolu continued to produce images that opposed the negative colonial characterization of Nigerians. These artists remained committed to their indigenous efforts to develop a positive and vigorous Nigerian identity. Both artists opposed colonial representation, and they became pioneers of an aesthetic that could be described as reactive. But if a reactive aesthetic was proper during the era of colonization, its role was questionable in an independent nation. Other artists, particularly those just leaving college at the time, began to speak in favor of a different type of revival of ancient Yoruba values. In their call for a renaissance, they investigated the compositions, myths, and values of ancient Yoruba arts including sculptures, paintings, textile designs, and ceramics. They saw no reason to oppose Western values. Why would a new nation and its artists react in favor of or against the past?

After 1960, especially with independence, it became clear that no viable independent identity could evolve well or harmoniously based on an oppositional aesthetic or reactive culture. There was a need to continue to revive ancient artistic heritage, but it had to be done without the oppositional vision that had served as a catalyst for producing new images in previous times.

The attainment of independence, after all, meant it was no longer necessary to politically oppose any outside force or to react against anyone. By 1965, after the first military coup in Nigeria, Nigerians began to place accolades and blame within their own borders rather than outside the country. Nigerian artists also began to recognize a change, reflected in a shift in the nation's philosophical and political attitudes.

After independence, Nigerians placed themselves in positions of power. It was no longer possible to blame others for the country's political predicament. The organizers of the first military coup, led by Major Kaduna Nzegwu, blamed the same nationalists who had fought for Nigeria's independence for corrupting the country they had helped to create. The same nationalist politicians who were supposed to be working to uplift the country economically and culturally were found wanting and were toppled by a disillusioned Nigerian Army. These politicians were accused of conspiring to destroy the country through ineffective leadership, theft, and nepotism.

Generally, the Nigerian population was becoming disillusioned and was beginning to view politics and nationalism sarcastically. As Nigerian artists began to free themselves from the reactive, oppositional approach to aesthetics and art making, they began to adopt a proactive exposition of their own cultural heritage—as individuals, as Yoruba artists, as Nigerians, as Africans, and as citizens of the world. These layers of identity are all interrelated, yet the most crucial factor was the artists' determination to use their works in a proactive, expositional manner rather than in a reactive, oppositional manner. In the history of Yoruba images, that transition and revisioning from the oppositional to the expositional marks the period 1960 to 1990.

This distinguished period of revived intellectual and creative activities, covering three decades of African history, is a particularly rewarding phase in Yoruba art, during which a large number of artists established themselves as talented and prolific individuals. Art academies, workshops, organizations, and associations were inaugurated in Lagos, Ibadan, Oshogbo, and Ile Ife, attracting and producing talented individuals including Yusuf Grillo, Jimoh Akolo, Twins Seven-Seven, Jimoh Buraimoh, Muraina Oyelami, Wọle Lagunju, and Kunle Filani. These individuals are associated with institutions of higher education that proliferated in Yoruba country from 1960 to 1985. Such institutions include the University of Ibadan, the University of Ife (later Obafemi Awolowo University), University of Lagos, Yaba College of Technology, Ibadan Polytechnics, Adeyemi College of Education, Ondo State University, and Ogun State University. These institutions have produced many artists directly through their academic programs and indirectly through the occasional workshops they organize.

The artists do not see themselves as reacting against any external distortion of their identities. Rather, they are free to focus on producing the creative definition of their identities as citizens of an emergent nation. They

regard their art as an exploration of their individual, cultural, and social values, as well as an exposition of the important issues of the times in which they live. Most of these artists began to explore their cultural heritage without the need to demonstrate to Europeans or anyone else that they could paint in realism. This political freedom gave them free rein to experiment aesthetically and more widely with forms by integrating the structures of their ancient art and adopting them into their compositions.

This freedom of expression and the revision of attitudes have not always been acknowledged by critics of African art. Ulli Beier, the intellectual and creative tour de force behind the organization of the Oshogbo art school in the early 1960s, saw psychological and philosophical differences between the positions of the workshop-trained and university-trained artists. He regarded the university-trained artist as someone in search of an identity or in construction of a forced identity because of a feeling of cultural emptiness or inadequacy. Beier saw an urgent need for the university-trained artist to construct some form of identity for himself (the artist was invariably a male), to proclaim his cultural hybridity: "His problem is that he has to proclaim it to the European audience, that he establishes his newly gained identity in the art galleries of Europe more often than in the villages of Nigeria."[1]

What Beier is not acknowledging is that the intellectually trained artist does not have to prove his humanity to the villagers of Nigeria. Those villagers were not raised on the notion that the African "intellectual" is less than human, primitive, or inferior. In fact, those who needed information about the true identity of the African "intellectual" were Westerners. It is not surprising, then, that the new African artists address Western audiences because fiscal and hegemonic negotiations are being done in the galleries and conference centers of Europe and the United States rather than at the shrines of Africa. These artists began to experiment with forms in ways Westerners might regard as abstract and derivative when in fact Yoruba artists saw their experimentations as a celebration of their indigenous culture. This demonstrates a total lack of understanding between two different cultures, both looking at the same object and seeing two different images. Where the West sees abstraction, the African artist sees a rebirth of ancestral African values.

LYING BEYOND ANY STYLISTIC CATEGORIZATION as "realism" or "abstraction" is the work of Yusuf Grillo. Although he recognizes Western forms as authentic and even inspiring, Grillo's work is not limited by those forms of artistic expression and explanation. Rather, he prefers to develop an inventive approach to creativity based on the redefinition of the African personality as progressive, adventurous, and creative. He does not see any need to limit his creative spirit or deny his experimental urges simply because he is trying to be a Nigerian. In his own words,

> The contemporary Nigerian artist must accept those influences which are vital to him. It does not matter whether these are drawn from Yoruba sculpture or Picasso paintings, both of which, incidentally, I find exciting. The artist should not worry about the results of these borrowings because the work, if sincere, cannot but be a Nigerian work since it is created by a Nigerian.[2]

As a creative artist at the forefront of the struggle for the revitalization of his indigenous culture, Grillo saw an opportunity to work outside of modernity, with its antagonism between realism and abstraction. He saw his art and that of his colleagues as a critique of modernism and a renaissance of African art, using not only two forms of expression but new materials and methods of execution. Grillo was conscious of his break with the old paradigms of Yoruba artistic traditions in the making of sculptures and murals. At the same time, he did not see his art as emanating from the intellectual trapping of Western art. He is not conversant enough with Western artistic traditions to consider his art a part of the Western art culture. Can we not say, then, that his art is a "hybrid" form—a new and composite experience that emanates from several cultural genes and genres? Scholars such as Uche Okeke and Solomon Wangboje, who analyzed the works of Grillo and his colleagues, used the word *synthesis* to describe taking the best from both African (in this case Yoruba) and Western art and combining both extracts to generate new forms.[3]

Grillo's experimental designs suggest that the product of the union between Yoruba and Western art should not reject either tradition outright; it certainly should not reject or oppose the ancient indigenous Yoruba artistic traditions because of its submission to colonization. At the same time, it should not reject or oppose modernism outright because it serves the culture of Western imperialism. This new design therefore becomes a renewal and reconciliation of two opposing traditions—an innovative reinterpretation and transformation of discarded objects, old designs, and other cultural detritus into new experiences, themes, and contexts.

Grillo's *Mother and Child* (Fig. 4.1) demonstrates clearly his ability to simultaneously embrace and evade two cultures. Maternity figures are common in the visual traditions of both Yoruba and Western cultures. Yoruba sculpture frequently features images depicting women in a standing, seated, or kneeling position, with their children seated or standing in their laps, strapped to their backs, or suckling milk from their breasts. Examples of women with children abound in the works of Bamgboye, Oosamuko, and Fakeye, as discussed in Chapter 4, and Grillo was exposed to these indigenous sculptures as he was growing up. It is therefore not surprising that he would explore the theme, especially since it is so common in Western art. Even though Grillo is Muslim, he was exposed through art history to the European and Westerner Madonnas, which he embraced both visually and thematically.

Grillo's depiction of the mother with child therefore references both the Yoruba and Western concepts of maternity. The woman is having an emotionally private moment with a child. She is in adoration and is amusingly tucking in and pulling out loose ends of the child's garment, admiring him shamelessly. The child seems to extend visually from her left arm, which hangs protectively around his body, intimately pulling him toward her body. The child's almost umbilical attachment to the mother gives the impression that he is somehow still connected to her beyond the edge of the picture frame.

In another interpretation Grillo shows the mother scolding her wayward child. Perhaps she has just said something soulful to him, or her indignation has not spared the rod. The child is still smarting from the lashing, refusing to look up to meet his mother's gaze. The mother is now tender and overtly affectionate, mending the fractured relationship. The intimacy between the

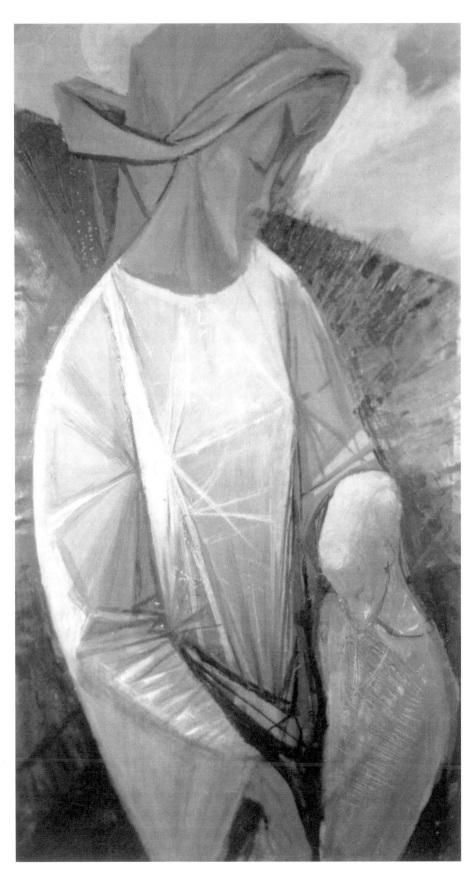

4.1 Yusuf Grillo, *Mother and Child*, oil on canvas, Nigerian National Gallery

two is emphasized by the diagonal arrangement of the two heads and in the sharing of the analogous colors blue and purple, setting a brooding context for the drama between mother and child.

In *Mother and Child* Grillo appropriates the sacred symbolism of the tragic portrait of baby Jesus, the child born to die, in a secular composition. But that tragic Christian symbolism is mitigated in Grillo's work by the optimistic Yoruba representation of children as *aṣọ,* or human wrappers. An old Yoruba proverb says "*Ọmọ bo ni lára ó jaṣọ*" (Kids cover our bodies more comfortably than wrappers). The textile suggestions in the surface design of Grillo's painting seem to allude to this proverb, drawing some sort of allegorical relationship between mother and child on the one hand and between the nude and her fitted costume on the other.

The textural theme of worn and draped fabric permeates the entire painting. The treatment of the background recalls textiles in its decorative yet painterly density. Crisp motifs of sharp planes defined by swift intersecting lines radiate throughout the *bùbá* top worn by the mother. Greatly muted, the diagonal lines radiate off the left arm of the woman's *bùbá,* only to disappear into the densely fabricated background, culled out of rough layers of blue and purple hues. The complimentary relationship between mother and child is thus likened to the relationship between nudity and apparel; one defines the other. This analogy is rendered as a form of visual tension in Grillo's painting, as the child becomes the costume the mother wears. Grillo also juxtaposes large and small bodies, allowing the mother's body to dominate the overall image, thus uniting the entire composition. The smallness of the child's head is emphasized by the ice-blue reflection shaping it, in contrast to the luminous indigo blue of the mother's face. Whereas the mother's features are most visible at the upper center of the composition, the child's face is largely invisible in its own shadows—its relatively minute head is placed at a lower angle than the mother's face. Her head is adorned with headgear suggesting a coiffure, whereas her child's head is fragile and exposed.

Perhaps most striking, despite the obvious Yoruba attire and ebonic coloration of the mother and child, is their strong linkage to the Western icon of Madonna and child. A sense of devotion, faith, and submissive calmness permeates the entire mood of the composition, reminiscent of the chapel Madonnas of the Medieval era and early Renaissance. The elongated corporeal figure recalls the Madonnas of Van Eyck, as well as the translucent colors and aspirations found in El Greco's religious compositions. A white pseudohalo surrounds her head, which she holds high among the tranquil skies. A dark pseudohalo forms like a shadow at the back of the child's head, deepening the contrast against the background. Still, the angularity of the two faces in Grillo's painting recalls the coolness of the indigo blue tones used to highlight the sheen of Yoruba sculpture.

THE POETIC APPROACH GRILLO PREFERRED calls for an almost abbreviated working technique. Other artists, such as Ṣina Yusuff, have chosen a more decorative, narrative, and prosaic pattern of painting that allows them to illustrate landscaped environments, as in Yusuff's *Kano Dyepits* (Fig. 4.2), or soaring thoughts, as in *Animal Kingdom* (Fig. 4.3). In *Kano Dyepits* Yusuff depicts a scene in Kano that has always fascinated visitors to this ancient city of com-

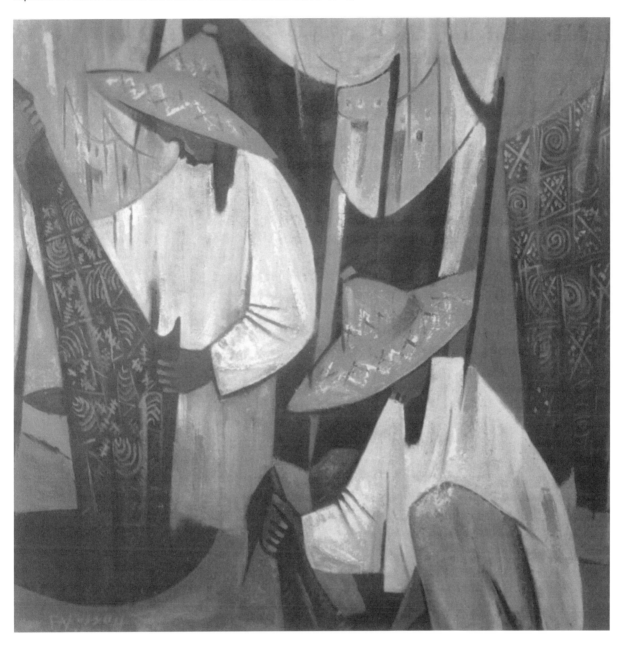

4.2 Ṣina Yusuff, *Kano Dyepits,* oil on board, Nigerian National Gallery

merce and industry. Kano is renowned in Africa for its rich indigo dyeing. Strategically located as a gateway between the north and south during the trans-Sahara trade routes across the desert, Kano became famous as a center for artistic excellence in calabash decoration, leather work, and fabric dyeing. Even though many people have seen the beautiful fabrics dyed in Kano, only those who have been there have seen where these fabrics are made, and even then only the dyers know the secret of how they are made. Outsiders can only see the pits dug in the ground in which the dyes ferment. From a safe distance, tourists in their vehicles can see the dyers dip the fabric into the dye pit and then move on to examine the textiles soaked in other dye pits.

This is Yusuff's narrative plot in *Kano Dyepits*—a tourist's snapshot of the dye pits of Kano. With broad straw hats to protect their heads, the two dyers occupy the foreground of the composition. The one nearest the viewer stoops

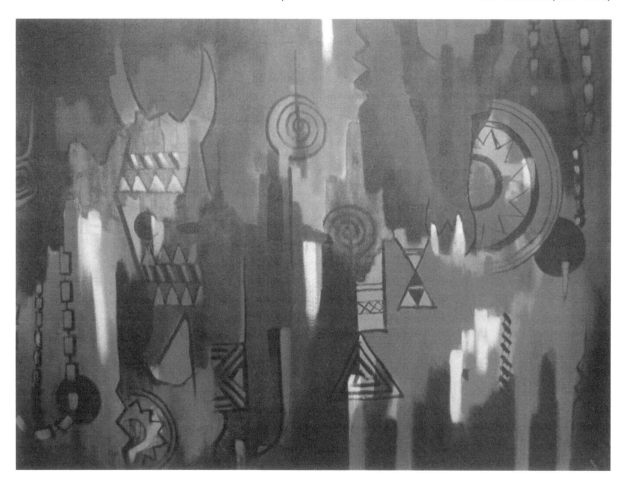

4.3 Ṣina Yusuff, *Animal Kingdom,* oil on board, Nigerian National Gallery

down to immerse some fabric into a dye pit. He is dressed in white, and his back arches in a gentle sweep of diagonal movement. The second dyer, also in white, is standing upright examining a piece of dripping wet fabric that is still being dyed. The concentration evident on his face shows a diligent craftsperson critically examining his product before passing it on for sale.

Immediately behind the dyers is a row of finished fabrics hanging on a line to dry in the sun. Dyed in a dark indigo color with decorative highlights in complementary pale blue tones, one hanging fabric is a striking contrast to another steeped in the darkest indigo shade without any redeeming design. At the background of the picture is the distinctive brown adobe architecture of Kano, one of the most elegant indigenous structures in Africa. The arching lines of the buildings swirl gently against the pale skylight to produce a convincing perspective of receding structures fading into the background.

Jimoh Akolo, a well-established Yoruba painter, looks at the same dye pits in his *Kano Dyepits* (Fig. 4.4) with a more painterly eye. Whereas Yusuff's work is graphic and lineal, Akolo's painting seems to totally dispense with the line, as massive areas of muted hues bleed into one another. The entire painting assumes the look of a tie-dyed fabric, faded yet still dripping wet from the dye pit. Akolo's choice of colors enables him to build a harmonious composition using tones of blue, purple, and pale vermilion lakes. The presence of the blazing sun radiates around the huge felt hat on the dyer's head, permeating his loose robe and bare feet. The luminous indigo hues shine in the pit,

reflecting the brilliant rays of the sky. Although Akolo does not directly show the sky, his use of light and choice of color have overpowering effects that bring solar radiance into the painting. The intensity of the deep blue shadow under the straw hat protecting the dyer's head from the sun, multiplied by the glare of the midday heat at Kano, produces a mirage in Akolo's painting. The viewer sees the illusion of a dye pit, when in fact he or she is merely looking at the dyer's head.

Even though the positioning of the dyer's head makes him look as if he is steeped in the dye pit, with surprising dexterity Akolo introduces details that give the dyer a brooding identity. The work becomes a study of the dyer's loneliness as an aesthetic exploration of loneliness and solitude among many artists. Even though Yusuff suggests loneliness in his painting of the dyers, the claustrophobic structural effect of the composition conceals that loneliness. Akolo does not try to hide the loneliness because he focuses directly on only one dyer, deleting everything else but the dye pits that define his identity as a dyer. The focused investigation on the emotional identity of the dyer sets Akolo's work apart from Yusuff's, whose dyers look almost anonymous and nondescript. Akolo's dyer is pensive, lost in thought, as he goes through the process of dyeing as if by rote. It is clear that his mind is not focused on what he is doing, but his mastery of the craft no longer requires him to focus fully on the work at hand to do a good job. Akolo has portrayed an artisan detached

4.4 Jimoh Akolo, *Kano Dyepits,* oil on board, Nigerian National Gallery

from his craft, transported to a different dreamland even while still busy at work.

Akolo's work seems like a subtle psychological analysis of the African subject, in various ramifications. His *Flutist* (Fig. 4.5) explores the famous musical performers from Igboland, who seem to blow sad notes from their brains through their tiny flutes, almost as a purgative measure. Focusing on the flutist's bust, Akolo pastes the flute to the musicians's body, making little separation between instrument and player. The musician's personality trans-forms instantly, as his eyes bulge sentimentally and his physique adjusts itself into a flute-playing medium, and he becomes far more than just a man blow-ing a tiny pipe. His right shoulder rises sharply into a bent and awkward angle as the sinewy rhythms of the musical notes flow through his chest. He passionately cocks his head while adjusting his lips to best address the elusive base of the fine flute. He totally absorbs the instrument, even as he becomes a tool of the flute he blows. As in Akolo's composition of the dye pit, the character in the painting is solitary. Unlike the image of the dyer, the flutist is focused and passionately absorbed in his work.

Although they were born and raised in the Yoruban southern part of northern Nigeria, both Akolo and Yusuff, as well as Yusuf Grillo, studied at the northern Nigerian art institution known as the Nigerian College of Arts, Science, and Technology (later Ahmadu Bello University, Zaria). According to art historian and educator Marshall Ward Mount, the education was based somewhat on the form the British colonial education department designed for the colonies:

> The University at Zaria has given a four-year art course, which, as in all other British-established art schools in Africa, may be supplemented by a one-year education course. Three major fields are taught: painting, sculpture, and commercial design, the last including graphics and textile work. The student begins with a two-year general course in which he samples the major art fields, and in his final two years he specializes in one subject.[4]

During the late 1950s the art students at that institution began to reexam-ine the colonial content of their educational curriculum. Describing the form of education as "Western-based," art historian Sharon Pruitt saw the college as "built from a previously existing model at Ibadan and . . . intensified and raised to university status by its initial affiliation with London University in the students' last years of study; the courses were organized and examinations were administered by the faculty of Goldsmith College, London University. Diplomas were then awarded by the British institution."[5]

The colonial nature of the curriculum bothered the students, who began to ask questions such as "What role, if any, did art education play in the sustenance of the aesthetics within the colonial culture?"[6] The art students realized that they had to devise a different aesthetic approach in defiance of and opposition to the colonial form available at their college. The students began to advocate a renaissance of their indigenous ethnic artistic traditions through a "synthesis" with forms from other parts of the world. In other words, the students resolved to create hybrid arts, based on a combination of elements from their indigenous ethnic arts and the colonial forms of the West,

4.5 Jimoh Akolo, *Flutist,* oil on board, Nigerian National Gallery

as well as the relatively obscure artistic traditions of the East. The products of their art were bound to be different from those of the colonizers and can be regarded as a critique of Western modernity, against which it is constantly measured.

In addition to artists such as Akolo and Grillo, artists from other ethnic groups, including Igbo (Uche Okeke, Simon Okeke) and Urhobo (Bruce Onabrakpeya), were fairly active at that time. All of these artists formulated exciting images that combine extracted elements from their indigenous ethnic traditions with adopted elements from Western and Eastern sources.

Yusuf Grillo's *Yoruba Woman* (Fig. 4.6) is his classic example of this melange style of countercolonial aesthetics, demonstrating influences from various artistic cultures throughout the world. The theme of the Yoruba woman frequently found expression in Grillo's work, largely because of the intense personal relationship he had enjoyed with his mother. Perhaps the backbone of the Yoruba family, the Yoruba woman subordinates all personal interests to the overall purpose and good of the family. Her identity is constructed around her husband, children, in-laws, and other members of her extended family. She is happy when they are joyful and sad when they feel sad. She thinks about them constantly, whether she is at home or away from home. In *Yoruba Woman* Grillo paints a woman returning home from a festival or ceremony in which she participated as cook, steward, and dancer. Because she is dressed completely in white, one can describe her as a devotee of Ọbatala, the Yoruba divinity of white. Balanced on her head is a bundle of condiments she has salvaged for her children, wrapped in an orange scarf. The straightness of her body shows in the way she leaves the orange bundle to balance at the center of her equilibrium rather than support it with her hand, even as she walks easily along.

The need to balance the orange bundle becomes the major tension that structures the entire composition around the fully clad female figure in Grillo's painting. Taut in its stretched form, the emphasis on the tense muscles of the woman's neck brings attention to her small, elegant head, whose importance is further emphasized by the whiteness of the headgear and the brightness of the orange head load. In a deliberate demonstration of elegance and contrast, Grillo makes the woman look down, away from the critical head load, making the enterprise of walking even more precarious. Yet anyone who has witnessed a Yoruba woman glide down the street with a heavy pot full of water balanced on her head will realize how easy it is for the woman in the picture to look down while strolling casually down the road.

But what is absorbing her interest so much that even with such a load she still looks down? It is a long stalk of sugarcane, which she holds like a prize asset as she strolls home. She is both imagining the thrill her children will have when she hands them the long stalk of sugarcane and gauging the risk involved in giving such a long stalk to several children. A fight will probably ensue as they try to divide the sugarcane, and someone is certain to get killed. Since Yoruba women are often lost in thought over the tiniest domestic detail, perhaps she is considering whether to cut the stalk into small pieces and hand each child his or her own piece.

With the use of large, comfortable, circular shapes, Grillo builds the woman's *bùbá* top almost as a protective armor within which she can safely

4.6 Yusuf Grillo, *Yoruba Woman*, oil on board, Nigerian National Gallery

hide. The volummetric fullness of the *bùbá* adds to the general rhythm of elegance in the picture. The contrast between the juxtaposition of flat planes and illusions of modeling imbues the painting with a conflicting sense of motion, a sort of pull/push orientation. The symbolism behind this multidirectional sense of motion is the compass located at the very center of the woman's breasts. It is the symbol of Esu's crossroads, as well as of the Christian cross. The woman thus embodies the artist's pursuit of both Western and Yoruba directions, all in the same footstep.

The overall posterlike appearance of the composition is akin to the flatness found in some Japanese prints. The use of the surprising orange color as an accent, the sharp contrast between foreground and background, and the vertical arrangement of the icon all refer to Japanese printmaking. There is a subtle reference to the cubist shapes of Picasso and Juan Gris and yet a noticeable mimesis of Yoruba sculpture in the shining blue sheen of the woman's pigmentation. The rather global scope of influences found in Grillo's work demonstrates his opposition to the colonial definition of the African as a simple individual, easily categorized and happy to follow the traditions of his or her ancestors.

GRILLO'S WORK DEMONSTRATES A COMPLEX PORTRAIT OF THE AFRICAN, as do the works of Laṣekan, Akolo, Akeredolu, and myriad others who used their talents and training as tools of colonial and postcolonial transformation. Despite the political purpose of their work, their commitment to high visual and aesthetic standards makes their compositions especially pleasurable. That is perhaps why many foreign critics miss the political aspects of Nigerian art in general when they make statements such as this one by the British art critic Eddie Chambers:

> First impressions of the domestic Nigerian scene seem to indicate that much of the work produced and exhibited is, within an international context, deeply conservative. . . . Market scenes offering no hint of modernity, let alone postmodernity; landscapes that indicate nothing of contemporary realities of the country. . . . For those who would wish to see debates about identity, history, gender, social stratification, etc., reflected in contemporary art within Nigeria, the apparently conservative nature of much of the work visible to the public can be both disappointing and frustrating.[7]

Chambers is experiencing the frustration of someone unable to complete the "half a word" of which the elders speak.[8] Otherwise he would know that although Laṣekan's landscapes and market scenes, Akeredolu's thorn carvings, and Akolo's imaginative compositions might have "no hint of modernity, let alone postmodernity," they do embody the most subtle and crucial discourse in colonial and postcolonial engagements and confrontations. They are a study in the aesthetics of discord and confrontational opposition, in which the protagonists and antagonists are represented with images too subtle for foreigners or the colonizers to decipher yet blatantly apparent to the colonized indigenes who read them as images of struggle, contention, and opposition.

Ulli Beier, who founded the Oshogbo art school, however, so immersed himself in the Yoruba culture that even though he was a foreigner he was able

to see the "debate about identity" that Chambers ignored. Beier does not agree that artists such as Twins Seven-Seven and Jimoh Buraimoh, both associated with workshop training at Oshogbo, have a problem constructing a new identity for themselves. According to Beier,

> The situation of the Oshogbo artists was different. They had never received enough education to become *oyinbo dudu,* or black Europeans, as the Nigerian graduate is sometimes called in his home village. They had never left Oshogbo to seek wisdom or skill outside. They had grown up with the festivals of Oshun and Shango and Ogun. Some of their relatives practiced traditional religions, others were Christians or Muslims. They had come to accept the juxtaposition of different cultures in their community as a matter of fact. They knew Yoruba tradition, but were no longer part of it.[9]

Even though Beier thought they were no longer a part of the Yoruba tradition, the artists later proved they still held a soulful connection to their heritage and still strongly belonged within that tradition. By using images that refer to their indigenous oral, visual, and performing arts, Twins Seven-Seven and Jimoh Buraimoh demonstrated that their works were yet another creative manifestation of the African renaissance and that their revival carried no opposition to colonial or Western powers.

TWINS SEVEN-SEVEN, WHOSE REAL NAME IS TAIWO ỌLANIYI, was one of the best-recognized Nigerian artists shown during the cultural jamboree FESTAC 77.[10] Prominently displayed at the Nigerian gallery of contemporary arts, his paintings were considered some of the most exciting representations of Nigerian art. After the festival he retired to his Kèkẹ́ Ẹlẹ́mu Gallery, which he used as both studio and residence, on the outskirts of Oshogbo. There he lived a life entrenched in mythology, from which the intricate themes and forms of his paintings emanate. This mythological life shapes and engenders his paintings, and they, in return, embellish and reinforce his mythological life. His very birth is steeped in mythology. The story changes slightly or drastically depending on the audience. One version claims he is an *àbíkú*[11] and that this lifetime is his seventh visit to this world. Another version purports that he is the last and only surviving twin of a set of seven male twins born to the same mother.

The incidence of twins is high among Yoruba people, and some people claim—without scientific data—that Yorubas have the highest number of twin births in the world. At the same time, Yoruba people are notorious for rampant infant mortality, especially among twins who are deified and worshiped as divinities. Twins Seven-Seven builds his art and his identity on this phantasmic blend of mythology and inventiveness, when the truth is simply what the viewers imagine, what they wish to see and to read into his compositions.

Before he became a dancer, Twins Seven-Seven was considered a "Boy Ajasco," a fascinating character. A Boy Ajasco is a combination dancer, actor, singer, magician, and musician. The character emerged in the 1930s and 1940s as the Yoruba countryside became increasingly urbanized, and huge throngs of strangers began to live together in unprecedented numbers in cities, towns, and villages such as Lagos, Ibadan, Oshogbo, and Ile Ife. A semblance of night

life was emerging in these places, and the Boy Ajasco was one of the first performers to entertain in nightclubs and beer parlors, to the appreciation of drinking guests who watched the shows for free. The nightclub owners often used these sideshows to attract drinkers who then became regulars. Eventually, the club owners paid the Boy Ajasco, who also sometimes received appreciative tips and ovations from the audience.

During the day the Boy Ajasco often worked as a street dancer for itinerant quack doctors, who combed adjacent villages and towns selling their medicinal wares. With a loudspeaker in hand, the quack would set up by the side of the road near a busy marketplace and play a popular radio song, to which the Boy Ajasco performed in an exaggerated, humorous, often gymnastic manner. As soon as a crowd gathered to watch the Boy Ajasco, the doctor would stop the music and loudly advertise his cure-all tonics. The quacks hired the Boy Ajasco on a somewhat regular basis. On his days off, the Boy Ajasco could be seen performing his magical acts at any open space where a crowd could gather.

Twins Seven-Seven was a Boy Ajasco who wandered into a nightclub in Oshogbo uninvited one night and began to dance. Drinking at the nightclub was Ulli Beier, an art collector and cultural critic who at the time was helping to develop some local theater groups in Oshogbo. Beier described his first encounter with Twins Seven-Seven:

> Seven-Seven appeared one night at a dance held at the Mbari Mbayo Club. His first appearance fascinated us at once: a blouse of rather bright Nigerian cloth which had "Seven-Seven" embroidered across the back, narrow trousers with pink buttons sewn along the seams, zigzag edges cut into sleeves and trousers, pointed Cuban-heel shoes and an embroidered, tasseled cap. Even in a colourful town like Oshogbo he caused a minor sensation. But his dancing was even more exciting than his appearance: his imaginative variations on accepted highlife dancing proved so spectacular that the large crowd cleared the floor for him—a rare happening in a community where nearly everyone is a born dancer.[12]

This chance encounter was Seven-Seven's big break away from the quack doctor because Beier immediately hired him to be a dancer at the Mbari Mbayo Club. During the summer workshops organized by Georgina Beier, Ulli Beier's wife, Twins Seven-Seven learned to paint. He took to it instantly. "From the first minute, his talent was distinctive. . . . He paints the world as he knows it and experiences it and there is no dividing line in his thinking between the earthly and the supernatural," wrote Beier.[13]

To create his exaggerated images, Twins Seven-Seven draws from motifs and icons of Yoruba oral, visual, and performance traditions. An example is a painting titled *Priest of Shango, the Yoruba Thunder God* (Fig. 4.7), completed in 1966. Clearly, Seven-Seven is influenced by the Yoruba icon of Ṣango composition, as shown in the sculpture representing the Ṣango devotee (Fig. 4.8). Seven-Seven combines elements from Ṣango visual and verbal traditions in the body of the composition. As in the sculptural piece, the central character in Twins Seven-Seven's composition is the devotee, carrying his paraphernalia of Ṣango worship. Further extrapolating beyond the wooden piece, however, Seven-Seven extends the possibilities of his painting technique to transform the Ṣango devotee into both a ram and an elephant. The ram is the totemic

animal of Ṣango, the animal he has adopted as his favorite pet and sacrificial beast of burden. The double-headed ax normally found in Ṣango images becomes the twisted horns of the ram. As the viewer continues to enjoy the intricate decorative motifs of the composition, the horns of the ram somehow transform into the lobes of an elephant gradually emerging from the density of the designs in the background.

The reference to the elephant is both a visual pun and the invocation of a verbal metaphor. Visually, Seven-Seven has successfully managed to hide a huge elephant in plain view. He has created a verbal metaphor by alluding to the size and position of elephants among the animals in mythology. The elephant is often described as the king of animals, and its size has inspired the proverb "*Àjànàkú kojá mo rí ǹkan firí*" (When an elephant passes by, it is beyond a fleeting experience). Ṣango is the king who became a god; therefore the analogy of the elephant is most appropriate.

Seven-Seven's treatment of the diviner's eyes is similar to what one finds in much of Yoruba sculpture, particularly concerning the depiction of Ṣango devotees. Ṣango is described in oral tradition as

Iná lójú
Iná lẹ́nú
Iná lórùlé ilé

[There is fire in his eyes
Fire in his mouth
Fire in the rafters of his roof.]

The entire composition seems to reflect the combustive energy this Ṣango praise poetry narrates. The central character is located in a three-dimensional space, suggesting a sense of interior. One can imagine the "rafters of the roof" in the background as if it were already on fire. Heads appear within heads on the elephant configuration of the Ṣango double-headed ax. Each head has eyes that seem to burn into the viewer, as the Ṣango praise poetry suggests. It seems Seven-Seven was aware of these lines as he made the drawings. Like the poet, he was working and thinking in lines, rhythm, and volume in this work. It is helpful to the viewer to know that Seven-Seven also worked as a poet, singer, and drummer. His sensitivity to the language of music and poetry therefore allows him to draw and arrange his thoughts visually in lines.

The lines thus become the most important elements in Seven-Seven's images, just as lines are crucial to the composition of poetry and music. Seven-Seven twists his lines into different contours, textures, shapes, volumes, and gradations. With the varied repetitions of these visual values he lays out his plot, patiently modulating his volumes and intensities to produce an infinite variety of line combinations. He uses the compositional device of "call and response" as a metaphor for the relationship between the main figure and the subordinate figures, as well as between foreground and background. The background and the subordinate figures seem to respond to the call of the main figure in the foreground. That compositional device works well in *Priest of Shango,* where the main figure imposes himself frontally in the middle of the composition, pushing everything else to the margins. Subordinate figures are forced to respond physically to the confined spaces in the background. To do that Seven-Seven distorts their bodies into stylized shapes that often have

4.7 Twins Seven-Seven, *Priest of Shango, the Yoruba Thunder God,* mixed media, private collection

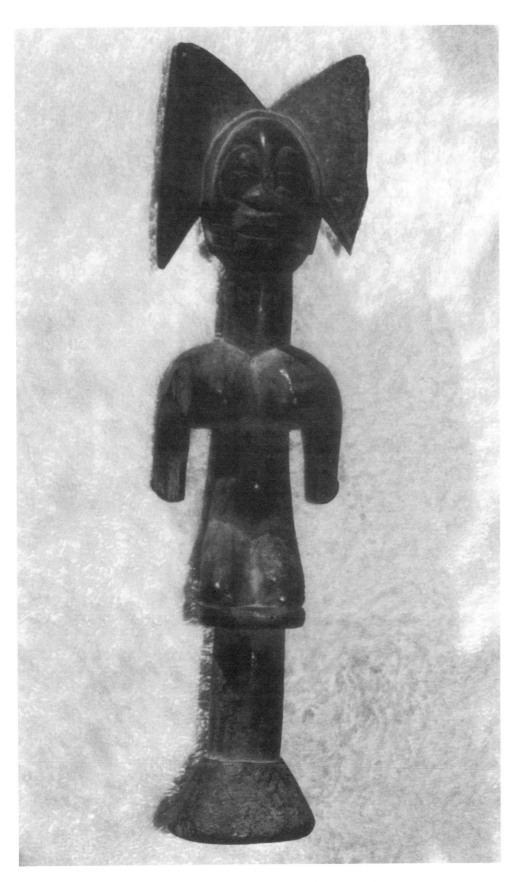

4.8 Akanbi Iyanda, *Osé Ṣàngó*, wood, private collection

little to do with the natural human figure and more with the limited spaces that frame the main figures.

The Ṣango priest holds a gourd rattle in one hand and a leather fan in the other hand. Seven-Seven could not resist the temptation to transform the gourd rattle into an astonishing human face, complete with cornrow coiffure. To further emphasize the main character's vigor, Seven-Seven draws thick, dark lines as outlines around its figure. He also thickens and darkens the designs on the body of the Ṣango priest, changing the textures of the lines to suggest different body parts as well as attires. Intricate decorations embellish the face of the Ṣango priest to depict the facial lines Seven-Seven wears himself in a country where it is much more common for people to wear permanent facial designs done with razors.

Even when Seven-Seven depicts mortals such as himself, he still imbues the composition with an aggressive visual energy that gives the images some superhuman characteristics and elevates them beyond the ordinary or mundane level of form. He often inserts himself into his compositions, as in *Inspiration of Mr. Kelly and Twins Seven-Seven and the Ghost of the Voice of America* (Fig. 4.9), which he completed in 1968. Mr. Kelly, a journalist at the Voice of America agency in Lagos, is the subject of this composition. In the work, Seven-Seven adds mythological elements to Western radio technology by representing what he calls the "ghost" of the radiogram. Seven-Seven places himself at the fore end of the composition and positions Mr. Kelly next to himself. With one gesture, Seven-Seven's hand leads the viewer to the body of Mr. Kelly, who is holding a microphone while broadcasting to the rest of the world. At the topmost part of the composition is a radio with a long, twisted cable leading to a loudspeaker.

Whereas the scientist is interested in the technology of radio broadcast, Seven-Seven prefers to regard this technology only as magic. What fascinates Twins Seven-Seven is not how the animate voice of Mr. Kelly gets into the body of the inanimate transistor radio. To Seven-Seven, using the Yoruba concept of being, no demarcation exists between animate and inanimate objects. Everything, including the transistor radio and Mr. Kelly, is alive. In Seven-Seven's mythological perspective, Mr. Kelly shrinks his body into a tiny radio so he can speak from inside the radio. Even the radio in Seven-Seven's painting has legs with fingers or talons. The chair on which Seven-Seven is seated at the foreground has small, knobby toes, and he appears barefoot, with long talons. Mr. Kelly, however, is wearing shoes with heels that dig into the plush carpet. The uncovered feet of the figure representing Seven-Seven are placed in the tiled part of the room, where checkered patterns add visual vigor to the surface of the floor. At the top of the painting, Seven-Seven introduces calligraphic elements into the composition, with letters suggesting the acronym USA. Each letter is loosely interpreted rather than copied and is freely repeated over the entire apex of the painting. Although the acronym is meaningful, Seven-Seven treats it like a decorative pattern that further adds to the sense of embellishment in his work.

EVEN THOUGH JIMOH BURAIMOH'S WORK IS LESS SATURATED WITH PATTERNS, he is equally dedicated to the use of decorations as a dominant feature in his composition. In many ways Buraimoh's personality contrasts with that of

4.9 Twins Seven-Seven, *Inspiration of Mr. Kelly and Twins Seven-Seven and the Ghost of the Voice of America*, mixed media, private collection

Seven-Seven. Unlike Seven-Seven, Buraimoh discovered himself as an artist after much hard work. After he attended Georgina Beier's workshop in 1964, it took some time before Buraimoh began to find a working style that suited his temperament. Whereas Seven-Seven's persona is impulsive and spontaneous, Buraimoh's is more ponderous and premeditated. At the Mbari Mbayọ Club where both artists worked for Ulli Beier, Seven-Seven became the theater's dancer and exhibitionist, whereas the more introspective Buraimoh preferred the behind-the-scenes work of technical lighting. But what Buraimoh might lack in imagination he more than makes up for in application and dedication. Unlike Twins Seven-Seven, who divides his energy among several arts and still leads a band, Buraimoh quickly found his quiet temperament was more suited to the visual arts, where he has placed his full concentration.

Buraimoh's breakthrough came when he began to incorporate beads into his compositions in a manner that intensifies the decorative structure of his work and links him to the bead-making tradition for which Yoruba people are famous. Indigenous Yoruba artists fashion many objects, including two- and three-dimensional images (Fig. 4.10), out of beads. Entire costumes, such as those worn by the Ọlọwọ of Ọwọ during the Igogo festival, are made out of beads. Beads are traditionally associated with royalty and the court, and Yoruba crowns are decorated with beaded details. Virtually all objects made for the king—including fly whisks, boots, staffs, and stools—are enhanced with beaded decorations. Most of the beads used by Yoruba artists are from European sources, but they have been so convincingly incorporated into Yoruba art that they seem as if they are manufactured locally.

This Yoruba tradition of using beads as art materials to make compositions in various colors has influenced Buraimoh's approach to design. His technical process has gone through several stages. At first he embedded the beads in a cement base to decorate stools and tables, like a mosaic. From there Buraimoh learned to use the beads in strings laid out on strong epoxy and applied to plywood. This allowed him to make lighter and larger pieces he sent to traveling shows in and outside of Nigeria. He combined paints with beads as a mixed-media statement that could be translated into a metaphor for his own identity, because he is a mixture of influences from various sources, including local and global traditions.

The next stage in Buraimoh's technical growth involved using combinations of beads, shells, and seeds, skillfully arranged within the same composition. On many occasions he made intricate paintings exclusively with beads, allowing the various colors of the glass beads to reflect one another, which created spectacular luminous effects. Some of his most successful pieces are combinations of beads and oil paints, as in *Peacock* (Fig. 4.11), *Faces* (Fig. 4.12), and *Protection* (Fig. 4.13).

In *Peacock* (Fig. 4.11) Buraimoh demonstrates the simplicity of his form in a clear format involving only one figure against a background. The body of the main figure in the composition is done in vivid colors, produced entirely with beads. It stands as a striking contrast against the muted colors of oil paint used exclusively in the background. Because it is lightly toned with white, the oil in the background is soft against the more striking beadwork used for the body of the peacock. The effect is a subtle contrast that turns the background

4.10 Unknown, *Yoruba Beaded Crown*, beads on fabrics, private collection

into the sky and transforms the entire composition into a landscape with a solitary bird.

Buraimoh focuses on the vanity of the peacock, flaunting its colorful feathers. The brilliant colors of the feathers are so intense that the peacock dominates and alters the coloration of the entire landscape in which it is located. To further separate the foreground from the background and the peacock from its environment, Buraimoh uses dark oil paints, applied as thick outlines around the body of the bird. By further breaking down his large areas into smaller sections of colors, Buraimoh subtly introduces patterns into the body of his painting. But because the smaller sections appear to be anatomical features, the patterns appear functional and not merely dispensable. The bold use of outline makes the work somewhat flat, yet the receding sky gives an illusion of depth that tantalizes the viewer's eye with a constantly shifting image.

Sometimes Buraimoh's compositions can be fairly similar, yet their meanings may be disparate, as in *Faces* and *Protection*. *Faces* (Fig. 4.12) refers to a Yoruba proverb that goes "*Ojú la rí, olúwa ló mọkàn,*" meaning "Faces are all we see, only the divinity knows the mind." Since faces do not reveal what is buried in the mind, they then conceal what is really in the mind. Faces therefore are like masks. It is not surprising that *Faces* seems to be a series of mask-like configurations arranged in overlapping structures. Another Yoruba proverb goes "*Ojú lòrọ́ wà,*" meaning "Words are formed in the eyes." Buraimoh's *Faces* emphasizes the eyes so intensely that they seem to want to communicate an urgent message. The hypnotic effect of staring into the eyes of figures in Buraimoh's work is so compelling that the viewer must break the spell by dragging his or her eyes away.

Protection (Fig. 4.13) has a horizontal structure similar to that of *Faces,* as well as the characteristic staring eyes. But in a metaphorical sense, *Protection* goes further than *Faces* by incorporating a bird at the top of the countenances. The presence of the bird instantly suggests that the faces underneath it are in fact eggs representing life, hope, and the future. The bird is sitting on the eggs to protect them until they hatch and begin independent lives. Among the Yoruba, the bird is the symbol of the *Ìyàmi,* or powerful women who regulate the fortunes of society. When they are happy with the community, peace and prosperity ensue. But when they are angry, they visit an endless reign of terror on the people. The bird-women protect or prey on the society, depending on their relationship to members of the community. In this instance Buraimoh is suggesting that the *Ìyàmi* should protect the people rather than attack them, just as the bird protects the eggs on which it sits rather than break them. During the exposition period Buraimoh and many other Yoruba artists saw an opportunity to revive and reinterpret their artistic tradition in a different manner, to create a new culture.

A FEW ARTISTS, NOTABLY GANI ODUTOKUN, saw the reinterpretation of the culture as an opportunity to also make political statements. The exposition period created a chance to make visual essays to expose the destructive activities and silly antics of the ruling elites and the irresponsibility of the followers. Odutokun had a broad, pan-African interpretation of culture. To fully understand his viewpoint, it is important to be aware of the historical circumstances that produced him. Fairly independent of colonial borders, Yoruba traders

had been active all along the coast of West Africa. Particularly active in these trading enterprises were the extremely migrant northern Yoruba groups, including the Ogbomoso, Igboho, and Offa. Ghana was one of the West African countries in which these immigrants settled in massive numbers as resident traders.

Ghana was receptive to these Yoruba settlers, even after the country became independent under the leadership of Kwame Nkrumah, who nursed a pan-African vision. With the collapse of Nkrumah's regime after Ghana's coup in 1965, the pan-African vision in the country began to dim and rapidly died. Soon after, Ghana became hostile toward the Yoruba residents, who had amassed a good deal of property and were seen as controlling the Ghanaian economy. To return the economy to the hands of the Ghanaians, the government asked the Yoruba residents to leave Ghana and return to their homes in Nigeria. It did not matter to the government of Ghana that many of these people had never known any other home, that they had been born in Ghana and their people had lived in Ghana for several generations. They spoke the languages of Ghana, although they kept the Yoruba language alive by teaching it to their children and using it among themselves as a language of commerce. Odutokun, one of the Yoruba people born in Ghana, was forced into Nigeria as a teenager, transplanted from the Ghana cultural system to the Nigerian cultural system.

Odutokun had trained in Ghana to be a stenographer at a commercial institution. After finishing his training, he was working as a stenographer in a government office in Ghana when the government asked all Nigerians to go back to Nigeria. He was displaced, but he liked it in some ways because he had hated the life he was living. His situation was particularly bad because he was deaf. He used a mechanical hearing aid that helped him to pick some conversation. He hated his job as a stenographer, in part because of his hearing problem and in part because it was not the job he wanted to do.

4.11 Jimoh Buraimoh, *Peacock*, beads and oil on board, Nigerian National Gallery

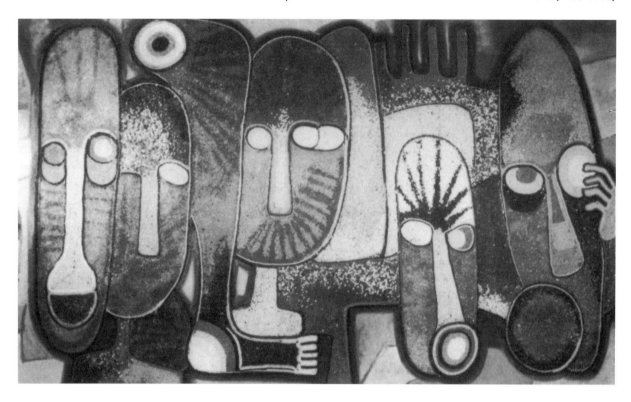

4.12 Jimoh Buraimoh, *Faces*, mixed media with beads, Nigerian National Gallery

Odutokun was therefore excited when the government of Ghana began to repatriate Nigerians in the late 1960s and early 1970s. Most Nigerians, however, were not happy about the forced dislocation. Hundreds of thousands of people left Ghana with no destination, no family ties, no job prospects, nothing to claim in Nigeria. The only tie Odutokun had to Nigeria was the knowledge that his family was from Offa, then in Kwara State. But there was nothing for him in Offa as a stenographer, a young man, or a refugee. He heard about Kaduna, the political, economic, and cultural "capital" of northern Nigeria, and arriving there he had no difficulty finding a job as a stenographer for the Kaduna brewery.

Kaduna was a total contrast to the small, sleepy town of Offa. Kaduna was a larger, more densely populated urban center with busy manufacturing and assembling industries. Offa was a tiny settlement in the middle of an endless terrain of undulating agricultural grassland. Odutokun realized Kaduna was less safe, but he was ready to experience the risks involved in living in an urban setting. Although he liked the more robust social life in Kaduna, he did not enjoy his work as a stenographer and resolved to become an artist. He had been fascinated by drawing and painting since childhood, but it was not until he came to Nigeria that he considered a career as an artist. He took correspondence courses to become a graphic designer, but after completing his course he failed to get a suitable job in the field. He decided to study further to improve his chances of securing gainful and fulfilling employment as a graphic designer. He was admitted to the prestigious Ahmadu Bello University, Zaria, only a few hours' drive from Kaduna.

At Zaria, Odutokun proved to be a star student, collecting every award in studio arts. He kept alive his ambition to become a graphic designer. Finally, he was persuaded by his professors, particularly the famous art educator

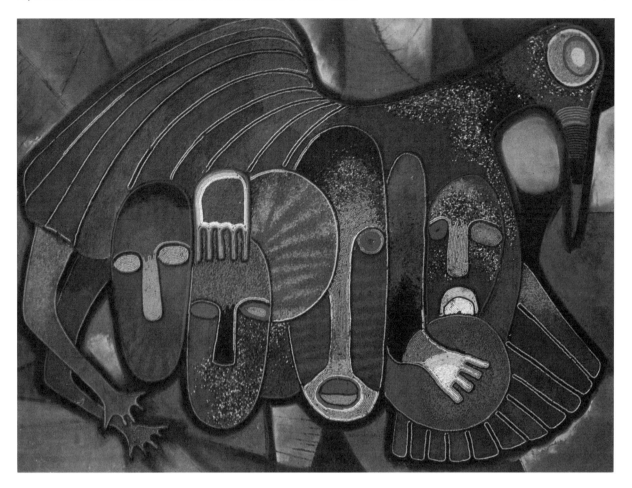

Solomon Wangboje, to specialize in painting, as he was developing a distinctive and colorful approach to painting that his professors found promising. He received his bachelor's degree in 1975 and completed his master's degree at the same university in 1979, remaining there to teach in the fine arts department until his tragic death in a car accident in 1995.

Gani Odutokun was a quiet, soft-spoken individual who, rather than proffer any strong opinion, allowed his paintings to speak for him—and they made eloquent statements about his indisputable genius. His paintings celebrate brush strokes, usually arranged to distort the natural anatomy with an imaginative use of color, textures, and shapes. The brush strokes twist inside out and turn abruptly, darting forward and recoiling with tantalizing and audacious intensity. They usually do not betray Odutokun's true feelings because they are too vigorously visual, and his message usually pales before the powerful thrust of his lively images. This is why it is so difficult to easily see the political intentions behind his pair of paintings entitled *Durbar: Emir's Procession* (Fig. 4.14) and *Durbar: The Race* (Fig. 4.15).

In an interview, Odutokun spoke about both paintings in 1979 at his Samaru residence, in part because he feared no one would see the political import of the work. The durbar—held yearly at Kaduna, where horses are raced to entertain the rulers, the rich, and the powerful—is Odutokun's metaphor for life itself. Odutokun explained that as in life, the durbar is all about spectacle and racing. Life itself is both a race and the spectacle that

4.13 Jimoh Buraimoh, *Protection*, mixed media with beads, Nigerian National Gallery

4.14 Gani Odutokun, *Durbar: Emir's Procession,* oil on board, Nigerian National Gallery

accompanies that race. What he emphasizes in the paintings—in the composition of each figure, in the placement of each brush stroke, in the relationship between the shapes, in the usage of color—is the simultaneous tension and freedom living entails. Freedom creates tension before it resolves itself into relaxation; but the simultaneous projection of freedom and tension, of relaxation and intensity, may remove the viewer's eyes from the philosophical import of the composition, which groups people as spectators, athletes, and referees. All of these groups represent allegories about real life, where races are run, winners and losers are made, and some people are the judges of others. Odutokun spoke of his worries concerning the rules of the game, the fairness in terms of equipment and handicaps, and the impartiality of the judges. This was especially important since in 1979 Nigeria was on the eve of an election, and several candidates were preparing for the political race.

But alas, he discovered that everyone believed the painting was simply about a horse race on an open track. In the same interview Odutokun asked, "Isn't that so disappointing? I will have to make them a little more obvious." And so he did in the *King and Queen Series,* which he launched in 1989 and continued until 1990 during the oppressive regime of General Badamosi Ibrahim Babangida, a military despot who ruled Nigeria in one of its most corrupt times. After his successful coup in 1985, Babangida began to create grandiose offices for the first lady. The first couple became very visible, the husband busy commanding the army and ruling over all and sundry, and the wife taking a closer and benevolent look at the plight of women in particular. This visibility engendered the *King and Queen Series.*

Odutokun is making a parallel between the story of Adam and Eve and that of Nigeria's first couple. His painting titled *The King, the Queen, and the Republic* (Fig. 4.16) shows how the people, represented by the Republic, finally

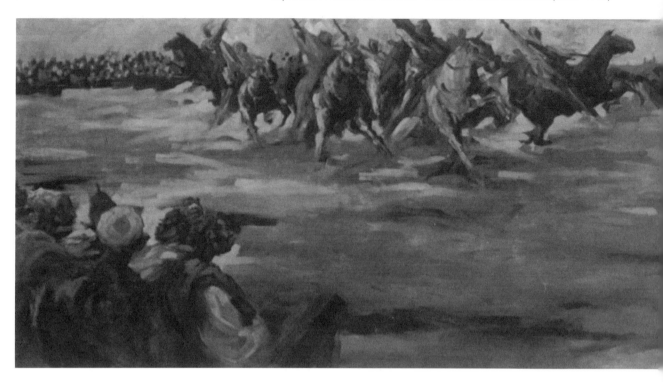

4.15 Gani Odutokun, *Durbar: The Race,* oil on board, Nigerian National Gallery

eliminate the king and the queen and save themselves from the reeking sewage of corruption that threatens to drown them all. It is the traditional narrative of goodwill prevailing over evil, of the evil couple swept away by benevolent forces. As in the biblical story of Adam and Eve, the figure representing the Republic in Odutokun's painting is holding a sword like Angel Gabriel's while the couple, in utter disarray, flees before that enigmatic figure. They are covered with the sewage of corruption, within which they have festered for many years. In other words, Odutokun is predicting that the Babangida regime and all other evil regimes that might follow will be forcibly expelled from their pleasurable seat of power, just as God expelled Adam and Eve from the Garden of Eden.

SOMEWHAT LESS JEREMIAD IS THE PAINTER TAYỌ ADENAIKE, who explores the Igbo women's art of *uli* in defining a cross-ethnic artistic identity for himself. Originally from the Ijẹbu-Yoruba group, Adenaike's childhood was divided between Yoruba and Urhobo countries. He received his secondary education at the Government College at Ughelli, in the heartland of Urhobo culture. After completing his secondary education in Ughelli, he did not return to Yorubaland but went to study fine arts at the University of Nigeria in Nsukka. Under the tutorship of Obiora Udechukwu and Chike Okeke, Adenaike was exposed to the women's lineal art of *uli*. This ancient art, originally drawn on wall surfaces and on the human body as decoration, has been reinterpreted under the leadership of Uche Okeke and Obiora Udechukwu into a dynamic influence for contemporary artists.

After learning the intricate ways of rendering *uli* motifs and the meanings and functions of those motifs not available in his indigenous Yoruba culture, Adenaike faced the challenge of incorporating them into his own compositions. Rather than literally copy the motifs, Adenaike studied and adopted

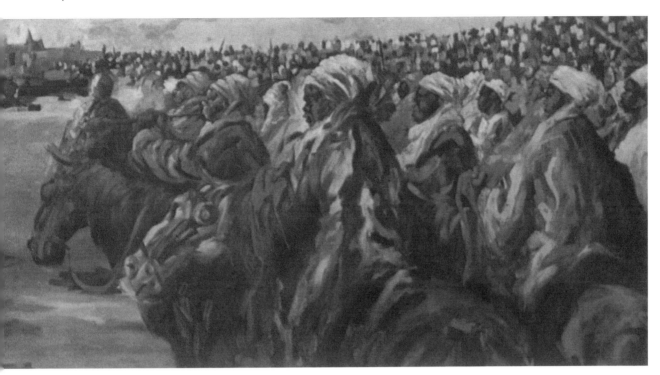

the design principles behind *uli* art. He used these principles in composing his paintings, allowing the *uli* art forms to influence his rendition of figures, use of colors, arrangement of lines, and application of textures (Fig. 4.17). The result is a form-oriented approach to composition that appears to subordinate meaning and intensify design. In fact, the design is the meaning in Adenaike's work, as it is in the work of many artists who trained at the *uli*-influenced art school associated with Nsukka. Adenaike has contributed to the renaissance of Igbo and Yoruba art forms, even though as a man he crosses both the gender and the ethnic boundaries in achieving his renaissance intentions.

THE APPROPRIATION OF WOMEN'S TECHNIQUE BY YORUBA MALE PAINTERS is not simply an ethnic issue and is not free of gender implications. The gender dimension is most rigorously investigated and intensified in the canvases of artist Kunle Filani. In a work clearly borrowing from Oluorogbo shrine painting while trying to depict the female body, Filani's *Beyond the Veil* (Fig. 4.18) ends up betraying his own concept of femininity as problematic and confusing, if not as a commodity.

Filani, a graduate of the university in Ile Ife, is a founding member of a group of artists named Ọna, which promoted the exploration of indigenous Yoruba forms and metaphors. As an Ọna member living and studying in Ile Ife, he became aware of shrine painting by women and therefore was conversant with the works of Obaluaye and Oluorogbo painters after which *Beyond the Veil* is patterned. The perpendicular structure of the composition directly references the vertical lines of Oluorogbo painting. Filani's painting is composed of five vertical strips or registers, echoing Oluorogbo painting, with each register filled with different details. Unlike the Oluorogbo painters, Filani allows figures from one register to spill over into another, resulting in a more

4.16 Gani Odutokun,
*The King, the Queen,
and the Republic,*
gouache on paper,
private collection

fluid composition. Second, Filani uses oil colors on canvas and paints in a symmetrical detail.

Beyond the Veil focuses on three women, two of them on the left and right sides of the painting with the third forming an arching bridge between them. To separate the intertwined bodies of the women, Filani uses bold outlines to define the contours of each figure, resulting in a two-dimensional look within a generally flat composition in which the only round forms are the women's breasts. All the women are depicted in the nude, allowing Filani to display intricate body decorations on their skin in a manner that enriches the surface appeal of the work, giving it a highly sensuous texture. He uses props consisting largely of textile fabrics in the background and around the women. To draw more attention to the women's breasts rather than trying to conceal them, Filani displays them under transparent fabric through which the breasts are not only rendered more appealing but made infinitely more erotic. The transparent fabric envelops the breasts as if they were toffee packed in gossamer foil, an impression amplified by the modeled swelling of the breasts into various candy configurations.

The title of the work, *Beyond the Veil,* demonstrates the metaphoric significance of the transparent fabric, as it is really a paradigm for Filani's concept of the veil. The gender implication of Filani's painting commences from the othering of women as a separate category that engenders curiosity from males. In other words, a veil separates men from women, one Filani suggests women have installed to conceal themselves from men. Each gender engages the other across the veil, as prisoners caught in self-installed cages. What we have here, however, is the male perspective, penetrating the veils of the female space with or without the awareness or permission of the women.

4.17 Tayọ Adenaike, *Untitled,* water color, courtesy of the artist

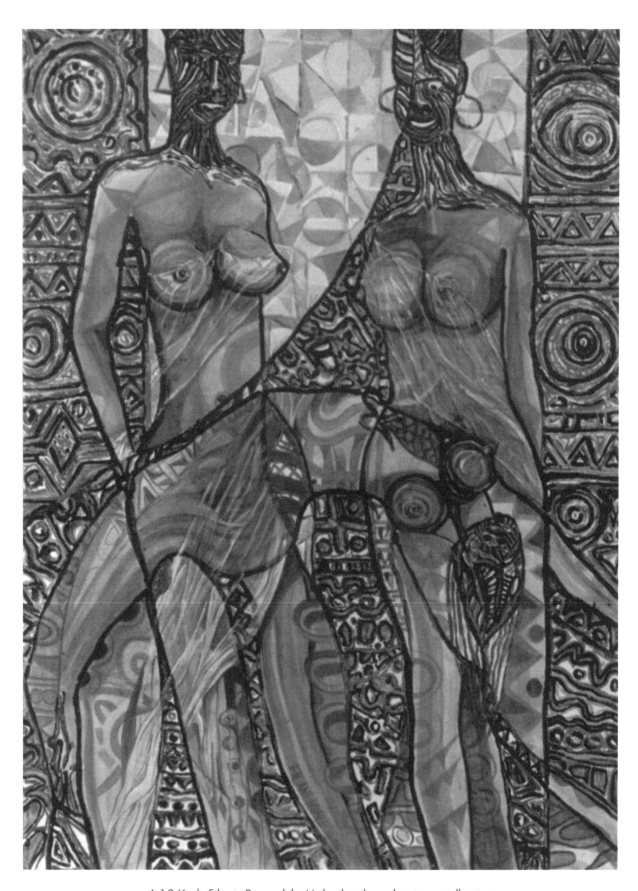

4.18 Kunle Filani, *Beyond the Veil,* oil on board, private collection

Filani casts the veil as a gate with massive posts on both sides of the women. The formidable size of the column, embellished with intricate linear decorations as in Oluorogbo painting, makes the female space seem impregnable from the outside and exclusive to those inside. Indeed, the women wear terrifying faces; they put up intimidating appearances and sport grotesque masks to scare away potential trespassers, as the figures stand like gatekeepers of a world whose sugary pleasures are suggested by the soft pastel hues of the register between their ripe bodies.

The three women are identical. They have large breasts, shapely bodies, and ample, rounded buttocks. They seem to fulfill the fantasy of many Yoruba men, from whose perspective Filani is casting a heterosexual gaze. The veil is one of distance, alienation, and estrangement that ruptures and separates the universes of the genders while detaching Filani from his female subjects. It is that distance that makes the subjects attractive in the first place as Filani, with testosterone high and familiarity low, tries to see beyond the Yoruba gender veil. What he claims to see shows more of Filani's heterosexual desires than it reveals of the true nature of Yoruba womanhood.

Yet Filani demonstrates how the form of shrine painting, a Yoruba invention, can be turned into a veil or gate through which to gaze at women and consume their erotic offerings, with or without their consent. His reading through the veil is obviously a refracted script of images whose meanings have been altered by the transparent veil that enables him to see through. In other words, the shrine painting structure through which Filani gazes into the women's world is not crystal clear since it is a veil and it appears perspicacious. In the guise of the painting tradition, the veil is a film that prevents any direct contact between Filani and the women, forming an actual intellectual and spiritual barrier between them. Using the shrine painting form of the women, in *Beyond the Veil* Filani reveals his lack of access to the culture across the veil of constructed gender rather than providing any insight into the nature of Yoruba women. His work provokes gender issues in contemporary Yoruba art, where virtually every known artist is male.

PERHAPS THE ONLY FEMALE YORUBA ARTIST OF INTERNATIONAL REPUTE is Nikẹ Davies, formerly Nikẹ Seven-Seven.[14] During the 1970s Nikẹ was one of seven wives of Twins Seven-Seven, all of whom served as his studio assistants. Nikẹ saw it as an opportunity to learn to make art, and she soon left Seven-Seven, with whom she had several children including the artist Ọlabayọ Ọlaniyi. An enterprising and hardworking artist, Nikẹ has a studio and gallery in Oshogbo to which visitors from all over the world flock to see and buy her art (Fig. 4.19). At her studio she runs a workshop where she trains men and women to make quilts, batik, prints, and drawings. Some of her students practice their crafts in Oshogbo and neighboring towns, adding to the remarkable sense of a renaissance.

YORUBA ARTISTS THEREFORE USED DIFFERENT STRATEGIES and achieved varying degrees of success during the exposition period. The invocation and revival of ancient traditional forms were no longer a tactic to impress outsiders but a proclamation of the artists' vital sense of being, as well as of an awareness of their historical responsibility. Diverse and unconnected as the works of Twins

4.19 Nikẹ Davies, *Shango Festival,* batik, private collection

Seven-Seven and Gani Odutokun are, both are guided by their dedication to a reconsideration of an oppositional attitude toward the revival of ancient African forms. Odutokun believed African contributions to the arts and sciences should be individual as well as communal expressions. He said, "If an African discovers anything in the natural sciences today, how African is it? That's why I don't think we should encourage narrowly looking at the African past."[15] In full agreement, Seven-Seven, in his painting *Inspiration of Mr. Kelly and Twins Seven-Seven and the Ghost of the Voice of America,* includes electronic and other Western technological gadgets, which he nevertheless gives mythological and African meanings. Do these foreign gadgets suddenly become "African" because they are inserted into a painting by an African artist? This is one of the many challenging questions faced by the artists of the exposition period, who, like Odutokun, began to perceive the immense schizophrenic complications of their hybrid vision.

The revisional stage of the exposition period was largely an era of self-questioning, interrogation, exploration, and experimentation rather than a time when artists expressed a rigid feeling of finality. The uncertain political terrain, fraught with numerous military coups d'état and corrupt, dictatorial, and intolerant regimes, amplified the insecurity the people felt. That sense of insecurity turns up in the art of this period largely through the adoption and critique of abstraction, with its open-ended form, as the major means of exposition. Yet the abstraction or its critique is not monolithic in structure or theme; it includes the fluid brush strokes of Odutokun's *The King, the Queen, and the Republic,* with its political theme, and the rather graphic image of Filani's *Beyond the Veil,* with its hedonistic suggestions.

5
EMIGRATION PERIOD
Relocation of African Artists
(1990-present)

The Yoruba have always conceived of their history as diaspora.

—OLABIYI YAI

 ong before it became obvious to many people, some African artists foresaw the ominous economic, political, cultural, and moral collapse and left Nigeria in the early 1980s. Others waited until the late 1980s. But by the early 1990s it became clear there was a steady flow of artists, intellectuals, and other professionals out of Nigeria. The emigrants were heading to the metropolitan centers of the new global village, to London, New York, Los Angeles, Paris, and Berlin. A few went to the oil-rich Gulf region of the Middle East, particularly to practice medicine. Most artists went to Britain and a few other European countries and to the United States. The Nigerian government, under Ibrahim Babangida's regime, named the Occidental journey the "Nigerian Brain Drain" and set up a special commission to study it. The commission reported back to the government with recommendations on how to stem the brain drain by providing incentives for artists, intellectuals,

and other highly skilled professionals to stay in Nigeria. Babangida welcomed the report with fanfare and promised to consider it. Later, he concluded that the brain drain was good for the country. After all, when people leave Nigeria, they create more room for others to prosper. Following that singular statement made in early 1990, an unprecedented tide of artists, intellectuals, and professionals poured out of Nigeria. Many saw Babangida's declaration as the sign they had been waiting for to get them to leave the country.

In 1983, following the fall of the Third Republic and the overthrow of Alhaji Shehu Shagari, the military officers who seized power began an uncontrolled and unparalleled plunder of Nigerian resources. They also launched a reign of terror, assassinating and imprisoning perceived oppositionists and dissenters. By intimidating trade union leaders, terrorizing university faculty unions, subverting the business community, and alienating the international community, the Nigerian military made life difficult for all Nigerians within and outside its borders. There was a perceived ethnic imbalance among the ruling elite within the Nigerian military. That imbalance allegedly gave certain groups—presumably the northerners—undue advantage and discriminated against others, particularly the southerners. Whereas Igbo people in southeastern Nigeria had felt alienated since the civil war that began in 1967 and ended in 1970, by the mid-1980s many Yoruba people began to express strong sentiments of political victimization. By the mid-1990s Yoruba people felt persecuted, as many of their leaders—including M.K.O. Abiọla, Gani Fawẹhimmi, and Olusẹgun Ọbasanjọ—were imprisoned. Throughout the chaos, Nigeria's only Nobel laureate, Wọle Ṣoyinka, a Yoruba writer and intellectual, fled the country, along with many artists, writers, performers, and dramatists, to seek political and creative refuge in diaspora.

But even when no chaos exists, the Yoruba world is one of diasporas, of dispersal and migration, according to the Africanist philosopher Ọlabiyi Yai. He observed in Yoruba culture a

> Territorial or geographical dimension through which history is viewed as expansion (not necessarily with the imperial connotation that has become the stigma of the concept in the English language) of individuals, lineages, and races beyond their original cradle. . . . The concept and reality of diaspora . . . are rationalized in Yorubaland as the normal order of things historically.[1]

When a Yoruba artist finds himself or herself in a foreign land, he or she does not usually simply integrate and conform to the conventional order of the diaspora land. This tendency recalls an old Yoruba saying "*A ji se bi Ọyọ la a ri; Ọyọ ki i ṣe bi ẹnikan*" (Although it is okay for others to copy a Yoruba person, never does the Yoruba person copy anyone). The Yoruba artist therefore seeks to copy no one but reinvents Yoruba forms wherever he or she goes and does not ask or force others to copy his or her work or style. In fact, "The ideal artist in the Yoruba traditions is an *are* (itinerant) . . . a permanent stranger, precisely because he or she can be permanent nowhere."[2] Yoruba art therefore celebrates movement, action, and mobility of form and style. The work of the artist becomes the artist's hand, and the legs become the metaphor for animation and alienation caused by traveling. The journey of the itinerant Yoruba artist is measured not only in terms of physical space but

also in terms of self-reinvention as part of death and revival, of demise and renaissance.

This concept of diaspora revival is scripted into the Yoruba proverb "*Bí iná bá kú, á fi eérú bo ojú; bí ògèdè bá kú, á fi ọmọ ẹ ròpò*" (When a fire dies, it layers its face with ashes; when the banana plant wilts, it replaces itself with its shoot). These are Yoruba metaphors of rejuvenation, renewal, and regeneration. They are about the Yoruba sense of renaissance, of revival and restoration. In the very marrow of Yoruba mortality is immortality, and at the heart of death is life itself. Yoruba elders say "*Bí ẹni bá kú, ẹni níí kù*" (One dies and another remains). Loss replenishes losers, and as one leaf falls, a bud replaces it. Nothing is irreplaceably crucial, nothing is totally worthless, and every experience contributes to the gradual turning of the wheel of time as society changes and the culture evolves, molded by the same people it is defining. "*Bí ọmọdé bá ṣubú, á wo iwájú; bí àgbà bá ṣubú á wẹyìn wò*" (When the young stumbles and falls, he or she looks forward; when the senior stumbles and falls, he or she looks backward). In the past lies the future (*Àná ló mọ ojú ọla*). When Yoruba artists arrive in the land of diaspora, they usually look backward into their culture in order to look forward into the culture of diaspora.

Two diaspora Yoruba painters, Moyọ Ogundipẹ and Bọlaji Campbell, who left Yorubaland for the United States in the early 1990s, are looking backward into Yoruba artistic traditions even as they look forward to integrating themselves into the American art culture. After practicing in Nigeria for several years, both artists relocated to the United States, "chased out by harsh social, economic, and political realities beyond our control," said Campbell.[3] Both painters trained at the university town of Ile Ife and worked briefly in Nigeria before relocating to the United States. In Ogundipẹ's work we see a renaissance of ancient Yoruba forms, including sculpture, painting, and textiles. In the work of Campbell the revival of Yoruba shrine painting is most prominent, even though his work also make references to the ancient sculptural and textile traditions.

Campbell's exploration of shrine painting (Fig. 5.1) and the use of soil as pigment to paint started in Africa, not in the diaspora. Although he learned to paint with the soil in Ile Ife, he was not born in the ancient city but went there to study in 1981. While studying in a Lagos institution, Yaba College of Technology, Campbell decided to find out more about Ile Ife because one of his teachers kept telling him to leave the school and go to Ile Ife to study. "He thought I was too outspoken for his class," Campbell said, "so he kept urging me to go and study at Ife. I felt that I really did not belong in his ceramics class. And maybe I . . . belonged in Ife. I wanted to find out. . . . I stopped attending classes at Yaba College of Technology and got a temporary job in a bank while I prepared to go and study at Ife."

Ile Ife, with its small size, small population, rural disposition, and ritual activities, proved a huge contrast to Lagos where Campbell grew up. Lagos, at that time the capital of the Federal territory of Nigeria, was already suffering from population explosion, which led to traffic congestion, urban crime, and metropolitan alienation for many people coming out of the small rural communities surrounding Lagos. If Lagos has emerged as the prosperous commercial center of Yoruba culture, Ile Ife remains its religious nucleus; because of the

5.1 Oluorogbo group, *Shrine Painting*, organic paints on wall

location of a major university within the ancient town, Ile Ife has become one of the largest and most productive intellectual centers in that part of the world. Whereas Lagos attracts hordes of people trying to escape the poverty and isolation of surrounding rural areas, Ile Ife continues to attract the cream of intellectual talent settling in the country seeking to blend in to a conducive academic environment.

The city's other major attractions include its ancient palace, shrines, monuments, and festivals, which interest people from all over the world. Ife priests are also highly revered around the world, as they are believed to be thoroughly schooled and exceptionally gifted. Priests from other parts of Yorubaland, as well as from Brazil, Cuba, the United States, and Europe, visit Ile Ife to further their studies and sometimes to acquire stronger powers. Devotees of many divinities make pilgrimages to Ile Ife shrines, believed to be the powerhouses of Yoruba spiritual preserves. Whereas many come to Ile Ife for short periods to gain spiritual rejuvenation and intellectual stimulation, huge numbers move to Lagos to settle and seek prosperity. Many young people are moving out of Ile Ife in search of professional success in larger towns such as Ibadan, Oshogbo, and Abeokuta. But the aged traditionalists remain in Ife to service the shrines, perform the rituals, and organize the festivals that keep the town running.

Moving to Ile Ife was like a homecoming for Campbell as a Yoruba man because Yoruba people believe their origin is Ile Ife, from where they have spread to all parts of the world. But Campbell had made a more significant move in 1966, long before he came to Ile Ife. Campbell was born in 1958 in

the city of Kano, in the northern part of Nigeria. In 1966, during the ethnic cleansing of southerners—especially the Igbos—by Nigeria's predominantly Hausa and Fulani northerners, Campbell moved south to Lagos. As a southerner living in the north with members of his family, his life was in danger in January 1966. He said,

> Even though I was a child of only eight, I knew what was going on.
> Children talked about what they heard and saw when we came together
> from various ethnic backgrounds and played. We also saw things with our
> own eyes. We saw houses set ablaze by Hausa-speaking northerners in the
> Sabongeri quarters where southerners were located. Some people went
> into hiding out of fear for their lives, especially the Igbo people. It was a
> little better [for me] because of my Yoruba ethnicity. Also I could speak
> some Hausa. But we were not allowed to go out anyway because it was
> dangerous. Adults who went out spoke of seeing bodies of lynched
> victims lying all over town. Soon after, my father arranged to send me by
> train from Zaria to Lagos to stay with my grandmother. Hundreds of
> thousands of southerners were fleeing from the north at that time.

The thousand-mile journey to Lagos from Zaria was the first major trip he undertook alone. Barely eight years old, Campbell arrived in Lagos to continue his primary school education in a public institution near his grandmother's house in Ijẹṣatẹdo. Fifteen year later he left Lagos for Ile Ife after completing his primary and secondary education. This time he was leaving Lagos to study painting at the university in Ile Ife.

If all Campbell wanted to study was Western forms of painting, such as those he had been learning at Yaba College of Technology, he was in for a shock. The art program at the university in Ile Ife had a fair balance of Western and African values, and it was not a simple imitation of a typical Western program. Many Ife professors were committed to the study of African values, structures, materials, and techniques, which constituted their research focus. Ife faculty who came out of the defunct Institute of African Studies at the university, from which the art program was carved, continued to conduct research on African art. The African Studies Program had such eminent scholars as Nobel laureate Wọle Ṣoyinka, Wande Abimbọla, Akin Euba, and Rowland Abiọdun—all of whom were teaching in various academic departments such as fine arts, music, drama, and literature when Campbell arrived in 1981. The British-trained Yoruba anthropologist J.R.O. Ojo, the U.S.-trained art historian Babatunde Lawal, and the experimental painter Moyọ Okediji (Fig. 5.2) were all teaching in the art department, as were other artists including internationally known sculptor Lamidi Fakẹyẹ, Raphael Ibigbami, Ọla Ọlapade, and P.S.O. Aremu, the fabric designer who studied at the Rochester Institute. These intellectuals had a commanding understanding of Western art forms and were avidly interested in African art, on which they were all conducting research.

The art program at Ife had a dual-tiered structure. The first two years were largely an introduction to Western forms. The final two years were designed to question those Western models using African examples, usually derived from faculty members' ongoing research. Because he had attended postsecondary school, Campbell was in a special program that enabled him to skip the first year and start in the second so he was able to complete his studies

5.2 Moyọ Okediji,
Transatlantic Akire,
terrachroma on canvas,
H. J. Drewal Collection

in three years and graduate. Campbell therefore was immediately exposed to advanced aspects of Western art studies when he began his undergraduate work. In painting, he took courses that introduced him to portraiture, land-scape, still life composition, figure painting, and abstraction using a variety of mediums such as water-based materials—notably water color, tempera, and gouache—during the first two semesters.

In the last two years of his study he was introduced to experimental painting based on faculty research on color in Africa, as well as African painting. All the exercises were built on the manipulation of alternative materials, including those in which Campbell was required to paint murals using the colors of the soil, rather than commercial paints, as pigment. He said,

> During my final year I studied mural painting with Professor Okediji, and that was when I was initiated into using alternative materials, beginning with soil colors. During the first semester I was asked to paint the facade of the sculpture studio, and I used soil hues. It entailed pros-pecting for the colors by searching for and collecting the different hues. I searched all over the campus and carefully collected available colors of the soil. The professor also brought some yellow soil colors to the studio to share with us. For black, I mixed charcoal with transparent glue and applied it on the wall. Ultimately, the wall became my own shrine. For me it was such a powerful experience, to take these courses. At that time I

experienced a new and exciting feeling, even toward works on canvas painted in oil. But I particularly liked the tactile qualities of the soil colors. I became more sensitive to images as a spiritual experience.

After he completed his undergraduate work in 1984, Campbell performed the compulsory year of national service and taught in northern Nigeria, where he continued to experiment with soil painting. In 1987 he returned to Ife as a graduate student, with Okediji as his adviser. This time Okediji took him to the shrine to see actual shrine paintings and talk with shrine painters. Campbell was now experienced enough to deal with the spiritual issues raised in the divine context of shrine painting. His adviser told him some of those issues troubled many students, who could not balance their Christian beliefs with the *orisa* tradition out of which shrine painting comes.

As a child, Campbell had seen shrine painting in the palace of the Odofin when his mother took him there on rare visits to the south. The palace tour remains vivid in his memory, particularly the shrine paintings and sculptures displayed in the courtyard. He recalls being frightened because he had never seen anything like them before.

As an adult in 1986, he had the opportunity to see shrine painting directly. The Oluorogbo shrine painting (Fig. 5.1) was completed when he visited that December, and he was able to talk privately with the priest, even though he did not meet any of the painters. The following year Professor Okediji took him to the Obaluaye shrine (Fig. 5.3). This time he was able to meet and interact with the painters. His first impression of shrine painting at the Oluorogbo shrine remains the most vivid. Campbell said,

5.3 Bọlaji Adefioye and the Akire group, *Ọbaluaye Shrine,* organic paints on wall

It was a totally different kind of painting, different in the sense that in the academy we are trained to express ourselves in the Western European tradition of mimetic image making. This is completely different from the Yoruba perspective I saw at the shrine. I find the shrine painting shocking. All that I saw was a pattern of decorations. They are all images deliberately painted flat. My initial reaction was to regard them as busy, heavily and indiscriminately decorated patterns, done without any selective sensibility. I saw them simply attempting to fill space. I thought there was no planning or structure, pattern or discipline about the way the images were put on the wall. Years later, when I revisited the shrine, I saw a totally different painting. Yet I still saw how my new view stylistically recalled the one I saw years before. I therefore began to understand that there was some kind of pattern or tradition here that the painters were following, that it was not simply a matter of filling up the picture plane. By the time I finally saw the Ọbaluaye, Orịṣaikire, and Loogun shrine paintings, I realized that the images in these paintings have meanings and that there is a restriction on what the artists could paint, as well as room for innovation.

Campbell now recognizes that several schools of shrine painters are present in the community and that they have their own approaches to composition, far beyond anything available to him in the classrooms of the university. Yet he appreciated attempts the university researchers made to explore the indigenous approach within the confines of an educational setting.

Three of Okediji's students who were ahead of me by one year were assigned some spaces on the wall to paint. These students were Ṭọla Wẹwẹ, Mọla Johnson, and Ayi Ekpeyong. That was the first time I ever saw anybody use those soil materials. I was curious and asked lots of questions, and they told me they were working with local materials used by shrine painters. I was fascinated. So I was not entirely unprepared for the shrine paintings when I finally saw them. But it was not until December 1986 when Professor Okediji took me to the Oluorogbo shrine that I encountered actual shrine painting.

Campbell's work has not been the same since he saw the works of the shrine painters. He was intrigued by their use of local materials, particularly their highly textured application of colors—which they used generously and freely because they did not have to buy the materials, which were freely available to collect from the local environment. As a graduate student with very little money, he found it liberating that he could use the soil colors in raw supply rather than the oils he had to buy. Second, he was fascinated by the realization that the shrine painters were not interested in depicting three-dimensional illusions on two-dimensional surfaces, as was taught in the university. They were not conscious of monocular perspectives and natural body proportions. They had their own approaches to composition that freed them from those conventions, enabling them to invent other approaches to composition beyond the Michelangelo and Da Vinci models of the Renaissance or the Picasso and Beckmann models of modernity. The shrine painting offered Campbell a fresh vision beyond the cubist appropriation of Negro sculpture, as well as an opportunity to work with artists outside the market economy of modern art. Campbell began to paint using their materials and

techniques, thereby moving his art from the use of oil associated with the Western academic tradition to the use of soil colors, with its revival of indigenous values.

These soil colors, which Okediji named "terrachroma," are mixed differently than the shrine painters' formula because during his research Okediji observed that the shrine painters' purposes are different from those of art students who want to develop a more permanent paint. Shrine painters are happy to keep their paints in the fugitive state because they do not move the works and they paint over the same surfaces annually. Okediji developed a more permanent binder for the students, and Campbell combined the colors of the shrine with raffia textures in a series of mixed-media compositions demonstrating his mastery of the medium. In Campbell's hand the soil medium combines with other materials to become a means of exploring Yoruba oral traditions, particularly proverbs, idioms, and axioms.

The idea of using visual images to represent proverbs became increasingly popular after it was pioneered by the Urhobo printmaker Bruce Onabrakpeya. Campbell had studied with Onabrakpeya when he attended St. Gregory's College where Onabrakpeya was teaching. At that time Campbell did not know of his teacher's international status as an artist and was unaware that he had invented deep etching and was a distinguished printmaker whose talent had been presented and acknowledged all over the world. Campbell and Onabrakpeya discussed art, among other things, particularly since Campbell was gifted at drawing, something his art teacher could not have missed. Onabrakpeya asked Campbell what he wanted to do when he grew up, and Campbell replied that he wanted to become a historian. Onabrakpeya suggested art history, saying, "Maybe you could write the first book about my work"—not knowing Campbell was on his way to becoming an artist and later an art historian.

Campbell later studied Onabrakpeya's work as a university student at Ife. He recalled some of the discussions he had enjoyed with this great artist, whom he had taken for granted several years before. He noticed that Onabrakpeya's works usually had titles inspired by proverbs, which enabled Onabrakpeya to weave visual and verbal metaphors together to create more complex webs of mythical imagery within his compositions. Similarly, Campbell observed that the Yoruba painter and architect Ibitayọ Ọjọmọ's work was also built around the concept of proverbs. Ọjọmọ lived in Ile Ife and was a professor of architecture and a highly respected painter with a strong national reputation. Campbell admired Ọjọmọ's work and later contributed to the first solo show Ọjọmọ had in Ile Ife. He became familiar with Ọjọmọ's work and particularly enjoyed the way Ọjọmọ used proverbs and other idiomatic expressions as the titles of his paintings.

Although Ọjọmọ painted in oil and Campbell worked in soil, Campbell studied Ọjọmọ's work as an academic exercise. Proceeding from the early pieces to the more recent works, he noticed that some of Ọjọmọ's early paintings were not based on verbal metaphors but had straightforward titles with ordinary diction. But as time went on, Campbell recognized that Ọjọmọ, recalling Onabrakpeya, changed from English titles to Yoruba titles and from ordinary to metaphorical language. A painting such as "*Èyin Àgbààgbà Tí Ẹ Jẹ Èṣébì*" (Fig. 5.4) comes from a slightly longer proverb, "*Èyin àgbààgbà tí ẹ jẹ èṣébì, ẹ pe*

5.4 Ibitayọ Ojọmọ, *Èyin Àgbààgbà Tí Ẹ Jẹ Ẹ̀ṣẹ́bì*, oil on canvas, private collection

ara yín jo," meaning "Those among you elders who eat corrupt food, gather for a roll call." The proverb attempts to convey the sense of righteousness the innocent feel when a crime has been committed and the culprits remain unknown. The painting, done in layers upon layers of opulent analogous colors, shows a gathering of figures at the center of the composition, with features so poetically muted that they are not blatant but implied. The figures are so intricately integrated that no clear boundaries exist between them as they fan out into a concentric configuration. The circular structure of the composition provides a form of enclosure within the canvas that suggests secrecy and conspiracy among the bent figures, who seem stooped by the weight of their plot and the sheer gravity of their corruption conference.

The essence of the proverb therefore becomes transformed into a visual image in a manner that transcends illustration while capturing not merely the meaning of the proverb but the spirit of what the proverb seeks to project. With the use of visual images, therefore, Campbell is able to manifest aspects of Yoruba verbal traditions without compromising the spectacle flavor of painting. Campbell finds that interplay between verbal and visual metaphors most stimulating in the art of Ahmed Oyebamiji, a palace painter Campbell met in Ilẹṣa, the hometown and birthplace of Campbell's father.

DURING HIS GRADUATE STUDIES IN ILE IFE Campbell's professor encouraged him to write his thesis on shrine painting, so Campbell returned to his roots in Ilẹṣa. The politics of hometowns in Yoruba culture deserves an entire volume, but it will suffice here to give a brief summary. Ilẹṣa is about 30 miles southeast of Ile Ife, and it is the capital of the Ijẹṣa people, a Yoruba subgroup including Ipetu-Ijẹṣa, Oṣu, and Ijẹbu-Ijẹṣa. Ilẹṣa played a significant role in ancient Yoruba politics as the administrative center of a vast stretch of fertile and agricultural country at the edge of the rolling Yoruba hills. The king, known as the Ọwa of Ilẹṣa, is a crown-wearing Yoruba monarch whose palace is the most impressive edifice in a countryside that boasts several great palaces.

Part of the greatness of the ancient Ilẹṣa palace results from its saturation with art objects by the rarest talents of the era. Sculptural pieces of all dimensions complement the indigenous palace architecture of the district, serving as house posts, doors, and details for the buildings. But with the advent of colonial and independent Nigeria, the power of the monarch has dwindled and with it the size of his palace. The scale of the palace art has been greatly reduced, even though it still includes several impressive sculptural masterpieces in its display. The walls of the palace are also painted. Rather than allow women to paint the walls, as is the tradition, the work was contracted out to a male artist, Oyebamiji, who made a bid when the project to paint the walls was announced.

When Campbell went to study shrine painting in Ilẹṣa, therefore, the palace shrine he saw and that fascinated him so was painted not by women, as he discovered in Ile Ife, but by Oyebamiji, a modern Nigerian artist of Yoruba descent. Oyebamiji, who is aware of Yoruba shrine painting by women, is from a category of workshop-trained artists, such as the Oshogbo school that produced Twins Seven-Seven and Jimoh Buraimoh. Oyebamiji's work seems derivative of Twins Seven-Seven's style. Oyebamiji's mural is a celebration of

Yoruba divinities he painstakingly painted on the sacred wall of the Ogboni complex in Ileṣa.

Ahmed Oyebamiji is a Muslim, but that did not deter him from seeking inspiration from the divinities when he was awarded the commission to decorate the walls of the shrine. Perhaps the highest achievement of his career was the opportunity to paint the shrine, which came after he used all the human and spiritual connections he had with the chief priest of the Ogboni shrine. He did not relent until he was given the commission, after which he committed himself to an unusual preparation process for executing the mural. He was fully aware that the mural was an unusual commission, largely because it was not a secular commission but a sacred one that directly dealt with the spirituality of the entire community, including himself. In other words, he was painting for gods and goddesses who had tremendous power in the society and could wreak extensive havoc if annoyed by the work of a painter. On the other hand, they could bring abundant blessings to the community and reward the artist and his patrons with wealth and health if they were pleased with the painting. In accepting the contract, Oyebamiji was aware of the sensitive nature of the commission and considered it his responsibility to do a job that would bring joy and prosperity, rather than curses and despair, to the society.

Just as Bọlaji Adefioye, the chief priestess of the Ọbaluaye shrine, fasted for seven days before the beginning of a painting session, Oyebamiji began a fast to purify himself in readiness for painting. In addition to fasting, he also practiced sexual abstinence and total avoidance of aggressive acts for a week before he began work. During that week he spent time with the priests of the shrine to elevate his mind to the spiritual level necessary to catch the attention of the divinities and beseech them for divine inspiration. His abstinence from food, sex, and aggression for a week affected him both physically and emotionally. Physically, he felt very weak after a week of living on nothing but water. But emotionally he felt transformed because throughout the fasting period he kept his attention focused on icons of the divinities, not only to familiarize himself with their details but also to enable the spirits of the divinities to enter his mind through the objects. It was therefore not surprising to him that when he tackled the shrine wall on the seventh day after breaking his fast, he was saturated with divine inspiration. He did not feel as though he was the one doing the painting. He felt as if he was merely the hands of the divinity, and through him they painted the images they desired—a feeling the Obaluaye women shrine painters had expressed before him. Oyebamiji was convinced he was nothing but the mouthpiece of the divinities, enabling them to express themselves through his hands.

When Campbell initially encountered Oyebamiji's work, he was baffled because the painting questioned his important assumptions about shrine painting. According to him,

> I was looking for shrine painting in Ileṣa, literally combing the town,
> when I stumbled upon Oyebamiji's work. I was surprised. As a matter of
> fact, I was reluctant to talk to him. I felt his work was not done with
> "traditional" materials as in the shrines I saw at Ife. His work is in
> enamel paint. He did not fit into my notion of shrine painting. When I
> later examined the work more closely, I concluded that the design was

not at all different from the shrine painting in Ile Ife, despite the different materials. [Oyebamiji and the shrine painters] use figures, dots, circles, and other geometric shapes in similar ways.

Campbell has since taken design lessons from shrine painters. He says his first major lesson was to understand their penchant for impromptu manipulation of space without using techniques for creating the illusion of depth, such as perspective, proportion, and modeling contours. His approach to composition has changed considerably since he encountered shrine painting. He has also discarded the Western techniques of illusory depth, finding the immediacy of the shrine painting technique more honest to the material and more visually stimulating, if less illustrative than in Western painting.

Since Campbell's interest does not lie in illustration and other forms of mimetic arts, he has adopted the flat surface of the picture plane as his frame of reference. Within that space he freely elaborates on forms sampled from the shrines he has seen while interjecting his own witty visual innovations. His use of textures is unparalleled, and his infinite manipulation of the subtle nuances of soil hues is not only poetic but musical in its arrangement of color chords.

WE CAN SEPARATE CAMPBELL'S WORK INTO FOUR CATEGORIES, based on his exploration of materials. The first category consists of pieces produced from imported materials, mainly oil and acrylic plus some water colors (Fig. 5.5). The second category consists of work made solely with soil pigments and binders (Fig. 5.6). The third category consists of work made with soil pigments combined with imported alternative art materials such as raffia, seeds, beads, bones, and similar materials. The fourth category consists of work produced from soil pigments combined with conventional art materials such as oil and acrylic paints (Fig. 5.7). In all of these categories he ignores the spatial relations he learned from Western art in favor of a Yoruba perspective that ignores laws of monocular vision. The result is a series of paintings that recall shrine painting while functioning within the tradition of easel painting.

Campbell's work thus becomes a bridge between two major traditions— African and Western—erasing the boundaries and blurring the edges while projecting new possibilities and adaptations. He claims to have one leg in the sacred world of the shrine painters, with their belief systems and dogmatic usages of mythological symbols and ritual calendar, spirituality, transcendental orders, and communal benevolence; his other leg he places in the secular world of postmodern art, with its defiance of belief, rituals, order, and dogma, its individuality, vulnerability, and paranoia. Moving away from both traditions, he becomes an alien in an iconological diaspora on a perpetual home trip. His forms parade fragments of the worlds from which he is departing while reflecting visions of the world toward which he is going.

TRAVELING ALONG THE SAME DIASPORA ROUTE is Moyọ Ogundipẹ, whose work maps the course of alienation that defines the journey into the unknown. Unlike Campbell, Ogundipẹ does not use the soil pigments with which shrine painters work. Yet he is able to achieve the swinging and fluid form associated with Yoruba shrine painting even though he paints with Western materials such as acrylic and oil. Does he consider himself a Yoruba, a Nigerian, or an African artist? He replied,[4]

5.5 Bọlaji Campbell, *Àbíyè* (Safe Delivery), oil on canvas, collection of the artist

5.6 Bọlaji Campbell, *Ojú Inú* (Inner Vision), terrachroma on canvas,
collection of the artist

5.7 Bọlaji Campbell,
Ènìyàn Ń Wojú
(People Only See the
Eyes), mixed media,
collection of the artist

It is futile to classify me as a Yoruba, African, or Nigerian artist. I am a
human being. I am an artist who happens to express myself in the mode
of painting. I paint the intense mystery and beauty of this world, the
symphony of life, from the atomistic to the cosmic, the perfect orchestra-
tion of the universe—this is what artists do, whether European, American,
or Asian. We try as human beings to express the deepest joys and sorrows,
the feelings and the emotions of this harmony.

But is the universe perfect? Ogundipẹ answered, "Both perfect and imperfect.
The perfectness of a petal of flower at full blossom; the perfectness of the
setting sun, orange like the yoke of an egg; the perfect parabola of the rain-
bow. The song of the birds."

But aren't all those "perfect" entities he describes transient and futile to
hold on to? He said,

> The beauty of the rainbow is that it is transient. It is a magic moment. It
> should not last forever. The beauty of the butterfly is in its impermanence,
> its metamorphosis, its cycle of eternal growth and death. Imagine that so
> much beauty, so much intense beauty is lavished on something that won't
> last forever, something so small, seemingly insignificant, like a butterfly,
> that such amazing beauty has been invested in such a transient object!
> That is the whole essence of beauty, an intensity that is almost magical; it
> is like a climax, the condensation, the distillation of experience, the
> enactment of a magical moment. It cannot be permanent. That is why it
> is so beautiful.

But these are all references to grand, universal representations of art and identity.
Is he Yoruba in any sense, shape, or form? He said,

> I think I am everything. I am a sum total of all these elements. I am
> Nigerian. Nigeria is, of course, a geographical creation of the colonial
> master, but then it exists as a political and cultural entity. I am influenced
> by Yoruba art, as well as the art of others who make up the geopolitical
> entity called Nigeria, called Africa. I think I am the better for it because
> I can draw from such a diverse cultural ground. I can borrow and adapt
> from the Nok, Islamic culture, the *uli* of the Igbo women, from Yoruba
> traditional carving. I am African. We seem different from and exotic to
> the West, and there is something in that mystery that has inspired a lot of
> great art. I can identify with that mystery because it is a kind of rhythm.
> The same kind of rhythm you find in my art you may also notice in

Shona stone or in *Kente* textiles from Ghana. You may find similar
designs in the *adirẹ* of the Yoruba and in *Adinkra* designs. So I am a being,
a man, a human communicating with other humans.

Does his work explore the mythologies of the human experience, then? Or
does he focus on recording daily events? He explained,

> Myth? Yes and no. We as human beings find ourselves in this strange
> environment called earth, going through the cycles of life and death,
> wanting to justify our mundane experiences, and wanting to tell stories
> about our lives. We want to explain our purposes and goals in this alien,
> sometimes hostile, often beautiful environment. So there is that element
> of storytelling, of myth making in my painting. But I strive to go beyond
> that. I try to recreate from nature using the principles of nature. These
> are principles based on designs, on patterns and images from my experi-
> ence, from the depths of my soul, from the Freudian territory of my soul.
> I try to invoke images using colors and forms and lines. I try to distill and
> condense my feelings as a human being, as an artist, on canvas using
> colors. I evoke memories and places and feelings words cannot evoke.
> There is that poetic musicality in my work because I let the spirit move
> me. I seldom prepare any elaborate sketch. I let the spirit of the canvas
> move me. I start with a simple line, a little dot, and allow that to trigger a
> kind of chain reaction, to lead to other things. It might be a green square
> that triggers other colors or other forms. I work with little quilts of
> feelings, with which I break down the surface of the canvas into odd
> shapes of varying sizes. I work on each section and try to create move-
> ments and directions, all in that tiny piece.

Has his Yoruba background helped him to formulate the sensibility he de-
scribes? Or would a typical American or English artist have experienced what
he has, and would such a person make paintings similar to his? He said,

> I started in the classical Western traditions of life studies, imaginative
> compositions, portraiture, and art history, and I think everything helps.
> But I have gone beyond all that. I have evolved my own style. I have
> tried to seek influences from my own roots. I have tried to find a
> synthesis among my training, my exposure to the art of other people, and
> the diversified beauty of my own indigenous traditions. I am striving to
> produce an art that is a genuine reflection of me, as well as a universal
> statement.

Are there not icons, such as horsemen, kneeling women, birds, and many
other decorative motifs, directly lifted from Yoruba sculpture in his work? He
explained,

> First, I love Yoruba traditional carving. I have commissioned some
> life-size pieces. I have worked with traditional Yoruba carvers. I simply
> love the forms of Yoruba traditional carving. That is my heritage. That is
> what I can borrow from. That is why you see influences of Yoruba
> traditional carving in my work. But then, my earliest experiments were
> with European classical forms and traditions, like Greek and Roman,
> because my father studied classics and understood Latin. I grew up in a
> house full of books on Greek and Latin culture. Those books are beauti-
> fully illustrated. Even though I could not read Greek or Latin, I was able

5.8 Moyo Ogundipe,
*Soliloquy: Life's Fragile
Fictions,* acrylic on
canvas, Denver Art
Museum

to copy the illustrations in the books. I simply enjoyed flipping over the
pages and looking at the illustrations as a child. My earliest influences
were from the illustrations in those classical books. As I grew up, I was
able to see similarities among the Greek, the Roman, and the African
traditional sculpture. I just allowed myself to open up to all of these
influences in my work.

Since he was born in a Yoruba town in 1948, wasn't his "European" home life
an island within a more traditional Yoruba community? He replied,

> It was a hybrid experience. I lived with young men and women in a
> Christian school compound. Because my father was a teacher, we lived in
> one school compound or another. We were surrounded by the larger
> community of villages with their herbalists, masquerades, diviners,
> markets, and Ṣango worshipers. We even bore traditional names. You
> could not really separate the school from the larger society. Everybody
> was from the larger society. But then I grew up on an island with very
> shallow waters. So the villages and the schools intermingled all the time.
> My training in the schools, which were always Christian, taught me that
> masquerades are for pagans. But this did not forbid me from going to the
> palace and watching the pageantry of masquerades. I saw it for the
> entertainment value. Maybe somebody else saw the religious value. For
> me it was simply drama, performance.

Do the colors of his paintings hint at the spectacle of masquerade perfor-
mances in terms of lavishness and texture? He replied,

My colors are African, free, full, unrestrained, vibrant. There is restraint in terms of technical application, but the effect is a loosening of spiritual restraints. There is considerable improvisation. There is the element of jazz, of musicality. I repeat a lot of things to generate rhythm. At first I was worried that I repeated things so many times. That I should be more innovative. But then I discovered that there is rhythm where there is repetition. Repetition is easy on the eye and draws you into the picture. It is predictable, yet it may also surprise you.

5.9 Mọyọ Ogundipẹ, beginning to paint *My Fictive Self,* acrylic on canvas

Does his work, as an evocation of Yoruba performance, expand the Yoruba canon? He explained,

I am a Yoruba artist of the twenty-first century living in America. An artist in diaspora, both psychic and physical. I am physically removed from my home for economic, political, and technical reasons. Our economy collapsed. It was run aground by our corrupt military rulers. My home country, Nigeria, is not free politically under the military despots. I need a free environment like this, as an artist, to grow my talent. I can show my work to a larger, more sophisticated audience in America. I also have the chance to see what my peers and other artists from other parts of the world are doing. I have access to buy materials here. I did not have that in Nigeria, where art materials are expensive and scarce. The political atmosphere here creates an environment without fear of molestation. All of this is in the physical realm. The psychic aspect is that alienation from home—family, water, smell, sight, sun, warmth, dust of home. There is the feeling of isolation in the diaspora, a sense of vulnerability. There is also a longing, a hunger and loneliness that ener-

gize and boost the diaspora feeling. It all makes it more profound. What
you miss physically you make up for in psychic compensation. It does
matter where I live. If conditions were right at home, I probably would
not have left, and my work would probably look different. Maybe
working with images in Nigeria, surrounded by family and friends in
the valleys and hills of Yorubaland, smelling the scents and seeing the
colors and lights of home would make my work more African, more
Yoruba? Maybe I would simply be differently Yoruba.

Could he be totally Yoruba? Would he want to be totally Yoruba? He said,

How totally Yoruba can you be, even in Yorubaland, given the extent of
exposure to Western art and education? You can live in a Yoruba village and
still read books on Picasso and watch movies by Woody Allen. I always try to
strike a balance between the two. I come from two seemingly conflicting
cultures, but I still manage to reach a synthesis. Every experience en-
riches my practice, adds to the sense of who I am and who I am not.

Is *Celestial Immigrants* (Fig. 5.10) a Yoruba painting? He replied,

Originally, I was trying to adapt an etching (Fig. 5.11) I did last year as
the basis for this painting. But the media are so vastly different. My
interpretation of the etching has to be different, and the final painting
turns out to be different from the etching. That transformation from
etching to painting has posed a lot of challenges, different problems I had
to find solutions to. Part of it was the bird I had on this female personage.
Initially, I thought it was going to be overkill. Maybe I did not need the
bird. First, it's a little bit big, so it is prominent in the painting. You see
the female figure, then the bird stands out. It looks like the focal point
when you look at that woman. It faces the left-hand side. Most of the
images face the left-hand side. The bird is looking down toward the
vegetation and the sad face toward the left. I stood back yesterday when I
painted it and checked it out. I found it doesn't belong. It did not
conform with the mood, it did not rhyme with the rest of the painting.
So I took a risk, I said let's wipe it off the canvas. And in conformity
with the surface of the forms, of the images of mythical animals, marine
monsters and fishes, humans both male and female, I changed the painting
of the bird. I decided to simply use patterns instead. Flowing patterns,
geometric and organic shapes, colors and shades all help to enrich the
bird. You just don't see the bird taking your attention away from the
general flow of the painting anymore. It becomes integrated into the
painting. You simply see the female forms, the tattoos, the decorations, the
scarifications, the beautifications, the breaking down of the anatomy, the
dissolution of the forms, the structure of the architecture of space.

It recalls Yoruba textiles, as well as the fluidity of Yoruba shrine painting done
by the women. But it is so much more detailed than shrine painting. Beyond
textiles and painting, why did he bury an Ọlọwẹ house post in the body of
the painting? He responded,

It is my way of showing my admiration for Yoruba sculpture. I had a
number of works and artists to explore but decided to select this [Ọlọwẹ
house post] for two reasons. First, it is an extremely beautiful, very elegant
work. Second, it is vertical and would fit very well into the format of my

painting. More than anything, I chose it for its visual power. It is an
excellent piece of sculpture. It is a pillar. A house post. I remember
growing up, traveling with my father from Ado Ekiti to Ise Emure, towns
located in the Ekiti hills of Yoruba country. We would pass by the palace
of the Ògògà of Ikẹrrẹ. As a child I remembered seeing these massive
posts arranged in rows. I always looked forward to the experience of
seeing these house posts at the king's palace. And we did pass by that
place frequently. My father was the headmaster of a secondary school in
Ise. The school was situated between two warring villages, Ise and Emure.
That is why it is called Isẹ-Emure Grammar School. The site picked for
building the school was called Oduruduru. It marked the point where
fierce battles between the two towns were fought. Because my father was
a prominent member of the town, one of the most educated men around,
and a member of the elite, I had access to the palace of the Arìnjalẹ̀ of Isẹ
and remember seeing some Ọlọwẹ sculptures in his yard. I did not know
at that time that Ọlọwẹ was going to be famous. I had no idea that forty,
forty-five years later I would be talking about one of those sculptures and
incorporating it into my painting. It is a familiar image to me, and in
my recollection of Yoruba art in diaspora I decided to begin with the
familiar before moving into unfamiliar territory.

5.10 Moyọ Ogundipẹ,
Celestial Immigrants in
progress

What motifs attracted him in the particular Ọlọwẹ he chose? Ogundipẹ said,

First, I love the equestrian figure. I love the way Yoruba artists have seized
the image of the horse and adapted it, stylized it, and reinvented it. The

5.11 Moyọ Ogundipẹ,
Celestial Immigration,
etching, courtesy of the
artist

Ọlọwẹ is one of the most magnificent forms of the equestrian figure that I have seen. It is an elegant form representing a noble person. The bearing, the carriage, the headgear are paraphernalia of power. The skill that has gone into the rendition of the sculpture is astonishing. The equestrian figure is mounted on a pedestal that looks like a divination tray. The abbreviation, stylization, exaggeration, and reinvention of forms are convincing and delightful to behold. The artist has refused to copy life as it stands but creates his own forms to represent aspects of life. From life he creates something new, making it up, imagining it, imaging it. Maybe Ọlọwẹ is sculpting some of the local heroes who fought in the notorious Oduruduru battles. Isẹ was close to both Ọwọ and Benin, two major art centers. Even though horses were not used during those battles, [the horse] was a symbol of power in Isẹ and Emure in those days and was sculpted by the artists. It was not a symbol of transportation so much as an image of power. And the horseman is powerful, as he has several women with him. Behind every successful man there is a woman. In the case of the horseman here, he has three women supporting him. They are not just carrying him, they are raising him. They carry everything, horse and rider, and with them the horse is ready to ride into glory. The horse stands on the divination tray, suggesting that the horseman is standing on his own fate. There is a symmetry, a balance, delicate architecture of space that are tough to capture, an impossibility to copy. In terms of sheer mass, the top segment of the work is heavier than the bottom. That goes

against the pattern of the viewer's expectations. But it gives it a rare kind of fragility and sway that suggests movement, almost as if the horse is on the spur of jumping forth. As if ready to leap, to move. That curve adds a lot of dynamism to the work.

5.12 Moyọ Ogundipẹ incorporating Ọlọwẹ's *Jagunjagun* (Warrior) into *Celestial Immigrants*

Surely he has seen African American artists such as Howard Smith incorporate the icon of the horseman into their compositions (Fig. 5.13). How legitimate is it for black artists born in diaspora to use images such as the horseman in their work? It seems that under the promotion of the various Candobles in Brazil and the nurturing of the Santeria culture in Cuba, these African religions and cultures have developed and preserved flamboyant aspects not unavailable in their mother continent of Africa. Has the land of diaspora been more fertile for the germination of Yoruba art and culture, even more than its homeland at present? Ogundipẹ responded,

> We must keep in mind that these people were displaced, in Cuba, Brazil, and even the United States. Because they were displaced, their fervor for the remembrance of what they lost and what they left behind in Africa plays a strong part in their lives, in their religions, their food, their thinking. The sheer fact that they were displaced under such brutal circumstances, enslaved, and transported across the Middle Passage, forced to work as slaves on plantations in hostile environments under hostile masters is very traumatic. They had a great need to constantly

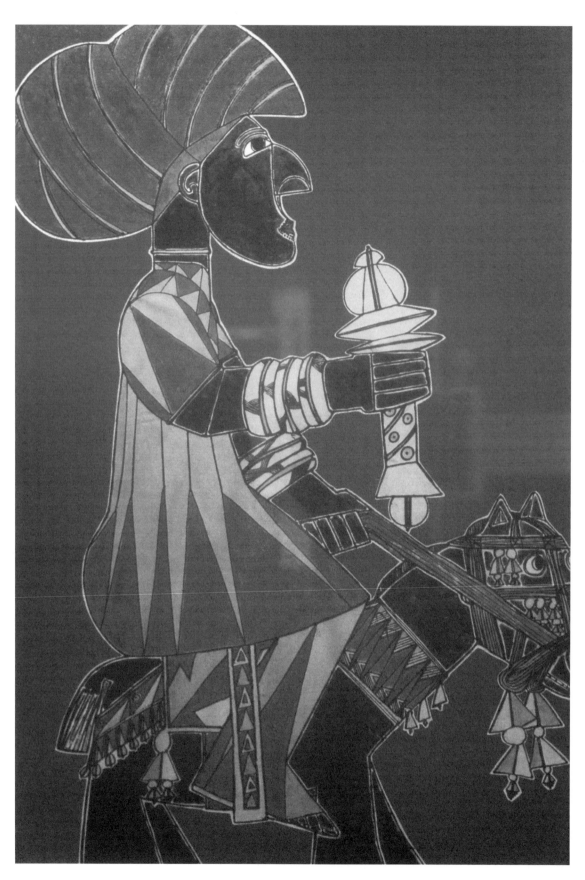

5.13 Howard Smith, *Horseman*, silkscreen, courtesy of the artist

remind themselves of where they came from and to strive to preserve whatever they could from Africa.

But should it not be more difficult to develop Yoruba culture outside of Africa? On the contrary, the Yoruba culture does better in diaspora than it does at home. For example, it is easier to get an excellent *bàtá* drum made in Cuba than in Oyo, Nigeria. He explained,

> These people in diaspora have moved from Africa to the West and are now able to enjoy the advancements in technology, science, and education available here. They came to a more production-oriented society. The combination of the longing for the past, the longing for home, and the longing for an African identity takes them back on a constant emotional voyage, back to Africa. At the same time, they now reside in a new world that was white, Spanish, French, and Anglo-Saxon, a totally different land. And they are taking their traditional rituals and their arts of Africa and transporting them into the Brazilian, Cuban, and U.S. cultures. The conjugation between Africa and these other cultures has actually helped in keeping alive and vibrant the African components of these diaspora cultures.

But doesn't such a conjugation also exist in Africa? Since colonialism has made Western culture so much a part of Africa today, why is the cultural fervor any different than it is in Cuba, Brazil, or the United States? Ogundipe said,

> The Middle Passage was a harrowing experience for slaves, and a life in bondage on the plantations was no better. The enslaved and displaced people needed something to make life meaningful, to make them feel human and not just expendable commodities as the slave holders made them feel. They were people with feelings and emotions, with pasts, a present, and a future. The zeal to hold on to the past is greater here in the diaspora because of the feelings of brutalization and alienation. When I was in Nigeria, in Yorubaland, before coming here there were a lot of things I took for granted because they were always there. I saw masquerades on an annual basis during festivals. It was not until I left my cultural home in Yorubaland and came here to the United States that I really began to miss these things. I now constantly think about the things I'm missing. They now have more impact on my life, on my attitude and beliefs, than they had when I was in Nigeria. That is the irony. Now that I am physically removed from home, the things of home mean so much more to me. I think the act of being physically removed is compensated by the kind of nostalgic thinking, ideas, and remembrance that go on in my mind today.

For both Ogundipẹ and Campbell, the longing for Africa after their relocation called for a sense of invention, a spirit of experimentation, and a rich fountain of imagination. These same qualities inspire the works of other Yoruba artists who have relocated to the West because of the political turmoil that gripped Nigeria. Some, such as Rotimi Fani-Kayọde, left Yorubaland for Britain as soon as the 1966 military coup occurred. Rotimi, son of the famous Yoruba politician Rẹmi Fani-Kayọde, excelled in installation art, performance art, and photography, producing images that constantly refer to Yoruba mythology (Fig. 5.14). He studied in Britain and the United States, and his art

5.14 Rotimi Fani-Kayọde, *Bronze Head*, photograph, private collection

insistently explores issues of his identity as a person from and in several worlds. He observed, "Even in Africa, my education was given in English in Christian schools, as though the language and culture of my own people, the Yoruba, were inadequate or in some way unsuitable for the healthy development of young minds. In exploring Yoruba history and civilization, I have rediscovered and revalidated areas of my experience and understanding of the world."[5] He was particularly fascinated by the Yoruba divinity of health, endemics, and epidemics, Ọbaluaye, whom he used frequently in his art (Fig. 5.15) after becoming ill from AIDS, the complications of which he died from in London in 1989.

5.15 Rotimi Fani-Kayọde, *Sonponno*, photograph, private collection

5.16 Ọlabayọ Ọlaniyi,
Mask, mixed media,
courtesy of the artist

Many other Yoruba artists, including Ọlabayọ Ọlaniyi, the son of Twins
Seven-Seven, left Nigeria for the diaspora at a much more mature age than
Fani-Kayọde. Ọlaniyi had imbibed more of the Yoruba culture before emi-
grating. He incorporates electronic circuits and beads into masklike compo-
sitions (Fig. 5.16), recalling Jimoh Buraimoh, whose works Ọlaniyi saw as a
child. Ọlaniyi also produces masquerade performances within museum set-
tings in the United States and has performed at several important cultural
institutions, including the Fowler Museum in Los Angeles and the Elvehjem
Museum in Madison, Wisconsin.

The sculptor Taiwo Jẹgẹdẹ and the installation artists Fọlạke Shoaga and
Dele Bamgboye were residents in London even before the brain drain began,

5.17 Fọlake Shoaga,
*Like Something Not Very
Concrete*, installation,
courtesy of the artist

whereas the painter Osi Audu moved to London as part of the early tide of that drain. Their nostalgic longings for Africa can be explained in terms of their romantic desire for a culture from which they have long been separated. Others who have only spent brief moments of their lives in Yorubaland also long nostalgically for an Africa they hardly knew, an Africa they wished they knew better.

Thus Shonibare creates nostalgic masquerade versions of European masterpieces, as in *Mr. and Mrs. Andrews Without Their Heads* (Fig. 5.18). The sculptural life-size rendition of his work appropriates both the British painter Gainsborough (*Mr. and Mrs. Andrews*) and the Yoruba artistic performance form of the *agbégijó* masquerade, where the satirical representation of the European couple is a standard act. In a picture shot in western Yorubaland, the performance scholar Margaret Drewal captures *agbégijó* performers donning Western garments and holding each other with affection and open admiration (Fig. 5.19). Because Yoruba people consider it ludicrous to display such open affection, the *agbégijó* masquerade act is a satire on the tendency of Europeans to cuddle publicly without shame or shyness. In a series of photographs, Shonibare extends the masking metaphor much further by clothing himself in costumes and positioning his body in satirical situations in the company of costumed Europeans in Victorian times (Fig. 5.20). The photographs are also reminiscent of the *agbégijó* masquerade, as the performances are based largely on the switching and changing of costumes, as in the *agbégijó* performances.

Taiwo Jẹgẹdẹ produces robust wooden sculptures clearly influenced by the Yoruba sculpture tradition of Dada Arowoogun, Ọlọwẹ Isẹ, and Bamidele Arowoogun. He concentrates expressive forms around concentric features

5.18 Yinka Shonibare, *Mr. and Mrs. Andrews Without Their Heads,* mixed media, courtesy of the Stephen Friedman Gallery, London

such as the head and buttocks, giving his work a wry wit that reveals the humorous and pleasant character of the energetic sculptor. Osi Audu is infinitely more intellectual, his work boldly combining the intellectual depth of the Ifá divination system with deep formalistic experimentations (Fig. 5.21).[6] His drawings and paintings become cryptic searches for meaning, as in the mythological interchange between priest and devotee during oracular consultations.

The inventive spirit that energizes the works of these artists does not consider diaspora a place of tragic loss, as the Yoruba philosopher Ọlabiyi Yai has rightly said. Diaspora is not catastrophic but simply different—a place for invoking novel forms of identities and images. According to a Yoruba proverb, "*Orúkọ tó wu ni là á jẹ́ lẹ́hìn odi*" (Beyond the border of your native land, you are free to choose and change your own name). A person may totally reinvent his or her identity in an alien land.

Yoruba artists who have relocated to the West use this license to reinvent their identities to construct a new world from a blend of their past with a taste of their future. Art for them is a celebration of a Yoruba renaissance, albeit in a new context, with new materials, new interpretations, and new concepts yet still based on the exploration of ancient forms, ideas, motifs, and myths. As Africans in recent migration to the West, they feel a different type of pressure

5.19 Margaret Drewal, *Yoruba Agbégijó Masquerade*, photograph

5.20 Yinka Shonibarę, *A Day in the Life of a Victorian Dandy*, color photograph, courtesy of the Stephen Friedman Gallery, London

than African Americans or Afro-Brazilians or Afro-Cubans who were not raised in Africa and who enjoy citizenship in Western countries. But as Chapter 6 indicates, the African artists who recently migrated to diaspora lands, and even some Afro-American artists born in the West, have come up with similar solutions to their nostalgic longing for an elusive Africa as they adopt Yoruba images to celebrate the dawn of a transatlantic African renaissance.

5.21 Osi Audu, *Juju,* mixed media

6
TRANSATLANTIC RENAISSANCE
Reclamation, Retention, and Returning From Diaspora

> they die of it
> this longing for their country
> young ones who will not eat
> old ones of crippled stature
> sit by the waters of an afternoon
> humming their prayers into the ocean.
> —RACHEL E. HARDING

> A son of Chango had allied himself with Santa Barbara, as cultural camou-
> flage, but surely, in a profoundly witty orchestration of spiritual similarity.
> —ROBERT FARRIS THOMPSON

inally, here comes the slow and magical hour of homecoming for a soul raised in diaspora land. Michael Harris is strolling along the meandering ocher streets of the ancient city of Ile Ife. As he deliberately saunters through the deepest recesses of the legendary town, he gawks at all those ancient-looking compounds, where the brown adobe houses seem to grow like plants from the ground as if they were not buildings fashioned by human hands. The edifices appear planted by the gods and watered for centuries to make them assume their present shapes, textures, and colors. The mud walls seem patiently sculpted, with their rough-textured, undulating wings into which are cut tiny windows and low, dark doorways. Domestic animals including chickens, goats, and dogs casually stroll around the compound grounds, almost as if they were conducting their daily inspections of the people. The sun has gone down, but it is not yet dark, and a subtle display of blue-purple clouds spreads across the

red-orange sky. People are idling, seated or standing in front of their houses relaxing after a day's work, or leisurely doing their final errands before turning in. Clad and naked kids run around excitedly, chasing one another, burning their last bursts of energy before the end of day.

As Harris takes in the idyllic landscape of Ife, his mind is simultaneously taking a walk in two cities in the United States—Washington, D.C., and Atlanta, Georgia. Awed by the virtually surreal feeling of the experience, he comes to realize in a personal way the Yoruba proverb purporting that life is a journey. A traveler is able to proceed along different roads at the same time as long as he or she knows where he or she is going. And sometimes, as now, the roads seem to carry the traveler along with them, as they now lead Harris along three avenues whose paths crossed in his own body well before he began traveling along them. He still cannot believe he is actually walking the streets of the ancient city because it is a city along whose lanes he always walked in his biggest American dreams. But to put on actual traveling shoes and walk in real life around the city of Ife was beyond his wildest imagination. And now it is being realized right before his feet, as he gawks at people who stream in and out of the adobe buildings with roots in the bowels of the earth.

He is still grappling with the concepts of *orí* and *àyànmọ́*. Could it all be in the *orí* (which is virtually synonymous with *àyànmọ́*)? *Orí* means the head in both its outer and inner manifestations. Sometimes you want to go in one direction, and you find yourself moving in another direction. When the calamities of life tackle you down, if your *orí* is good you can still resculpt yourself with your own hands and continue on the journey of life. The opportunities of life often present themselves as calamities, and in the process of confronting them you could become stronger, richer, and better prepared for the future.

Puzzles rather than answers fill Harris's mind as he surveys the Ife landscape that looks strangely familiar, even though he has not been here physically before. Yet can it really be true that this black boy born in Cleveland, Ohio, is actually walking along the legendary streets of Ile Ife, a place he encountered among the pages of books at Howard University? His mind flashes back to July 14, 1948, as if he had been present at that moment. He was born to a young nurse and a bus operator in one of the biggest industrial cities of the twentieth century. Cleveland was part of America's heart of steel, an area stretching as far as Pittsburgh built around the mining pits up in Michigan. Cleveland formed a steel manufacturing center for producing parts of machines, mechanical engines, machine tools, and accessories such as ball bearings for the motor industry. "In a 500-mile range," said Harris, "you could take the ore, process it, and turn it into some kind of industrial product. So many people worked in those factories, and the auto industries were very important."[1]

The biggest plants included General Motors and Ford, whose presence was larger than life at that time in Cleveland. The city of Cleveland, with a population of about 1 million in 1948, was largely built around the needs of the steel factories, which attracted blue-collar workers like magnets from all over the United States and Europe. Harris worked in the Ford plants during college summers. When the Soviet tanks rolled into Eastern Europe and Hungary fell in the 1950s, immigrants from Poland, Czechoslovakia, and other

parts of Europe came to bolster the growing European community of blue-collar workers in Cleveland. At the same time, there were large Jewish and Italian communities, as well as some Mexicans and Puerto Ricans. People from West Virginia were moving up from the Appalachians; African Americans tended to come in from Alabama and Georgia. Harris's mother, Caroline, moved from Cincinnati with Harris's grandfather in the 1940s when she was in high school and her mother had just passed away, and his paternal grandparents migrated up from Georgia. Ollie Harris Junior, his father, was born in Cleveland. Grandad Ollie Harris Senior was a preacher, but Michael never knew him because he died before Harris was born.

The African American population in Cleveland constituted more than 40 percent of the city's 1 million people. There were integrated schools in Cleveland in the early 1950s when Harris began kindergarten, and he remembers attending integrated institutions all through secondary school—well before the Brown decision in 1954 that enforced integration. Cleveland's eclectic and mobile economic class structures made it one of the more racially accommodating large cities in the United States. In Harris's classrooms the student population was always multicultural, with blacks and whites at about a fifty-fifty ratio and occasional Asians and Hispanics. Cleveland elected the first black mayor of a major U.S. city during the late 1960s. Carl Stokes, before he became a popular politician, lived a block from Harris's house, and Michael remembers that his father and Stokes were acquaintances. He bears no memory of any racial brutality as a child, and he did not feel persecuted or vulnerable as a black. Harris grew up with a healthy psychological attitude bereft of ethnic animosity and inclined toward middle-class Christian values. He spent the first twenty-eight years of his life in his cradle city but left in the 1970s and never returned.

Cleveland has lost the prominence it once had on the industrial map of the United States. From the swelling 1 million plus in the 1950s when Harris was growing up, the population fell by about 300,000 in the late 1970s when he was ready to leave for greener pastures. Harris said,

> As the auto and heavy industries began to shift overseas—and we had more Japanese and German imports, we had more steel manufacturing in Japan and other places—those jobs that kept Cleveland big and prosperous dried up, and people began to migrate elsewhere. Since a lot of the migrants came from the South, and with the nice changes occurring in the South, people like myself found the southern weather appealing.

From 1967 to 1971, Harris went to Bowling Green State University near Toledo, Ohio, on an athletic scholarship. Sports ran in his family. His maternal grandfather had made history in competitive sports in 1924 as the first black to win an Olympic gold medal. Since age five, Harris had wanted to do nothing but play baseball. His Olympian grandfather had mentioned Bowling Green to Harris, who won a scholarship to play baseball for the school. It was difficult at that time for black students who wanted to be athletes, largely because scholarships were scarce and the environment was hostile.

> I had confidence problems because I was the only black student on the baseball team for four years. And at that time we already had the Black Power movement really taking off, Afros, the clenched fist of the Black

Power signs, a lot of racial tension. We began to agitate to get the school to recruit more African American students. . . . I was in the middle of all that cultural turbulence. Vietnam protests, drugs began to show up. When I got to Bowling Green there were about a hundred black students, and most of them were athletes. By the time I left, we had gotten the number up to about 500 through efforts to reach out to high schools to recruit students.

Needless to say, the political interests of the few black students in the school did not always receive the blessing of the overwhelming majority of students and authorities, giving rise to much racial tension on campus. All of this affected Harris personally and began to threaten his dream of playing baseball as a student and a potential professional.

I was not comfortable a lot of the time because racism on campus was sometimes virulent, but oftentimes it is in the way people assume the world to be, the way they naturalize whiteness, when they just didn't take any other way into consideration. So I felt alienated in a lot of cases, but then because of the hippies and liberalism, a lot of whites did try to reach out, and a lot of people met in the middle, with the Woodstock generation and the Jimi Hendrix kind of music and people smoking marijuana together. It was a time of transition that generated different types of relationships. There were the exclusive conservative white fraternities and sororities that I felt very isolated from as my baseball mates began to join them and I couldn't. . . . My baseball dream was not about to happen.

He joined a black fraternity, the Omega. Since he could no longer consider baseball as a possible profession, he was faced with two options: to study English or art. He loves words, so literature was a real option, but he had enormous problems with the focus of American literary studies on British literature at that time. He found the British authors exotic and their writings obscure and removed from his immediate cultural flora.

If I majored in English, I would have to read nineteenth-century English literature. And I find it to be horribly dry. Also since I had never been there [Britain] and was never a part of that society, all the minute descriptive detail was not something I could relate to. I didn't feel I wanted to read more Charles Dickens and T. S. Eliot and all that. At that time, black authors were not considered part of the canon. I wouldn't have gotten Richard Wright and James Baldwin and Jean Toomer. I wouldn't have gotten much of Hemingway back then either. So I said, I'll choose art. I like that too.

It did not occur to him at the time that the cultural terrain in art could be similar to that of literature. Although he was reading black literature almost as a subversive activity, he never thought of the visual arts in terms of black or white races. He did not consider that he knew of no great black artists. It just seemed natural that the only names he knew were those of white artists, almost all of them male. He now wonders why he never asked himself, "Where are the rest of the folks?"

It was only after I got into it that I started to consider black art versus just "art." When I was in school I loved the abstract expressionists. I loved

the Impressionists, and people like Van Gogh and Gauguin are still my favorite artists. Certainly [Gauguin] was a horrible person. I just wanted to paint. I began to see things differently by my junior year. One of the relatively well-known black artists at that time had graduated from Bowling Green, and he was an athlete. Then I began to notice black art in magazines and became more interested. I was painting black subjects and trying to do some political things in my art. So I began to nurture an awareness of creating art that relates to our sense of the community. By the time I was a senior, I was well along that path. The department chairman argued with me about the fact that there was no black art. There was no such thing, there could be no such thing. And I believed there could be. I just thought the art would reflect who we were and how we thought, [would] show black subjects, and would have a black political consciousness. And the more I learned, the more I discovered that he [art department chairman] was wrong and I was right. That there was a whole school of art out there that was invisible. One of the most revelatory publications was *Black Artists on Art* that Samella Lewis published. It was not until much later, in graduate school, that I knew about famous artists like Bearden and Douglas. There was no way to find out about them when I was an undergraduate. They were not taught, and no books were available on them. They were not shown in the galleries, nor were their works in any of the museums.

Harris graduated in 1971 with a burgeoning political consciousness. The atmosphere outside the campus was different. Within Cleveland, he merged with the racially diverse populace milling about, too involved in their daily business to focus on the subtle patterns of racism that might be displayed. In 1971, with its groovy soul music and discotheques, the social, economic, and political atmosphere was in a state of flux, giving room for much optimism and enthusiasm among those trying to climb the ladder of success in the United States.

Like a strategic crossroads to the South, North, and Midwest, Cleveland—with its red and orange soil, lush green leaves, and busy downtown—was as perfect a place as any for a young black man to settle, earn a living, and raise a family. He decided to marry and take root in Cleveland, settling down to life as an art teacher in the public schools. Cleveland combines the flavors of its myriad immigrants almost as much as Washington, D.C., in a way that is not fully impersonal but also not sleepy and safe. Ile Ife, where he now stands, on the other hand, lives in the realms of fantasy and legends, where folktales and magic emanate and stories of ancestral heritage mingle with racial and self-pride.

And yet, it is real. The reality lies in the fact that Ife people of all descriptions, men and women, old and young, are milling around Harris as he makes his way to the compound outlying the king's palace. He is going through, perhaps, some of the oldest parts of Ile Ife, where traces of ancient potsherd pavement floors still decorate ageless, open courtyards. Indigenes regularly dig wells for water and bring up brass and other archaeological objects, which they convert to personal use rather than turn them in to museums. Ife is truly a different world from Cleveland or Washington, D.C. Yet strangely, something about Ile Ife recalls Washington, D.C. The former is the spiritual capital of a black civilization, and the latter is the political capital of the West.

Harris did graduate work at Howard University in Washington, D.C., receiving a master's degree in studio art. It was a spiritual quest, a crucial step along his long journey to Ile Ife. He had visited Howard with a friend, and there was an exhibition of the work of the Harlem Renaissance photographer James Van Der Zee at the Fine Art Gallery.

> I had just seen those same photographs in *Harlem on My Mind,* a book my uncle had. The photos, as you know, are of Harlem in the 1920s and 1930s. It was just so wonderful for me to see in person the work I had just read about, work by a black artist. . . . Howard was going to be something new, something I needed and was hungry for. So I immediately . . . planned to attend Howard in January 1974.

Living in the nation's capital was an experience far beyond Harris's imagination. Graduate school gave him an opportunity for crucial years of intense political and aesthetic ferment of ideas while studying at Howard. He met or saw some of the most powerful members of the U.S. black community, who came to Howard to articulate their ideas to the black students. His time at Howard was a period of both spiritual and artistic realization, when he began to develop an artistic identity with a humanistic hope. He encountered the works of some of the best African American artists of the twentieth century. He said,

> I knew there was the best possibility of finding out more about black art at Howard University. Sure enough, many of them [black artists] were right there at Howard. I met Jeff Donaldson [the leader of AfriCobra]; Skunder Boghosian, the Ethiopian great; and so many more people. Plus I saw my first exhibition of contemporary African art. Kojo Fosu [the Ghanaian art historian] created that show. A whole new world opened up to me, and I felt grateful.

He mingled with some of the most organized radical black artists of the 1960s, who were plotting out new directions for the 1970s. He went to as many exhibitions of black artists as possible during a period of intense radical posturing by those artists, who were struggling to become visible as he was striving to analyze their works. His stay in the nation's capital was as much an opportunity to study art as a chance to get to know himself better in a new metropolis.

> I got to work with Jeff Donaldson [from 1974 to 1979] and Skunder Boghosian, and it just made a tremendous difference in my outlook. At that time I was influenced by the work of Will Barnet. There was a coolness in his work, and I think it reflected a great sadness in my life. At Howard, Skunder began to push me to loosen up, but it took a long time for me to feel comfortable with loosening up. I started adding patterns to my work. I started looking at North African patterns and Egyptian works more closely. That gradually started my process of loosening up. It was a wonderful experience for me.

Harris was attending perhaps the leading black institution in the United States, which implied that he could not ignore the political atmosphere of the time, especially in the nation's political center, Washington, D.C. The predominantly black neighborhoods palpitated with anger, disbelief, and ulti-

mately shock, with a profound sense of bewilderment and confusion. The sense of despondency, especially among black youths, following the death of Martin Luther King Jr. was real and paralyzing. If the murder of Malcolm X was interpreted as a violent end to a prophet who advocated judicious employment of violence but still left the people with Martin Luther King for leadership, the assassination of King was far more devastating. His advocacy of nonviolence was incongruent with his death, which left blacks in disarray and with no single voice or leadership.

> I had come from a working-class environment. People worked hard in mills, factories, and things like that. But Howard also had this bourgeoisie history, and that class of the African American community often had the financial means, the education, and the leisure to explore certain cultural outlets. Duke Ellington, for instance, was from Washington. You had this old black community that goes back to before the turn of the [twentieth] century. I began to find exposure and access to all of that. Then there is the wealth of museums and libraries in that area. More than that is the human wealth—meeting people, seeing prominent and successful African American culture workers, whether they be writers, filmmakers, or artists. And also to be exposed on campus to people from the entire African world—Africa, Caribbean, Mississippi, and California. At Ohio in Bowling Green the students tended to come from Michigan and Ohio, a few from maybe Chicago and Indiana, but it tended to be a Midwestern student body. But at Howard I found an international student body. It was a broadening experience. It was liberating because I did not have to deal with racism. I only dealt with how we felt as a people, our common language, our common expression and problems. The richness and diversity of African peoples without having to experience the reduction into black and white. So it was just a liberating and wonderful experience. I got to see black excellence. Haki Macebuti was on the faculty. Donald Bird worked with the Music School. Tony Brown was helping to develop the School of Communications. Lois Maillou Jones was there, just getting ready to retire. My environment was incredible. When I did my master's thesis, Al Smith and Malkia Roberts were my advisers. James Phillips came in as an artist in residence.[2]

As the political pessimism among blacks in the inner city of Washington, D.C., increased, the artistic culture burgeoned. The integrated Jimi Hendrix music was out. From the black community emerged the new "gold": music. The environment changed as the music industry finally began to push black sounds; and great new individuals and bands such as James Brown, Aretha Franklin, Earth, Wind, and Fire, the Supremes, and the Jackson Five signaled the arrival of popular black music. Black films such as *Shaft, Cotton Comes to Harlem,* and *Uptown Saturday Night* were box office successes. But black literature had yet to blossom as it now has, even though many colleges were beginning to study the works of Ralph Ellison, Eldridge Cleaver, and Amiri Baraka. The visual art scene fared even worse because art galleries were mostly closed to black artists, except for a few like Romaren Bearden and Sam Gilliam.

Two contrasting forces were pulling at each other in the visual arts dynamic among blacks in the 1970s. One was the negative reception to black art in the United States, and the other was the attempt to push black art by

enterprising and resourceful black artists. To open an avenue for discussion and creativity among black visual artists at the time, people explored alternative means to the galleries that closed the doors to them. In particular, the themes of social and political consciousness, as well as community awareness and involvement that interested many black artists, irritated the generally white curators of mainstream museums and galleries. Embarrassed by the subjects of black art, white mainstream art critics averted their gaze, and the black visual artist remained unacknowledged and invisible. To make members more visible, several groups of black artists emerged, the most prominent of which is AfriCobra. At Howard University, Michael Harris studied with the leader of AfriCobra, Jeff Donaldson, and later become a member of the group himself.

ALTHOUGH BLACK ARTISTS WERE BEING IGNORED AND DENIED in the United States, a positive experience was happening in Africa, specifically in Nigeria. The continent was preparing for perhaps the biggest artistic jamboree in recent African history, the Second Black Festival of the Arts in Lagos, Nigeria. It was the dream of pan-Africanism gradually coming to fruition, initially through artistic insemination and germination. Black artists in the United States were busy preparing for the event, which was supposed to happen in 1975 but was postponed until 1977 because the patron of the event, General Murtala Muhammed, the Nigerian head of state, was assassinated in 1975. Jeff Donaldson was in charge of organizing black artists all over the United States, selecting who was going to represent the country and which works to present in the American gallery in Lagos. The activities of preparing for the African festival, which stretched out over several years, helped to counteract the effects of rejection within the United States among these artists. They had a goal toward which they fixed their attention, making it easier for many to bear the constant rejection in their own country.

Harris did not go to Nigeria with the American contingent, even though some of his instructors—notably Jeff Donaldson and Winnie Owens—made the trip and returned with wonderful stories that sounded like fairy tales. Harris wished he could visit the places in Africa these artists had seen, including Ile Ife where Owens had visited and to which she returned only a year later to take up a teaching position at the local university.

But Howard University is located in the inner city, as are virtually all black colleges established before World War II. The neighborhoods surrounding Howard gradually decayed into urban guerrilla fronts in the period following the death of Martin Luther King Jr. But Howard's proximity to the street did not adversely affect Harris. He said,

> By the time I got to Howard, "the Block Boys" that used to terrorize
> Howard students were more under control but would still mug and harass
> you. We are looking at class warfare. Poor blacks versus rich kids, dark
> versus light skin, whatever real or imaginary boundaries they set up
> between each other, they were out for war. Being in that community was
> not as dangerous by the time I got there. I knew where not to go. Drugs
> had not devastated our community yet. We're talking of the mid-1970s.
> Things like cocaine, crack, those things that have set up the warfare in
> that community, the human devastation we face, we are talking of the

1980s. So the black community around Howard back then in the 1970s was not that bad. Howard is in the northwest [quadrant] of D.C., which was not and still isn't as destitute as the southeast. There were black galleries and artists in the area. Sam Gilliam is from Washington. During the same period, David Driskell had come to the University of Maryland in Baltimore to teach. Things were still happening all over the place.

Harris obtained his master of fine arts from Howard University in 1979 and joined his wife in Virginia Beach for a year before they moved to Atlanta, Georgia, where he was appointed artist in residence at a neighborhood art center. He ran art workshops and managed the art center's gallery for a year before having the opportunity to teach part-time at Moorehouse College. The job became full-time in 1982. He stayed until 1987 and went to Yale to pursue his doctorate. Harris reflected,

> I had been doing some work on curriculum development, since interest in multiculturalism had begun to grow in the United States. I helped the Portland, Oregon, public schools write their multicultural materials. I was revising the curriculum and creating a handbook for teachers . . . that included the art contributions of Africans and African Americans. . . . I felt I didn't know enough and decided to get a master's degree in African American studies. . . . Yale had a good African American program. I knew Rick Powell had gone there. . . and Robert Farris Thompson [was] there, too. . . . The two-year master's program was . . . interdisciplinary, so I got to study Caribbean history with Kamau Braithwaite, the Jamaican scholar; African American history with John Blassingame; and art history with Robert Farris Thompson. I took African studies from the prominent British anthropologist John Middleton, who had been a student of Evans Pritchard. I began to be aware through Thompson of the African continuity in the art expressions of people in African diaspora. I began to take the Yoruba language, and it all just blossomed into a positive experience.

It is therefore unbelievable to Harris that he is in Ile Ife, the spiritual capital of the Yoruba, years after leaving Howard and now as a research student from Yale University. The first thing he has discovered is that textbook Yoruba language is very different from what people actually speak. The rhythm of the naturally spoken Yoruba is smoother and faster than what is taught in the classroom. Even the context of conversation is entirely different from the sequences pieced together in the classroom, making everything he learned before coming to Ile Ife seem at first ridiculous and unnecessary. But on second reflection, he realized that the classroom situation mitigated his culture shock, which could have been profound had he had no Yoruba language classes.

The most immediate and exacting shock is culinary because he is not prepared for the texture, color, and taste of Yoruba food. Yoruba people eat little meat, with most of the diet consisting of vegetables, carbohydrates, and plant protein. Fruit is seldom eaten with meals but is regarded as a snack. Milk is rarely consumed. The people eat sparingly, and the nature of dining parties depends on the size of the family and the type of home. Harris's host is a bachelor who does his own cooking.

His host's apartment is located at the outskirts of town, far from the king's palace. Its location and architecture could be described as middle class in

Nigeria. The apartment forms the upper part of a house that has another apartment below, both of which are occupied by Nigerian artists. The artist living in the apartment below is Wale Olajide, known for his silk appliqué work.

Harris had heard about the famous hot pepper of which Yoruba people are so fond and had asked his host to prepare a particularly hot dish so he could experience the notorious potency of the Yoruba spice. The Yoruba people have a song about how whites are unable to stand the strength of the pepper in their food. The song, in pidgin English, is a farce:

> Òyìnbó pepper
> He no dey eat pepper
> If he eat pepper
> He go yello more more
>
> [Caucasians hate peppers
> They don't touch pepper
> Should they eat pepper
> They turn red and redder.]

Harris has found, to his bewilderment, that people have been mistaking him for òyìnbó, the term reserved for Caucasians. His host reassures him that Yoruba people have a special way of defining identity based on ethnicity and not on race. He explains to Harris that by reading his spoken and body language they define him as a Caucasian type, which is why they call him òyìnbó. To claim that he is not òyìnbó, he must eat the local pepper diet and not turn crimson.

Although Harris demands the hottest dish possible, his host knows better and prepares three sets of dishes. The first is the full dose of pepper he ordinarily consumes himself. The second contains the tiniest bit of pepper, the quantity served to toddlers to introduce them to pepper. The last contains no pepper. His host serves Harris the one with the smallest bit of pepper.

The host tastes the dish containing the full dose of pepper. Harris, served the mildly peppered dish, scoops a fork full of rice and turns red and purple and back to red. His mouth ignites with an explosive fire that burns everything within. For three days after the meal his mouth remains on fire, thus commencing his culinary shock. Even after six weeks in Yoruba country visiting shrines, talking to artists, listening to elders, witnessing rituals, consulting divinations, commissioning works of art, making friends, taking photographs, taping interviews, asking questions, and riding around on barely passable roads, he still does not enjoy the Yoruba diet. In Ile Ife, with nothing in sight that he wants to eat, he craves a large pepperoni pizza with cheese topping. He appreciates how very American he is as he begins to interact with other American and European researchers and students in Ile Ife. When he returns to Atlanta after his visit, he has lost thirteen pounds and is hungry for the customary American diet.

The physical toll the trip to Ile Ife had on Harris's body was instant. His fasting intensified the visit, making it transcend a routine academic field trip or tourist visit, and the entire experience has produced a spiritual effect and afterglow. Africa revealed a different side of his identity, something that is multiple and impossible to define in words, something that released a hidden

mood in him. The mood continued to mature and grow—provoking him, filling him with a fuller sense of being while causing him to pause and reflect before drawing any conclusions. That, he thinks, is what the Yoruba people use their proverbs for. The distance created between the proverb and the real world demands abstraction, which only reposed reflection can provide. A painting could be a visual proverb, a way of reflecting on the world, of abstracting human thoughts and communicating metaphoric aesthetic patterns of reasoning. Like the Akire work in Ile Ife and other shrine paintings he has seen, a painting could also be an altarpiece, a way of communicating with benevolent spiritual forces as part of humanistic and beneficial community work.

> After my experience in Nigeria, the shrine paintings I had seen seemed
> to gestate inside me until 1994 when they burst free and began to change
> my aesthetics from one based on African American quilts and various
> improvisations of the grid and geometric patterns to [one] that emerged
> from the shrine paintings. One that first starts with dark colors as a
> ground, the *dúdú* [cool] with the *pupa* [hot] and *funfun* [cold] colors laid
> on top. In addition to improvising with that aesthetic, I learned from the
> symbolic images that were on the shrines. There was a quality to them
> that was like the hieroglyphics of Egypt, where the images were symbolic
> of fields of information, certain kinds of ideas. This led to the use of
> language in my work. The written language is, after all, using graphic
> symbols to evoke the voice, the sound that makes the word that is the
> sign. So I began to play the one-step image that is hieroglyphics. Like
> the birds and snakes in the paintings, the use of language (Yoruba words)
> in my work led to the exploration of graphics from all over Africa and
> the world. My work is now less structured on grid patterns and more
> with a kind of improvisational asymmetrical structure you find in shrine
> painting.

The work of Michael Harris falls under two types of formal design, the first linear and geometric, the second cyclic and organic. The first type of aesthetic synthesizes his educational and artistic career prior to his journey to Africa. The second commences from the point of his return from Africa, after directly encountering the smells, textures, tastes, sounds, and figures there. His work therefore reads like one long, related self-reflective script that is its own best critic. The relationship between the two major phases of his work is similar to the dynamic between two succeeding designs: each is a critical comment on the preceding one because it strives to achieve a challenge the previous one did not face or fully tackle. To appreciate the critical content of his work is therefore to see how the pre-Akire phase is related to the post-Akire phase. The relationship is not merely a formal experiment, as many may be inclined to think, but a fundamentally different and new way of understanding concepts of reading designs in a totality that transcends the visual to embrace music, poetry, and language.

The pre-Akire pieces based on African American quilt designs are richly embedded with a comprehensive projection and interpretation of the arts. Even though they respect the linear rhythm of the grid structure, they activate rhythms laden with surprising accents and cadences, plus constantly shifting paces. That open-ended structure, even though grounded in a grid field, is like the percussive pace of the bass guitar in jazz. It enables the artist to ex-

plore depths that are beyond the ambits of the classical musician. In other words, Harris's pre-Akire painting is to easel painting what jazz is to classical music—a critical statement on a canon that does not sufficiently explore the possibilities of improvisation, thus curtailing creativity. But beyond that, his post-Akire painting is to his pre-Akire painting what his pre-Akire painting is to easel painting—another critical statement on a phase that does not sufficiently explore the possibilities of improvisation, limiting his creativity. The major difference between the two phases lies in the degree and accent of improvisation.

> My improvisation before I went to Ile Ife was on top of the structure or beneath the structure. My improvisation took a different turn in this sense; I've learned that improvisation is an important characteristic in African life. The whole idea of ìtàn, the story among the Yoruba, is a process of selecting from the àṣà . . . a word that refers to selection of what is to be considered tradition. There is always this selective process that each time changes a little bit, allowing a little room for flow, for movement, for adding some more. There is that aspect of African life and culture that I came to understand as the root of improvisation. Rather than symphonies that may have been written and all you can do is perhaps change the inflection, but you have to play it precisely like it was written. The African improvisation philosophically reflects a collective mentality in the sense that the artist is not just self-involved but is interacting with the audience or interacting with the specifics of the time, and so that is going to change the dynamics of the performance. And as an artist sometimes you improvise with your interaction with the art itself. Because sometimes you see things in a work, and no matter how well you planned it, the interaction dictates that you need to do something else. That is what the musicians do. They interact through the music and play off one another. It is a sense of having ìmojúmọ́ra, an awareness of what is appropriate for the moment. An awareness of not being alone and being part of a system and interacting with that system, whether it be social or just experiential.

The difference between the pre-Akire and post-Akire phases lies in surface versus structural improvisation, respectively. The jazz impulse to renovate, extend, and sculpt stringed fragments of sound was not abandoned after Harris's return from Africa. He enriched rather than suppressed his quilt techniques and aesthetics by reverting to work on paper rather than textiles. He further embedded the paper work with rags of photographs, text, and selected objects. About three years after returning, he produced an eight-color process lithograph celebrating motherhood and femininity entitled *Mother and the Presence of Myth* (Fig. 6.1). It turned out to be a crossroads in Harris's venture into artistic experimentation.

A relatively small work, *Mother and the Presence of Myth* begins from an essentially Yoruba perspective in which motherhood is celebrated and constantly evoked to ensure prosperity and stability in life or, when life is out of joint, to repair it. A masking festival, Gèlèdé, is staged annually in western Yoruba country specifically in honor of mothers and the power and agency of women. During this festival masked men dress as women, wear headdresses portraying them as women, and dance like women. Some wear large carved

6.1 Michael Harris, *Mother and the Presence of Myths*, silkscreen, courtesy of the artist

breasts, often so turgidly pointed that they project phallic implications. With playing bands, the masked dancers perform in honor of women at town centers for several days a year during the Gèlèdé. The women are referred to as "Àwọn ìyáa wa," or "Our mothers." It is therefore revealing when Harris inscribed the 1994 lithograph with the phrase "Oríkì fún àwọn ìyá wa," meaning "Salutations of oriki ancestral poetry to our mothers." The key words àwọn ìyá wa immediately launch Harris into the rituals of Gèlèdé and other Yoruba celebrations of women. One begins to access glimpses into his construction and invocation of female power for his own self-empowerment as a product of female labor. Not until three years later, when he painted *No More Ugly Ways* (Fig. 6.2), did he come to full terms with the theme of motherhood, which he explores in that mixed-media work, fully loaded and resonant with layerings of Akire mythography. *Mother and the Presence of Myth* clearly shares iconographic form and meaning with *No More Ugly Ways,* and it was the beginning of a journey that led to the 1997 mixed-media work.

Both print and prayer, *Mother and the Presence of Myth* contains the iconic spirit of Akire painting in its conception and representation. For the first time, Harris uses the "asymmetrical improvisation" of the Akire altarpieces, thus freeing himself of the gridlock strictures of quilting that had hitherto projected and defined his vision. He redefines his identity with a Yoruba mind, signified by his new Yoruba name Olushina (the Gods have opened and paved the way) and oríkì of Ayinla Opo and the middle name Ọlọnade—placing himself firmly in the lineage of wood carvers, complete with a genealogy of sculptors who carved mighty òpó architectural house posts. These are the famous sculptors who transform things from the raw to the sophisticated, who work wonders and improve community life with the use of their minds, symbolized by their hands. Their dictum insists that Ọwọ́ ẹni ni a fi í tún òrò ara ẹni ṣe (You employ your hands to transform your life).

The hand, positioned in the middle of the print as the central icon of identity, is therefore conditional to an understanding of Harris's *Mother and the Presence of Myth.* That primacy is visually signified by the placement of a left hand, the mother's hand (in Yoruba thought), on the very heart of the composition, almost as an oath of allegiance to femininity. It is a declaration of his support for the mothers, daughters, and sisters of men, as well as a proclamation of responsibility. He has decided to take things into his own hands, control his own situations, take the moment and turn it into eternity. The hand thus becomes the metaphor for the effort he has taken, both signifying and commemorating that initiative, a point of reminder as well as a binding spell. The openness of the hands is a welcoming gesture, a readiness to embrace as well as to reach out, a gesture of undisguised honesty as transparent and warm as Harris represents it in *Mother and the Presence of Myth.* At the same time, it is a defensive shield for the vulnerable heart of motherhood he so strongly cares for. The radiating bones of the fingers are a second set of ribs over her precious heart, protecting it from the view and harm of ayé, or the inimical ones. As much as the hand offers protection against the machination of diabolical forces, so does it threaten to offend those who raise their hands against motherhood.

As an oríkì, a long poem albeit visual, the print must be systematically explored for its multiple layerings of meaning, fully embedded into the iconic

6.2 Michael Harris, *No More Ugly Ways,* mixed media, courtesy of the artist

complex. The eight-color process allows Harris to bury strata of iconic fragments one color after another until the plenary body of the print emerges. Perhaps as striking as the hand are the two figures that define a strong diagonal line across the center of the entire print, in the middle of which lies the open palm. At the upper left section of the print, to the northwest of the hand, is the image of a bird sampled from the Ọbaluaye Shrine. It is one of the many avian figures that populate and thrive in the altarpieces, signifying the power of women in general and the grace and elegance of the bird figure, with its commanding beak features and elaborate tail. These ornamentations are metaphors of female body decorations and the magnetic appeal of women, as well as an indication of the potency of female power.

At the other end of the diagonal line, positioned at the bottom right side southeast of the equatorial hand, is a childhood picture of Harris's mother. The picture is a sepia-toned print, smokily grained with soft-edged lines and a poetic, dreamland mood. It is evocative of a near distant past, witnessing a moment of history shared with posterity. At the same time, its euphoric peacefulness conveys a sense of openness and honesty the palm presages. The magic of time traveling reveals itself on a piece of paper, as the past is now printed into the present and thus imprinted into the future. This mother, the first symbol of adulthood, savvy and secure, is now presented as a child, innocent and vulnerable, a somewhat disorienting representation. This unmediated projection of the past into the present disrupts the immediate stability but provides a more three-dimensional image of motherhood, not only as a parent but also as a sibling, not just as an adult but also as a child. The hidden inner part of the mother becomes exposed, and a taboo appears broken. Now that you can see before you were born makes it seem as if you have been in this world long before you actually arrived. Time forfeits its controlling minutes and seconds and yields to alchemy, where anything is possible and the oldest mothers can become babies again. That which time labels old is found at heart to be a mere child. Time lies, yet only time will tell what it has dutifully concealed when the right time comes.

The diagonal line across the print is thus the line of motherhood, connecting the left side of the composition to the right, the top to the bottom, the light with the dark, the text with the image. For only when that line of motherhood is followed does it lead, like a umbilical chord, from child to mother, as well as from bird to child. The child at the bottom of the print is both the mother being celebrated and the spirit of all children who in time will celebrate motherhood. It embodies the eternal youthfulness and appeal of motherhood, which both bird and child signify. The ideographic rendering of the bird further lends to the illusion of artlessness and lack of sophistry, hence promoting the appearance of innocence and transparency. What could be more transparent than the film from which the serenading sepia tones of the photograph are printed or the layered films of color superimposed to build the translucent body of the bird?

The sheer positioning of the bird and the child at extreme poles of the diagonal line proposes a direct line of communication between them. The intensity of that communication increases as the viewer realizes that the bird's beak points directly to the child's head. Soon the shifting qualities of light affecting the prints begin to toy with depth. The bold outline emphasizing

the chest and belly of the bird suddenly pulls the figure nearer the viewer, and the soft-edged, nonlinear picture of the child seems apparently distant in space and time. The child now seems to be looking at the bird and contemplating the future in a dreamlike fantasy suffused with light, smoke, and buoyant apparitions of images and text. A form of mythological interaction is transpiring between them as they break down the barriers of differences—including those of language, time, and space—to communicate thoughts and vibrations, transcending mortal limitations. It is a glimpse of eternity as bird and child are engaged, and the mysterious essence of each protagonist is multiplied by the electrifying impact of the encounter. The momentous dimension of this engagement fills the entire surface of the prints with cosmic charges.

As if to protect the child from the bird's strange knowledge of the wild, the hand remains in waiting, ready to intercede if need be. The hands seems to gesture to the bird to keep its distance, not to leave but to stay up high where it is, away from the child. The child's innocence is what the bird seems to recognize and want. At the same time, the child seems to recognize the free spirit of the bird, its ability to bridge gulfs and fly away into the stars and moon. Next to the bird's head, Harris positions a poetic firmament populated by twinkling stars and a moon shaped like an upturned boat. Addressing the bird with her utter silence, the child sees possibilities beyond her own body, recognizes the symbolic nature of her feet and arms, and sees that they really are wings with which she could fly. As a child, she addresses her child the printmaker, telling the bird what she wants it to tell time, to tell Harris.

Both the stars and the slice of moon are sampled from Akire altarpieces. Taken from the same source is a python that stretches out in a languid zigzag formation to frame the right side of the composition. Another borrowing from the Akire altarpiece is the frame running across the top part of the print like a subordinate frame, preparing the viewer for the end of the composition while iconologically linking the print to Yoruba traditions of mythological prayer painting. Because the shrine painters speak and sing while they paint, Harris inscribes text into the composition, at the top of which is a Thanksgiving prayer, "A dúpẹ́ o," meaning "We thank you." He is now giving thanks to all mothers. Here he is referring back to the "àwọn ìyá wa" he mentions in the line directly below the open palm. At the right side of the print, like a margin running parallel to the snake, Harris positions the Yoruba word of invocation, àṣẹ, meaning "power, sanction, amen, may it be so." In the same brown color as the writing is a cosmic symbol that could be a sampling from Yoruba tattoo design, Kongo cosmography, or Benin or Haitian chalk drawings. The symbol unites all of these black African cultures into one simple visual signification of the world as a gigantic crossroads, with cardinal points marking the four corners of the globe.

Although *Mother and the Presence of Myth* is a visual poem and takes specific iconographic sampling from the Akire altarpiece, it does not really project itself as an altarpiece. Even though Harris considers this work a process of communicating with forces that are sometimes invisible and more powerful and transcendental than human forces, he continued to make such prints and paintings before beginning to make paintings he now regards as shrine pieces. Every painting is either a shrine on its own or part of a shrine complex. It took about two years after he began to sample figures from Akire altarpieces

before he created the first of the shrine series, entitled *Family Shrine* (Fig. 6.3), in 1996.

Family Shrine is an *oríkì* visual poem, although its title clearly indicates it is also something beyond a visual composition created merely for the sheer aesthetic pleasure of painting. The mythological references to Akire altarpieces are clearly indicated, both in identifying with the spiritual traditions of the altarpieces and in employing the asymmetrical forms of Akire painting. Beyond this, however, is an evident desire to create an original altarpiece. *Family Shrine* was completed in 1996, a year in which Harris experienced considerable creative release. He had completed his doctorate program at Yale University and was divorced from his second wife. He felt free from the rote of dissertation writing and the tension of a sour marriage. *Family Shrine* can be seen as the culmination of creative energy released by his feeling of freedom.

Infinitely more textured than *Mother and the Presence of Myth, Family Shrine* contains a wider range of materials—including actual photographic prints, sand, coins, and paint—in addition to the text and cosmographic images largely drawn from Akire altarpieces. In this painting Harris limits himself to the *pupa, funfun,* and *dúdú* colors used by Akire painters. The high energy of the white dominates the composition, which is unified by the red tones of *pupa* and darkened and shadowed with *dúdú* color. The coins are pale *funfun* dots of various sizes on dark *dúdú* backgrounds.

The viewer's immediate impression upon encountering the shrine/painting is to regard it as total formlessness. The figures seem to be flung and scattered over the entire space of the canvas with a reckless abandon that allows no sense of order while breeding an organic looseness in the composition that lacks planning. To anyone conversant with the forms of Akire altarpieces, however, the form of *Family Shrine* is familiar. It is actually meticulously planned after the organic rhythm sustained by Akire painters, where figures radiate to the viewer with varying intensity.

The figure with the most intense radiation in *Family Shrine* is the bird. It is a beautifully drawn, elegant figure on tall legs, with toes fanning out and a tail in a graceful pattern suggestive of the peacock. This poetic bird is beyond any single bird because it also has the beak of a woodpecker and a highly attenuated set of shoes for an avian figure. Represented in profile, as found in the Akire altarpieces, the bird is contoured with a red line meticulously and flawlessly laid out around its body. Fine rows of *pupa* red dots line up in arranged queues all over the body of the bird, except for its bare head and tail.

The irony of discovering such a carefully crafted unit in such a chaotic atmosphere becomes apparent when one conducts a meticulous geometry of the bird. The bird's measured topography suggests that the painting itself contains a hidden topography that can be carefully excavated and read. In that reading the spatial relationship of the various bodies in the painting becomes much more apparent, as they all form a giant triangle from which several smaller geometrical figures are projected.

The glowing, pale colors of *funfun* dominate the arms and body of the triangle around which *Family Shrine* is formed. At the apex of the triangle are the moon and stars, with the upturned canoe shape of the moon glowing against the dark shades of brown in the background, terminating the top of

6.3 Michael Harris, *Family Shrine*, mixed media, courtesy of the artist

the pyramidal substructure. At the two angles forming the base of the triangle are two photographs, the one on the left side that of a single person, whereas on the right is Harris with his two daughters. The rectangular edges of the photographs are reshaped into irregular contours from which the figures in the photographs materialize. Along the base line of the triangle is a picture of a girl wearing a long, pretty dress, hugging a huge book she is reading as she confidently stands in front of a tall hedge, her head pensively cocked to one side. She seems oblivious to the photographer and consumed in the book, which seems to be a large children's illustration book, just right for her age of eight or nine. She adds a homely touch to the painting, expanding upon the theme of the family picture at the left.

The family picture shows Michael playing the role of a doting father to his two daughters, seated at the dining table. It is an interior domestic scene that sharply contrasts with the exterior shot of the young girl in a pretty frock. The close-up and horizontal format of the intimate interior scene is also in contrast to the full-length, vertical exterior shot. The emotional relationship among the three people at the table is clearly intense, as the father bends over his daughters to help them. These pictures seem similar in many ways to those in the 1994 painting, since both appear to focus on the issues of family, spirituality, and collective destiny.

The most remarkable difference between the content of *Mother and the Presence of Myth* and that of *Family Shrine* is the latter's reference to Christianity. Here we see a mass-produced iconic print of the risen Christ with hands extended in a gesture of blessing and reassurance to a genuflecting follower. Christ is depicted in a rather stiff and surreal manner that suggests he is levitating, even though his feet remain on the ground. The tense atmosphere of anticipation and awe that colors this print projects a religious divinity in which Christianity is unquestioningly and innocently embraced. That indiscriminate and naive acceptance of Christianity must be read in the context of the surrounding figures, which are based in *òrìṣà* tradition. In other words, the Christ Harris is presenting is not simply the jealous Medieval monarch but a more multicultural, savvy Christ who is ready and able to share space with different faiths without compromising his message and integrity as the friend of the friendless, the helper of the helpless. Harris has rediscovered a new Christ in Akire altarpieces who is not monotheistic but who falls within a larger polytheistic pantheon. This is an accommodating, understanding, human, and more loving Christ who is truly dedicated to the salvation of his followers.

As the photographs, birds, and moon form the major triangular structure of the painting, a marginal circle is formed by subordinate figures, beginning with the slight curve of the mythological arrow at the top left corner of the composition. The curve of the arrow flows into the curve of the moon and continues on the other side of the composition in the body of Ifá, the signature marks pressed in *funfun* color on a dark background. The circle then continues into the cosmographic representation of the global crossroads below the Ifá signatures, overlaps the major structural triangle, then joins the collection of coins. Flowing through the dark open palm and returning to the left side of the composition at the bottom section, the subordinate circle once again overlaps the major structural triangle, picking up the bow and arrow on

the left side of the composition before joining the tail of the arrow where the circle shoots out of the composition. It is a rough circle indeed, meandering over a wide surface both to rope in several figures within its loose configuration and to disguise its ovoid shape with an amorphous appearance.

Located beyond both the triangular and the circular structural patterns is the only written text in the composition. Printed in big capital letters rendered subtly in sepia tones on a background of similar tonality, the text reads as *ORIKI,* meaning praise poetry. It is an echo of the text from Harris's 1994 print, which spelled out in shy handwritten letters *"oríkì fún àwọn ìyá wa."* Harris has moved from using uneven handwritten letters to even, printed letters, which contrast sharply with the organic terrain of his painting surface. The singular word *oríkì* shows that the work is not only a visual poem but addresses his entire family rather than just his mother, as in the 1994 print.

This is the first time Harris regarded his work as a "shrine," even though since his return from Ile Ife he had been enjoying the spiritual dimensions of art and refocusing his productivity around physical and psychological self-therapy. Harris is using art to release positive emotions and intensities within his psychosomatic system, and from that moment his work becomes a combined aesthetic search with unmitigated spiritual fervor. Every work becomes an altarpiece or a fragment of altarpieces, as in the Akire painting. For him art no longer is mere form. It is a prayer, a way of moving not only nearer his fellow beings with the use of skillfully crafted images but away by communicating with higher metaphysical powers. In his hands Akire painting makes its middle passage across the Atlantic Ocean, following the same route mapped by the human Middle Passage but no longer steeped in bondage. The Americanization of Akire art now transpires in the context of liberty and pursuit of happiness, in an aesthetics of freedom where his personal interest lies in embracing the liberating communal values of a progressive society. Nevertheless, it is contained within a larger sociopolitical culture of modernization or, perhaps more appropriately, metamodernization. It is more than anything else a renaissance of African aesthetics on diasporic American soil.

THIS COMMITMENT TO AN AFRICAN RENAISSANCE IN THE UNITED STATES also informs the spectacular Santeria installation *Achè* (Blessing) (Fig. 6.4) by Israel Garcia, an immigrant from Cuba to the United States. Garcia, a Denver, Colorado–based Santeria practitioner, regards his work as a rebirth of African oral and visual cultural traditions in the diaspora. For Garcia, this renaissance is a gift or a blessing from Africa to the Americas:

> The renaissance of Ọbaluaye, to give Americans good health; rebirth of
> Ochun, to make America fertile; rebirth of Olokun, to make America
> wealthy; rebirth of chango, to protect and defend America from enemies;
> rebirth of Yemọya, to bring America beauty and grace; rebirth of Echu,
> to secure the fortunes of America; rebirth of Ọrunmila, to make America
> wise and prudent; rebirth of each and every one of the 401 *oricha* who
> came down from the other world at the morning of dawn. It is all full of
> *achè,* blessings for America.[3]

But coming as they do from Garcia, who speaks no English and whose Spanish is interspersed with ritual words in Yoruba, the renaissance of blessings is

6.4 Israel Garcia, *Achè* (Blessing), installation, 2000, Denver Art Museum

a benediction emanating from fragmented memories, shattered recollections, and precarious reconstructions of *òrìṣà* in the United States. Spanish, of course is not the original tongue of the *òrìṣà*. The *òrìṣà* divinities speak Yoruba as their first language. Several generations ago, however, Garcia's ancestors were taken out of Yoruba country as captives, enslaved, and brought to Cuba to work on tobacco and sugar plantations. All they took with them were memories of the blessings (*achè*) of their *oricha,* and those memories and blessings have been passed down from generation to generation until they were entrusted to Garcia, whose responsibility as a priest is to pass them along to others. In Garcia's hand the renaissance of African aesthetic values is not merely an academic or an aesthetic issue. It has a deep spiritual dimension that provides direction not simply for people of African descent in the United States but for everybody who seeks to benefit directly or indirectly from the renaissance.

The renaissance Garcia witnesses, proclaims, and embodies has experienced a transformation of African forms and values to reflect the morbidity and rebirth that have taken place in the void across the sea. The transition of the *oricha* across the Atlantic caused substantial transformation, mostly out of necessity because for Garcia the rebirth of Ọbaluaye is Babaluaye, a hybrid between a saint and Ọbaluaye. Ọ ṣ un at her rebirth becomes Ochun, now syncretized with a saint, Ṣ ango who becomes Chango, syncretized with Santa Barbara. This hybridization of divinities is a veritable manifestation of the renaissance, a historic and monumental marriage of convenience between Yoruba beliefs and Spanish Catholicism, a wedding that has produced the syncretic Santeria mode of worship and lifestyle.

This way of life began several generations ago when Garcia's ancestors, discovering that they were slaves in Cuba, found they were not allowed to practice the religious beliefs and values of their ancestors, which ran contrary to those of the slaveholders. Their owners expected them to become Catholics so the owners could feed them with myths of equality before God and salvation after death. Being Catholic, it has often been said, is crucial to the concept of being Hispanic. Since the Yoruba slaves were being initiated into a Hispanic culture, they were expected to become Catholics to give meaning and value to their Latin identity. The slaves were not only discouraged from congregating, they had no time to congregate since during the harvest the average slave labored twenty hours a day. Suicide and vagrancy were common. To project the minds of these enslaved people beyond their immediate plight, the Catholic religion was offered as a promise of luxury and pleasure after death, when they were assured of eternal salvation. The uprising in Haiti, fueled by the religious and mystical forces of "voodoo," made the need to Catholicize the slaves even more urgent. The most abiding form of resistance the slaves explored was to keep their African religions alive but hidden from their captors, who were afraid of these practices and regarded them as devilish. The brutality of the murder of white slave owners by black slaves during the Haitian slave revolution only added to that fear of indigenous African religions, inducing the owners to ban the religions.

But the Africans would not allow their ways to suffer a permanent death, even in the land of diaspora. Armed with memories of their original homelands, the Africans intended to organize a renaissance on Caribbean soil. Given the obstacles the slaveholders imposed, the practical way for the Africans to continue their ancestral ways was through stealth: to keep their ways hidden and practice them secretly. Long adept at masking, the descendants of Yoruba masquerade performers devised a means of masking the African religions within Catholicism. This device worked efficiently because what was being banished—the worship of Yoruba òrìṣà divinities—was being masked under what was being imposed—the worship of Catholic saints. Whenever the enslaved people saw Catholic paraphernalia, they mythologically assumed they were in fact seeing Yoruba cultural materials. They successfully used what was being imposed as a catalyst for promoting and preserving what was being deposed, and the deposed faith thrived under the camouflage of the imposed faith.

Since the end of slavery, the Santeria religion has gained more visibility, but the collaborative relationship between Catholic and Yoruba systems persists. More often than not, the Santeria devotee was also a Catholic, and until recently Santeria priests demanded conversion to Catholicism before novices could be initiated into the Santeria. Even though such demands are no longer made, devotees believe it adds to one's understanding of Santeria rituals if he or she is also a Catholic, whereby he or she could benefit from both Yoruba and Catholic divinities.

With the movement of Santeria into the United States, its Spanish requirement of Catholicism is disappearing as it acquires more English cultural features. Even though Garcia speaks little English and mainly relies on the Latin American community for his clientele, he welcomes everyone to his practice. He is open to ideas beyond the Latin community, and when an

installation of a Santeria altar is proposed to him, his enthusiasm is warm and instant. That was the beginning of the making of *Achè*.

Achè comes from *àṣẹ*, a Yoruba word mythologically linked with divine power. Rowland Abiọdun, in an original interpretation of the concept as a transatlantic manifestation, said,

> *Àṣẹ* is variously translated and understood as "power," "authority," "command," "scepter"; the "vital force" in all living and nonliving things; or "a coming to pass of an utterance," a *logos proforicos*. To devotees of the *òrìṣà* (deities), however, the concept of *àṣẹ* is more practical and immediate. *Àṣẹ* inhabits and energizes the awe-inspiring space of the *òrìṣà*, their altars (*ojú ibọ*), and all their objects, utensils, and offerings, including the air around them. Thus religious artifacts are frequently kept on the altars of the various *òrìṣà* when not being used in public ceremonies.[4]

Garcia's *Achè* therefore stands at the very center of Yoruba aesthetics of altar installations. With *Blessing* as a subtitle, it becomes a positive invocation of *achè*, which could also be deployed maliciously. *Achè*, when used in the context of *èpè* (curse), *ọfọ̀* (incantation), or *ohùn* (spell), could have considerable negative power, which is contrary to the benevolent and positive radiations of Garcia's altar installation.

Garcia's *Achè*, centering around a feast of the gods or sacrifice to the divinities, is a table throne installed to invite the *òrìṣà* to descend and dine. Large quantities of artificial food are carefully presented in plates as offerings to the divinities. Food is one of the most universal articles people share with the divinities, even though they do not always eat the same things. Although there are different cultural aspects to the act of dining, the activity itself has been ritualized in virtually every society. In the Catholic religion the Eucharist is one of the most romantic rituals of dining. Among the Yoruba, each divinity is associated with certain meals, which its devotees must constantly provide as forms of sacrifice. Ṣango, for instance, enjoys the yam-flour meal known as *ọkà*, Ogun likes the taste of *epo* (palm oil), and Ọbatala relishes *Iyán* (pounded yam).

Many rules and regulations are associated with food and eating in different societies. Among the Yoruba, food is a ritual shared between people and the divinities. Every time food or drink is consumed, a tiny, merely symbolic bit of it must be offered to the ground, or *Ilè*, the spatial, architectonic divinity of the earth we inhabit. When Yoruba people are unable to make this offering physically, they must make it symbolically in their minds by uttering certain *àṣẹ* words of power, inviting the divinities to dine with them. It is important that they share the food because if the destructive forces see the divinities eating with the people, they will realize that the people have powerful allies and refrain from attacking. And because people are constantly sharing their meals with the divinities, the divinities will readily come to their defense. Food, like blessings and *àṣẹ*, is to be shared between people and their divinities, just as the Catholic Church displays crops for its divine harvest and thanksgiving ceremonies.

Achè is therefore a ritualistic offering in recognition of the dynamic relationship between human beings and the gods. The symbolic offering made to

the gods is the return of only an infinitesimal quantity of what the deities have provided for the people. In *Achè,* the gesture itself is the message. The plates placed on the altar table are empty, not because the divinities have consumed the offering but because there was never anything on the plates. The symbolic food or artificial, plastic food is placed on the altar not to serve the divinities but to add to the display of color on the altar.

Color is one of the most emotional aspects of Yoruba divinity. The Catholic religion also has its own color symbolism, including the Saint Antoninus system recognized during the Renaissance in which white was equated with purity, red with charity, yellow/gold with dignity, and black with humility. Among Yoruba people, certain colors have mythological associations specific to the *òrìṣà,* and that is also true in Santeria color symbolism, where the divinities are associated with certain colors that are specific to them and refer to their personalities. These colors are brilliantly displayed in Garcia's *Achè.*

All the colors of the rainbow are present on the altar, whose chromatic lines recall the experience of the rainbow. In addition to the colors of the rainbow, *Achè* bears black-and-white strips of color, all made from transparent fabrics. Through the dazzling gossamer, one can view the brilliant explosion of colors emanating from planted floodlights projecting from the center of the installation. These orbs of color are beamed onto a highly reflective backdrop of colorful opaque fabrics whose stripes are color matched with the transparent fabrics spanning the foreground. The entire experience is an extravaganza of color, creating a lavish visual spectacle. This color carnival seems to represent and illuminate the food offering to the divinities, who are invited to dine on the array of prismatic delights, presented as an altar. It is a lavish chromatic feast in which there is more than enough food for everyone, human and divine.

Standing on scepters, images of the divinities are raised like flags amid this brilliant display of color. All the divinities depicted here are regarded as the principal divinities among the Yoruba, and their Catholic corollaries are also prominent saints selected for their special attributes by the enslaved populations, for whom, within their narrowly framed and agonizingly focused lives, every act is symbolic and ritualistic. Although these Catholic icons are essentially masks for Yoruba divinities, they also operate willy-nilly as collaborators, if not conspirators, with the slaves in the subversion of the slavers' system. Nowadays they may be regarded as allies in a multiple cultural complex that is both African and European, both Yoruba and Catholic. Together they have seen the fall of slavery, and even though the old antagonism still exists between the descendants of slavers and the descendants of slaves, as they look forward the future promises more amity and reconsideration in an increasingly Santeria culture.

THIS CULTURE, FOR MICHAEL HARRIS, is another black Atlantic culture he is exploring on a trial-and-error basis—following his instincts, willing to learn, to stumble, to take risks, to explore, to invent. When children stumble, Yoruba elders say, they look forward (to understand the meaning and reason behind their fall); when elders stumble, they look backward. "*Mo ti di àgbàlagbà*" (I am now quite old), as Harris constantly reminds people who are deceived by his baby face. Whether moving forward or going backward, the journey of

life is a spool of thread that often gets entangled, and sometimes the more we try to undo the knots, the more ensnared we become. These knots of life are crossroads along the journey, where the individual must make crucial decisions to fork left or right or proceed straight ahead, where every step takes one nearer to or further from home. The black spiritual singer, thousands of miles from Africa, thus croons in metaphoric images of traveling:

Sometimes I feel
Like a motherless child
A long way from home.

That was the feeling Harris sometimes experienced when he was in Ile Ife, the epicenter of the Yoruba world of Africa, thinking about the United States. Often hungry, he craved the comfort of "home" food. He wanted pizza, bacon, cheese, and all the things he could not have in Nigeria. That same feeling returned when he was back in the United States after his stay in Ile Ife. He began to pine for a spiritual food Ile Ife provided, of which his paintings only allow glimpses now that he is in the United States. In other words, even the United States does not feel like home. Africa does not feel like home, and Brazil, he discovers after several visits, also does not feel like home. Additionally, as he said in interviews, "I did not expect Europe to feel like home, but my mind was open." So where is home? "Home? There is no place on this planet where it is an advantage to be black. *Ayé lojà, òrun nilé.*" In other words, his spiritual being is no longer in any one particular spot but is everywhere, with fragments from the United States, Africa, and Europe. He cannot seek himself in any one of these places alone. He has to look everywhere to find himself. He is not just an American painter or an African diviner or a European aesthete. He contains bits of each of these, combined into a recomposed complex that displays the shards of cultures as some sort of unifying experience. He is not the modern artist on a colonial safari to Africa. He is a global being, a postmodern artist on tour of his rightful cultural domain.

He no longer needs to make physical forms of diasporation. Right there on the streets of Chapel Hill where he now teaches, all he has to do is entertain the thought and he is psychically transported to the streets of Ile Ife or London or Rio de Janeiro or some other cultural capital where he needs or wants to be. His physical journey to Bahia in 1998 is as graphically loaded into the memory of his mind as the one he made to Ile Ife in 1991. Equally impressive and exceedingly nostalgic are his recollections of European cities, even though he has reservations about the repressive political atmosphere in many of them. His global identity thus allows him to psychically globe-trot in a matter of seconds, during which postmodern cultural fragments and collages present themselves. These same collage forms, skillfully improvised, now inform his more recent altarpieces, which have evolved into full installations like the Akire altarpiece in Ile Ife.

The diasporic African culture is now reinventing itself in the hands of Spanish American artists such as Garcia and African American artists such as Harris. These artists are carefully developing a visual art tradition that revives the African Yoruba culture in the United States within a transformed cultural terrain of the Americas. Like African artists of the imposition, opposition, exposition, and emigration periods, these artists live in a period that has raised

the issues of reparation and repatriation, of emigration and immigration, of departure and returning home. Their works—in Africa, the United States, and Europe—testify to a burgeoning African renaissance culture, largely predicated on the revival of Yoruba and other African cultures.[5]

CONCLUSION

hree works will serve as a conclusion to this book because they are visual equations that balance new proverbs on the ageless pillars of African creative traditions. The first work is by Moyọ Ogundipẹ, whose painting *Èlùjù Itú* (Forest of Many Wonders) explores life as a wondrous journey. The second is a painting by Obiora Udechukwu entitled *Our Journey,* which explores human existence as a long, winding, and quizzical road. The third is Chris Vondrasek's sculpture *Èshú Elḗgbára,* which in mixed media portrays the divinity of the crossroads.

Ogundipẹ is a Yoruba artist living in diaspora in the United States. Udechukwu is an Igbo artist from Nigeria living in diaspora in the United States. Vondrasek is a white American artist who lives in the United States. Ogundipẹ's art is an equation that balances Yoruba and Western values; therefore it exemplifies the work of many artists who combine Yoruba and Western

C.1 Moyọ Ogundipẹ, Ẹ̀lùjù Itú (Forest of Many Wonders), acrylic on canvas, courtesy of the artist

ideas, as discussed in this book. Udechukwu's work is an equation that balances Igbo and Western values; therefore it exemplifies the work of artists from other parts of Africa who combine their indigenous creative values with Western ideas. Vondrasek's sculpture is an equation that balances Western and African influences; therefore it exemplifies the work of Western artists who combine contemporary Western values with African ideas. Beyond that, Vondrasek belongs to a Western category rather different from those of Michael Harris, who is African American, or Israel Garcia, who is Latin American, because Vondrasek is a Caucasian American.

Ogundipẹ's Ẹ̀lùjù Itú (Fig. C.1) explores life as a mysterious terrain within which the individual may discover himself or herself as a member of a community whose identity is in constant mutation, even as the road ceaselessly transforms itself. The title of the painting refers to the novel *Ogboju Ode Ninu Igbo Irunmole*, written in Yoruba by the late Nigerian writer D. O. Fagunwa. The novel, which focuses on the odyssey of certain Yoruba heroes into the world of myth, wonder, and magic, was translated into English as *The Forest of a Thousand Demons* by Nigerian Nobel laureate Wọle Ṣoyinka. The English title influenced the title of Ogundipẹ's painting, which he translates into *Forest of Many Wonders*.

The painting represents human existence as not only baffling but also challenging and rewarding. To suggest the puzzling nature of life, Ogundipẹ removes all figurative references from the composition, leaving only cryptic allusions that viewers may find dense and inaccessible. Because the forest may be confusing and inaccessible to those entering it for the first time, life seems like a forest that is constantly surprising those journeying through it, travelers who constantly wonder at the many surprises life presents on a daily

basis. The rather nonfigurative structure of the painting turns the viewer into a traveler who must explore the work in the context of individual experiences and personal expectations.

Nigeria, from where Ogundipẹ made his way to the United States, is the beginning of his journey into the realms of wonder, marvel, and surprise. But if Ogundipẹ found Nigeria baffling to those trying to understand it, his experience in the United States has been a total mystery, perhaps because he came as an adult. His views were already formed, and he constantly finds himself looking at the United States through the tinted lenses of a West African adult. This esoteric perspective allows him to see the United States as a place of enormous wonders, mythic proportions, and total transformation. He regards the United States as a journey into the unknown, an adventure in which he takes one step after another as he tries to figure out the cryptic images the American landscape presents to the curious traveler.

Udechukwu's *Our Journey* (Fig. C.2) is an acrylic on canvas composition completed in 1993. The work is autobiographical and a metaphor of the life of Nigeria as a journey. In this age-old trip, both Udechukwu and Nigeria reached a milestone in the mid-1990s when he painted the work. Nigeria has experienced several milestones including colonization in 1900, independence in 1960, military rule in 1965, and a civil war in 1967. All of these events had a tremendous impact on the life of the artist, who was born in 1946. In the mid-1990s he was engaged in confrontation with military political interests in Nigeria. The ruling military powers harassed and incarcerated him several times for allegedly inciting students to engage in antigovernment activities. He was a professor of art and a prominent cultural figure, and his art was regarded as critical of contemporary issues and government policies. Particularly suspect were his line drawings that document the experience of the country all the way back to the days of the internecine civil war, in which he was on the losing side.

Udechukwu depicts Nigeria's harrowing experience and the story of his own life as a long trip in *Our Journey*. The work is broken into four panels, suggesting the fragmentation of the country as a result of its eventful history. The multiplicity of the panels also reflects the conglomeration of cultures, languages, and ethnicities in Nigeria. From that multiplicity and diversity, a formal unity is achieved when the four panels are placed together to form a single composition. The work therefore becomes a metonym for how the country could either stay together or fall apart if the center no longer holds.

When the panels are placed together, *Our Journey* turns into a long painting that is light on the right side and gradually darkens to the left. From the lightest extreme right panel, a coiling belt of bright orange color makes its way to the left side of the composition. It is reminiscent of the opening words of *The Famished Road* (New York: Doubleday, 1991), a novel by Ben Okri, the celebrated Nigerian writer living in Britain: "In the beginning there was a river. The river became a road and the road branched out to the whole world" (p. 3). The orange belt that winds its way across Udechukwu's fractured canvas, uniting the sections, is not just a road and a river; it is also the plumes left by a jetliner as it flies across the sky. The long canvas then becomes a landscape that drains from east to west, following the path of the sun. That seems to explain why the painting is light toward the east, where the sun rises, and

C.2 Obiora Udechukwu, *Our Journey,* acrylic on canvas, courtesy of the artist

dark where it sets in the west, at the left side of the composition. It was also going to be the direction of Udechukwu's flight when he and his family were spirited out of Nigeria to prevent him from suffering further incarceration by the ruling military power. In 1997 Udechukwu came to the United States for the opening of an exhibition of his work in Washington, D.C. He decided not to return to Nigeria because he was afraid for his life. His trip has therefore been like that of a bird following the rising sun from east to west, as his painting reads.

Udechukwu's art borrows from both Eastern and Western cultures. The canvas and acrylic with which he paints are Western. His imagery and metaphors are African, taken from the traditions of Igbo art of Uli and Nsibidi drawings. According to him, "An analysis of Igbo drawing and painting reveals that space, line, pattern, brevity, and spontaneity seem to be the pillars on which the whole tradition rests. It is these same qualities that I strive, both intuitively and intellectually, to assimilate in my work."[1] When he successfully marries the Uli art of Africa to Western easel painting, as he does in *Our Journey,* the result is a provocative hybrid art that reflects the autobiographical life of the artist, as well as the cultural history of his society.

His journey marks a path many artists in other African countries have taken. Kofi Antubam of Ghana, Sam Ntiro of Tanzania, Skunder Boghosian of Ethiopia, Francis Nnagenda of Uganda, Liyolo M'Puanga of Zaire, and countless other artists have been on that same road that leads to alienation and diasporation on Western shores. Some, such as Nnagenda, later returned to

Africa, but most artists—especially since the 1990s—have remained in diaspora like Ogundipẹ. They have made the West their home, forming a diaspora *nouvue* parallel to the Middle Passage retraced by Michael Harris and Israel Garcia. For Chris Vondrasek, the story is completely different.

In his *Èshú Ẹlẹ́gbára* (Fig. C.3) Vondrasek makes a psychic connection between Western and African cultures using the mythological image of Ẹṣu, the Yoruba god of the crossroads, as the point of intersection. His journey to the junction of Ẹṣu images started in Seattle at a community project called Home Street Home. The project was intended to raise public awareness about poverty, and it gave Vondrasek an opportunity to venture out of his studio and meet minorities, especially blacks, with whom he would not otherwise inter- act through professional and club contacts.

> It gave me a chance to do things that were more engaged with the
> community and more out of the studio–gallery–collector culture that
> hangs something on rich people's walls' vision of art into something that
> is more, art that has more meaning than just as collectible objects. . . .
> Since then it has been more important to make work that has intellectual
> or social connections rather than something that just has aesthetic sense.[2]

To extend the metaphor of moving out of his studio, Vondrasek decided to see the world as his community and to travel to the more needy parts of world, especially Africa, to see things for himself. He chose to go to Zaire, in part because his sister was in the Peace Corps there. He made an extensive

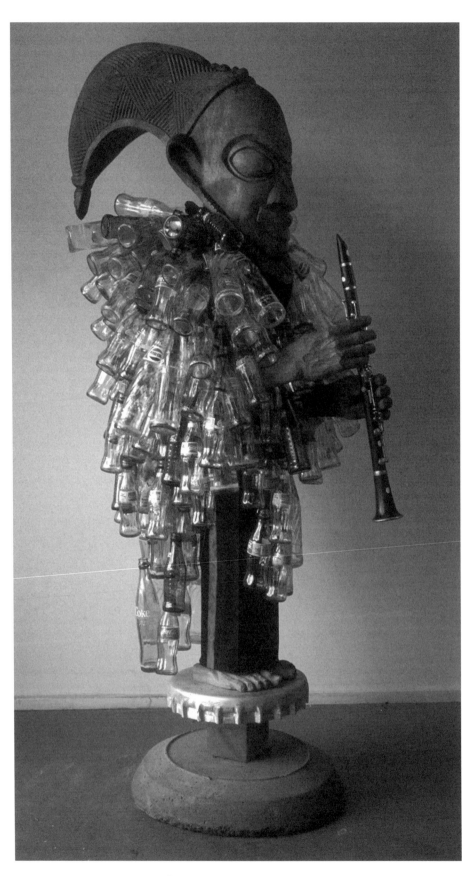

C.3 Chris Vondrasek, *Èshù Ẹlégbára*, mixed media, courtesy of the artist

physical journey to Africa because he did not want to approach it directly without emotional knowledge of African societies. He decided to get to know Africa through its art.

> We drove around northern Europe for a couple of weeks. We visited the Belgian National Museum of the Congo in Brussels. It has a lot of the art the Belgians took from Zaire and Central Africa when they became colonizers. There are also huge exhibits about the agricultural life and the way society was organized when Belgians got there, the way they tried to change it, what plants were indigenous and what plants they introduced into their farming. That museum gave us the background for what might be on the ground when we got to Africa.

His experience in Africa left an indelible mark. Despite the long journey during which he attempted to prepare himself for what Africa would be like, the reality of the place shocked him. He had never been in the midst of so many black people. It was somewhat strange for him to be in the minority, even though that minority had far more power than the peasant majority of Zaire. He found the people's standard of living abhorrent: "The level of government, the amount of corruption, and the way people struggle to survive just forced me to look at things completely differently." He was also fascinated by the strange vibrancy that enlivened the spirit of the people, something distinctive that emanated from within them and made them different from others.

He decided to explore this mysterious presence through his art both within Zaire and after he returned to Seattle, which was what led him to the crossroads of Eṣu. Well after his return, Vondrasek encountered the figure of Eṣu inside his Seattle studio when "I tried to expand my drawings on the people I met in Zaire. I recalled lots of street peddlers selling shoes or fruits or vegetables. I began to draw those people and tried to expand on them. . . . I put African sculptural heads on their bodies or changed their features and made them much more like a carving than a human being."

He also began to read voraciously about African art, particularly the work of Robert Farris Thompson, the gifted Africanist art historian at Yale. Thompson has led many Westerners—white, black, and brown—to the backyard of Yoruba cultural studies because of the convincing power of his writing about Yoruba art and culture. Despite the fact that Yoruba culture has its own intrinsic appeal, the talent and creativity Thompson has brought to the study of Yoruba art constitutes that of a powerful artist whose work cannot be ignored. Vondrasek also found the works of Henry and Margaret Drewal intriguing, as well as the scholarship and insight of Rowland Abiọdun.

> Thompson describes Eshu as "the AT&T of the spirit world," or conduit to the spirit world. There is something mysterious and elegant in an inexplicable way about Eshu's particular form—with the rich line of the hair, the very phallic hair, and this crossroads personage of Eshu. He began to make sense as somebody whose features would be in a drawing. After that it all came together. I bought a clarinet at an auction . . . and since Eshu has a clarinet or bugle in his hand, it would fit in. . . . It wouldn't be someone from the streets of Zaire but that he would wear a tuxedo and the cowrie coke bottles. The transformation just happened

after I began to look at ways of integrating the street people of Zaire with the African sculptural faces.

Eṣu, the Yoruba god of the crossroads, has therefore once again become a metaphor that connects Africa both within itself and with the outside world. He is the divinity that leads the traveler along the journey Henry Drewal describes as "*Aye lajo*" (the world is a journey) and that Udechukwu depicts in his 1993 painting. This same spirit is the one that holds the hand of the traveler negotiating the intricate paths and mnemonic crossroads Ogundipe constructs in *Èlùjù Itú*. This forest is a metaphor for life, not only in Africa but especially in Europe and the Americas, especially following the attacks of September 11, 2001.

Vondrasek's *Èshú Elégbára* therefore raises promise of a different sort of germination of African art far beyond the racial divide and the formal experiments of early twentieth-century European modernism associated with Picasso's work. Eṣu, as he takes the stranger through the confusing crossroads of the world in Africa and in diaspora through African, African American, Latin American, and Caucasian American art, is a living presence that transcends formal studio experiments and becomes a means of knowing and organizing new meanings out of an old world that is constantly changing. Eṣu, as a primal guardian of this fluctuating multiracial and multidimensional transatlantic culture, therefore becomes the spirit of the Yoruba renaissance that enervates this project. In affirmative terms, it answers the question "Is there an African Renaissance?" with which this book began.

CATALOG

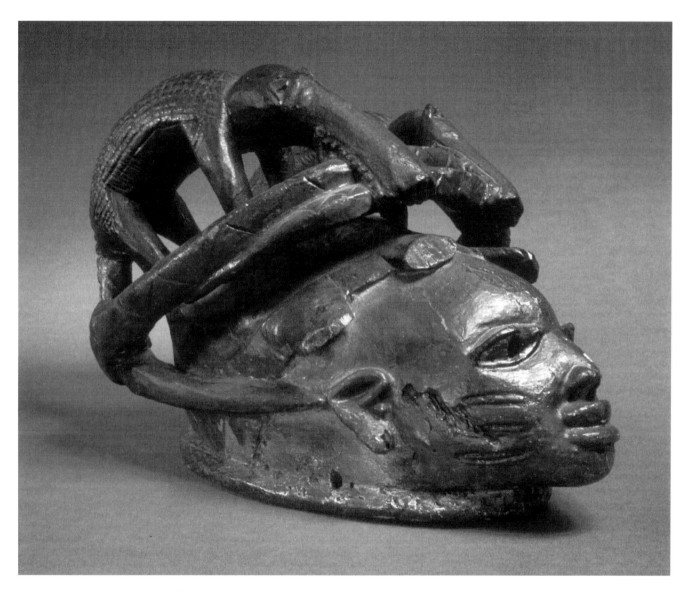

1. *Mask*, Gẹ̀lẹ̀dẹ́ Society, unknown Yoruba artist, early 20th century, Denver Art Museum

2. *Incense burner*, unknown Yoruba artist, N.D., Denver Art Museum

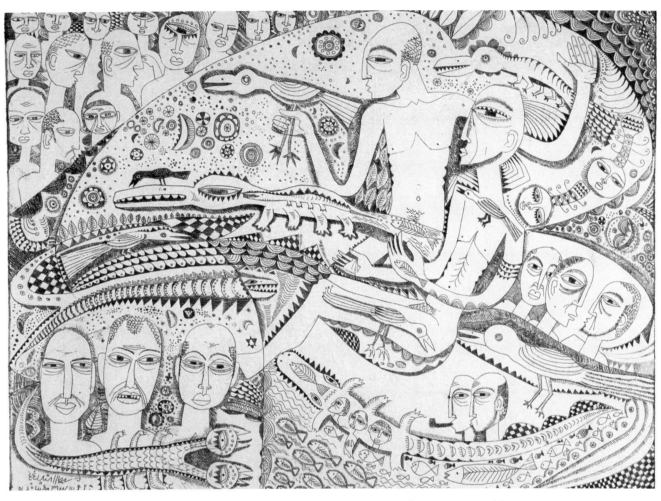

3. *Celestial Immigration*, Moyọ Ogundipẹ, 2001, etching, courtesy of the artist

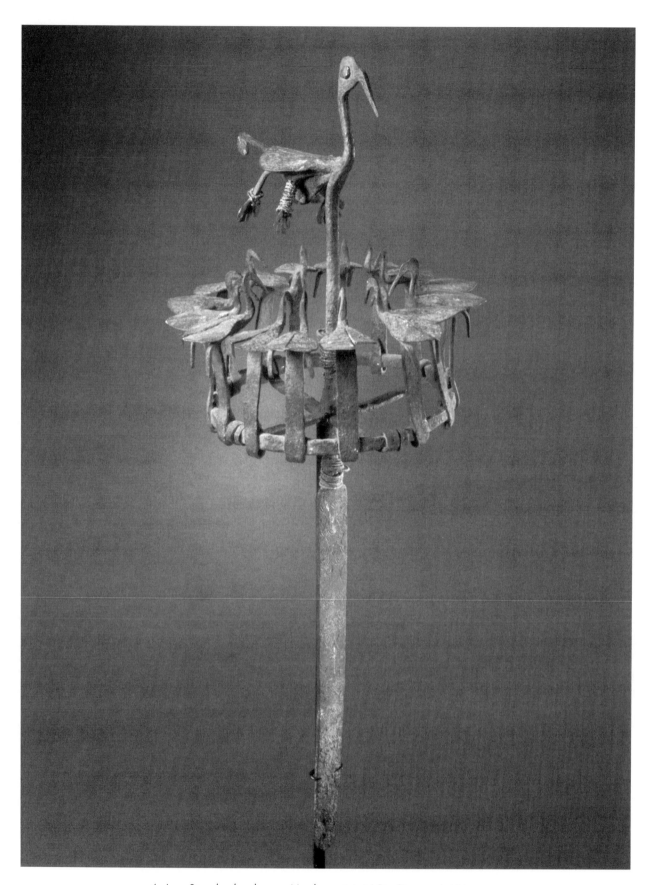

4. Iron Standard, unknown Yoruba artist, N.D., Denver Art Museum

5. *Divination Board*, unknown Yoruba artist, N.D., Denver Art Museum

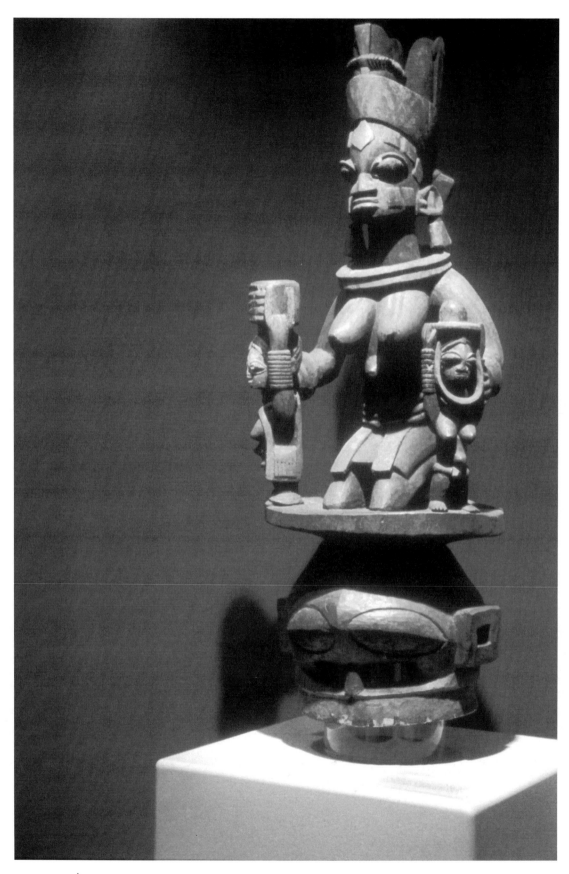

6. *Èpa With Kneeling Woman*, Ooṣamuko of Osi, wood, pigment, Denver Art Museum

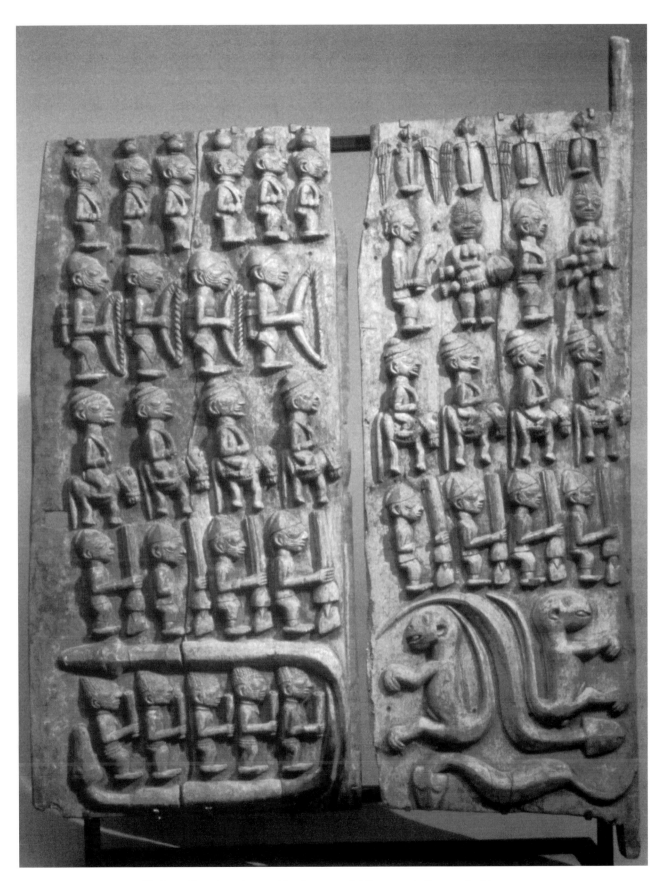

7. Door Panels, unknown Yoruba artist, N.D., wood, Denver Art Museum

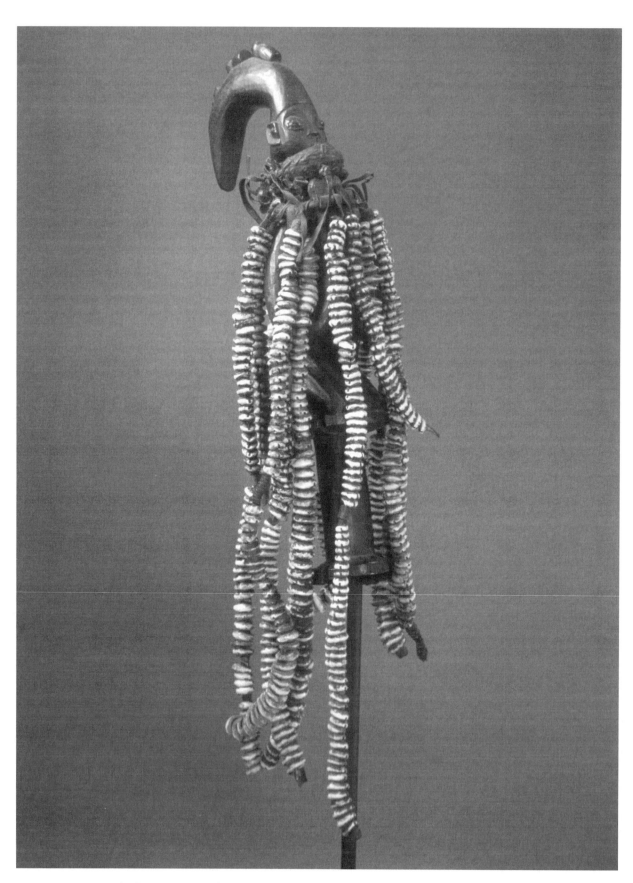

8. *Ẹ̀ṣù Ẹ̀lẹ̀gba Processional Figure*, unknown Yoruba artist, 20th century, Denver Art Museum

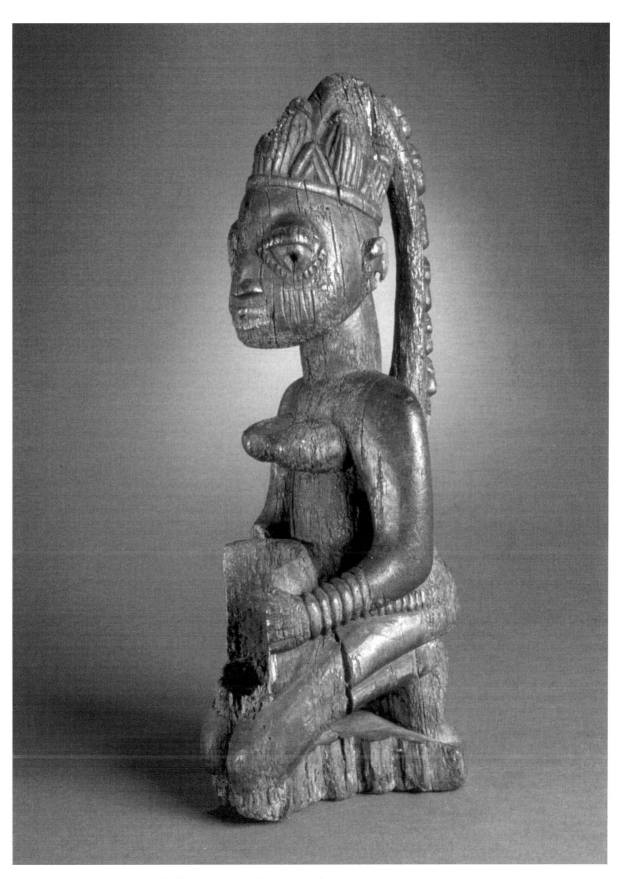

9. *Female Shrine Figure*, unknown Yoruba artist, N.D., Denver Art Museum

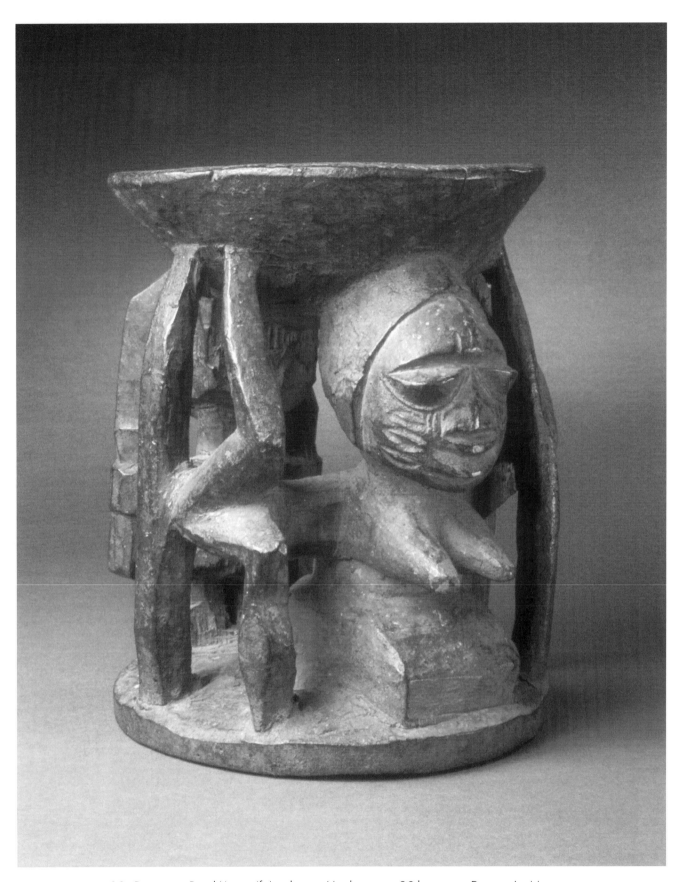

10. *Divination Bowl (Agere Ifa)*, unknown Yoruba artist, 20th century, Denver Art Museum

11. *The Death of Metaphors*, Moyọ Ogundipẹ, 2000, ink drawing, courtesy of the artist

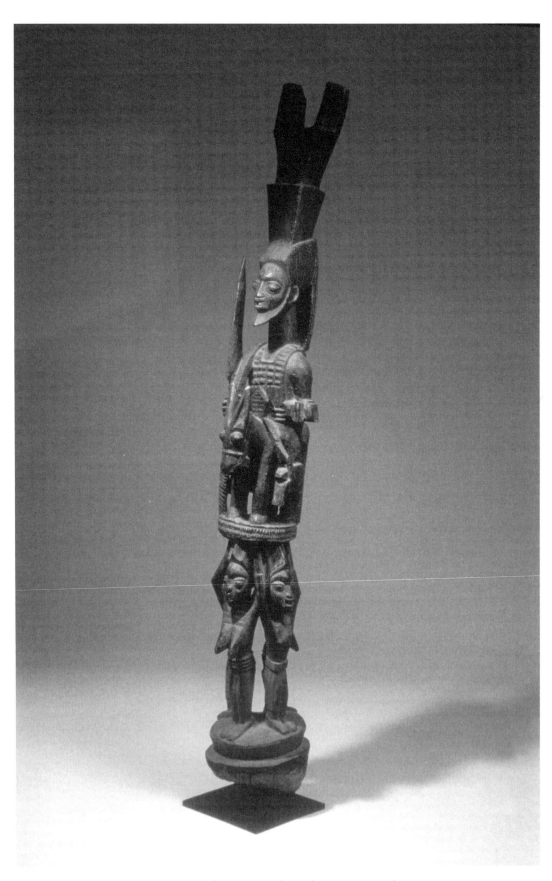

12. *Jagunjagun* (Housepost), Ọlọwẹ Isẹ, early 20th century, wood, Denver Art Museum

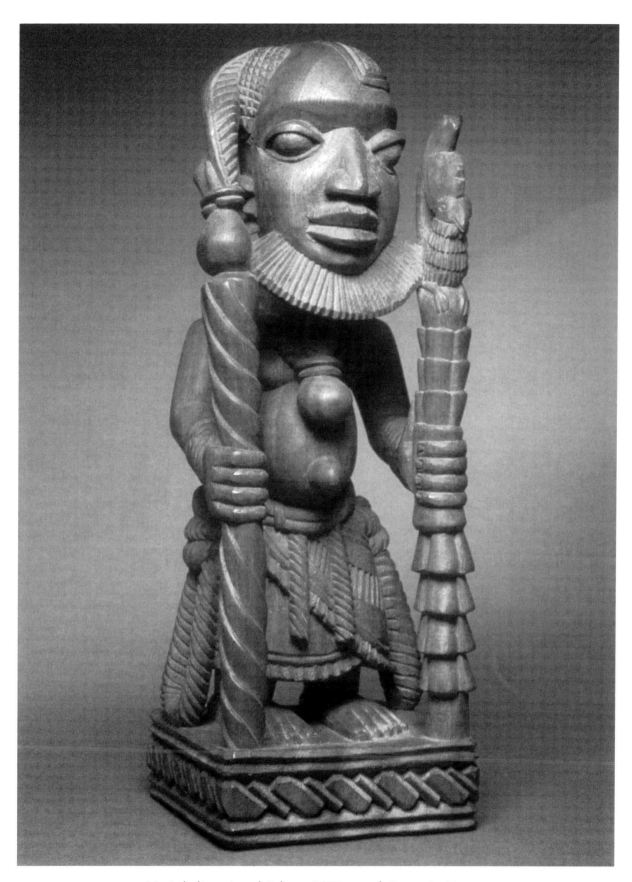

13. *Babaláwo*, Lamidi Fakęyę, 1999, wood, Denver Art Museum

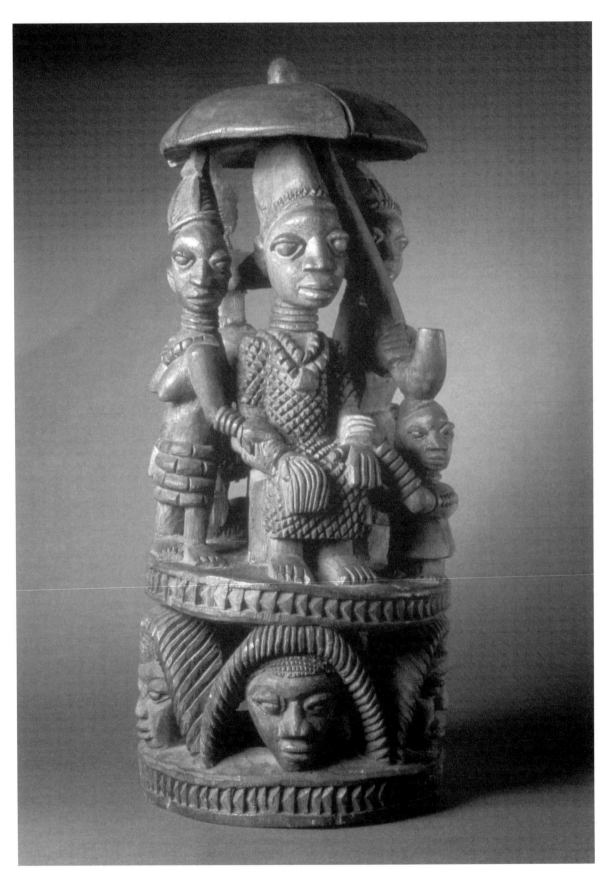

14. *Kabiyesi*, Bamidele Arowoogun, mid-20th century, wood, Denver Art Museum

15. *The Final Phase*, Moyọ Ogundipẹ, 2000, ink drawing, courtesy of the artist

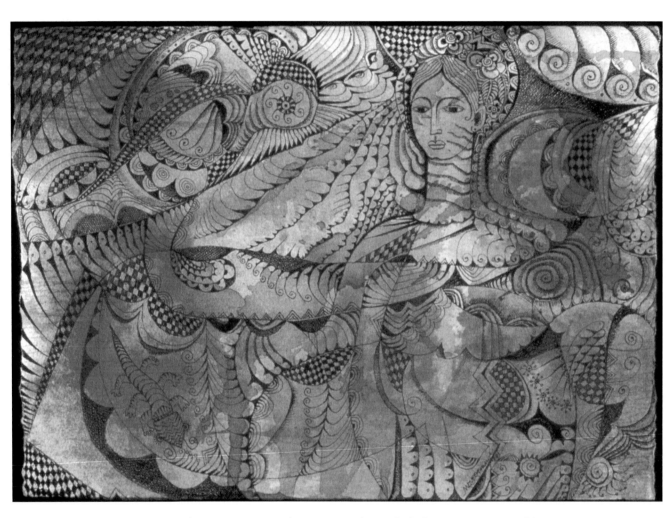

16. *Diaspora Taboos*, Moyọ Ogundipẹ, water color and ink drawing, courtesy of the artist

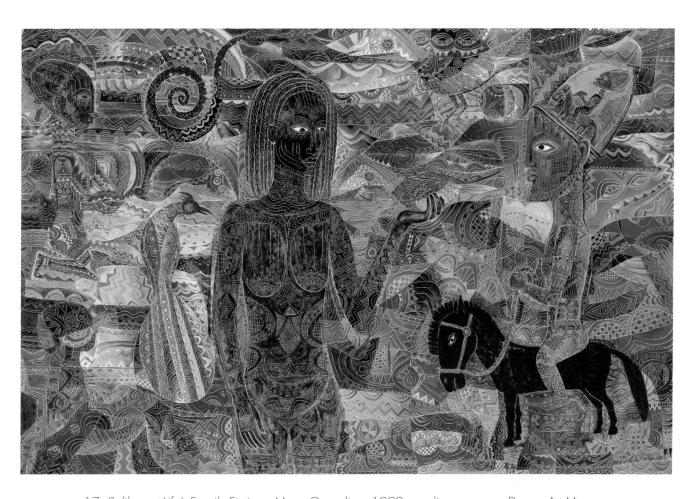

17. *Soliloquy: Life's Fragile Fictions*, Moyọ Ogundipẹ, 1999, acrylic on canvas, Denver Art Museum

18. *Mr. and Mrs. Andrews Without Their heads*, Yinka Shonibare, mixed media, courtesy of the Stephen Friedman Gallery, London

19. *Ẹ̀lùjù Itú* (Forest of Many Wonders), Moyọ Ogundipẹ, 2001, acrylic on canvas, courtesy of the artist

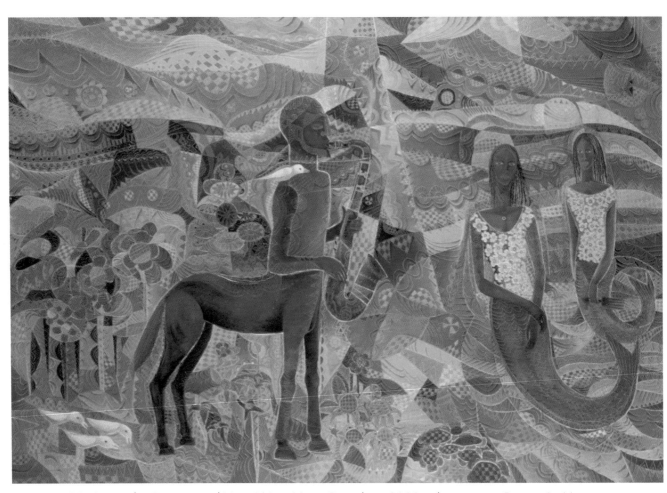

20. *Serenade: Centaurs and Mami Wata*, Moyọ Ogundipẹ, 2000, oil on canvas, Denver Art Museum

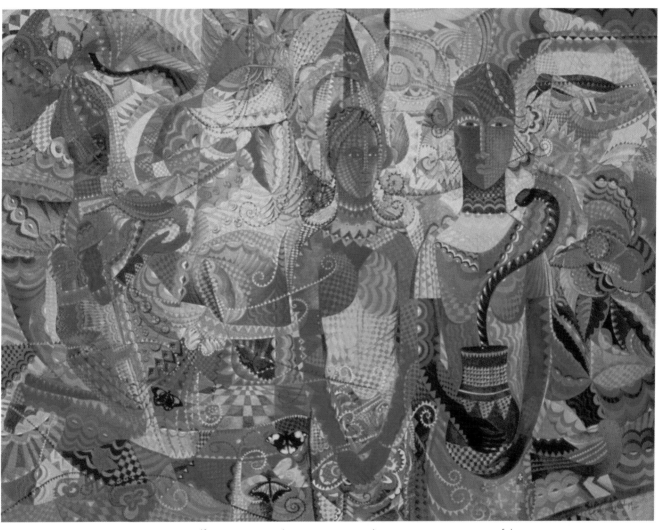

21. *My Fictive Self*, Moyọ Ogundipẹ, 2001, acrylic on canvas, courtesy of the artist

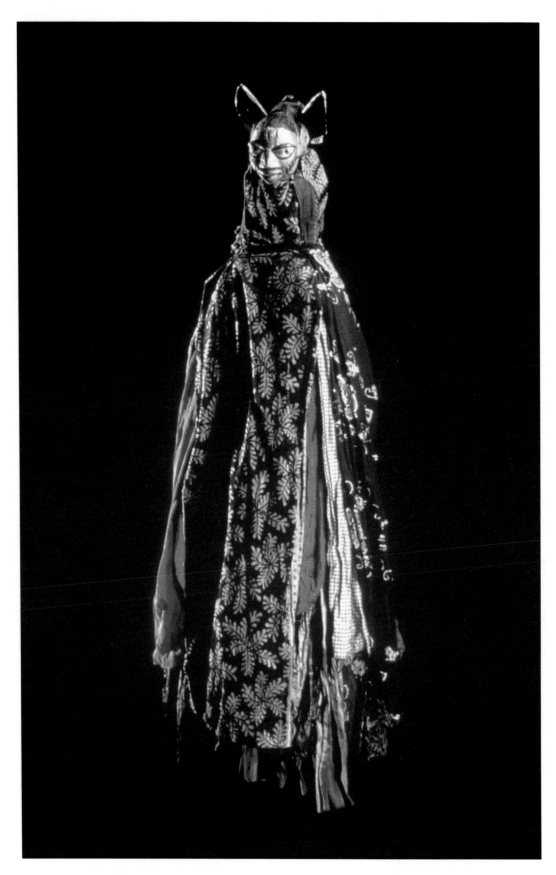

22. *Headdress*, Egungun Society, unknown Yoruba artist, N.D., Denver Art Museum

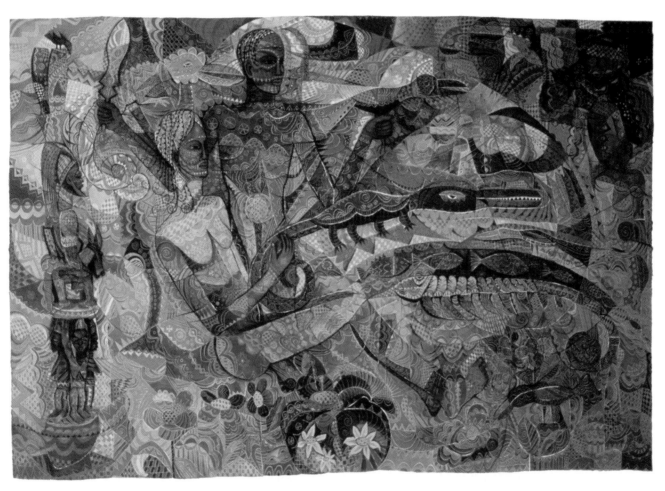

23. *Celestial Immigrants*, Moyọ Ogundipẹ, 2001, acrylic on canvas, courtesy of the artist

24. *Ènìyàn Ń Wojú* (People Only See the Ey

25. *Our Journey,* Obiora Udechukwu, ac

...aji Campbell, mixed media, collection of the artist

canvas, courtesy of the artist

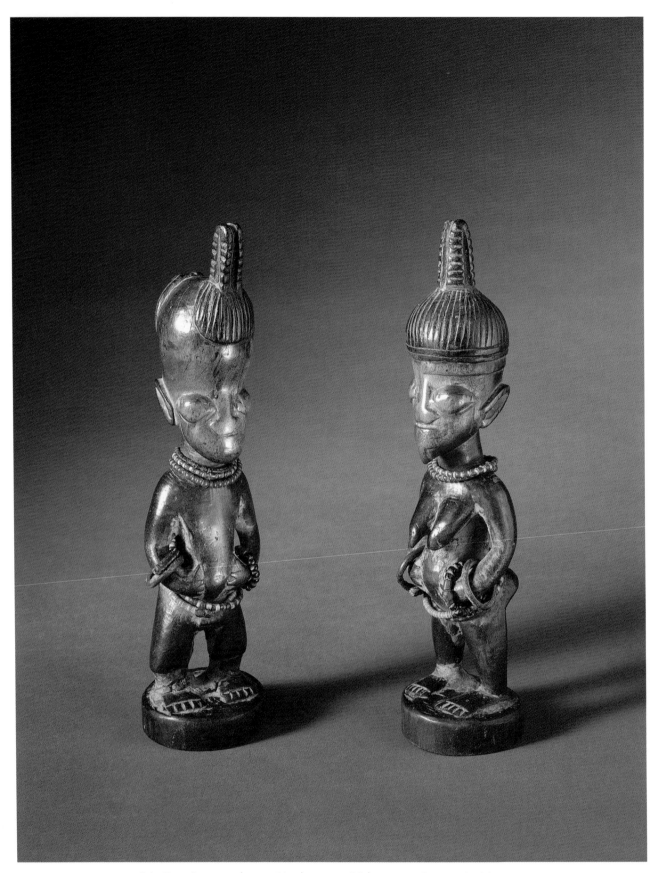

26. *Twin Figure*, unknown Yoruba artist, 20th century, Denver Art Museum

27. *Mother and Child*, Yusuf Grillo, oil on canvas, Nigerian National Gallery

28. *Kano Dyepits*, Jimoh Akolo, oil on board, Nigerian National Gallery

29. *Protection*, Jimoh Buraimoh, mixed media with beads, Nigerian National Gallery

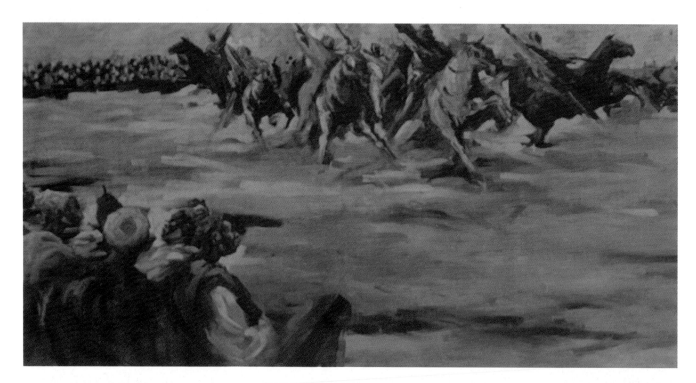

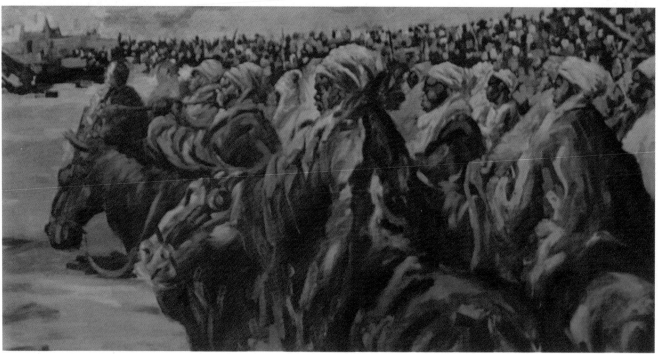

30. *Durbar: The Race*, Gani Odutokun, oil on board, Nigerian National Gallery

31. *Family Shrine*, Michael Harris, mixed media, courtesy of the artist

32. *Achè* (Blessing), Israel Garcia, installation, 2000, Denver Art Museum

NOTES

INTRODUCTION

1. Italics mine. See Ulli Beier, *Contemporary Art in Africa* (New York: Praeger, 1968), p. 109.
2. Peter and Linda Murray, *The Art of the Renaissance* (New York: Thames and Hudson, 1997), p. 7.

CHAPTER 1

1. Henry Drewal, in *The Yoruba Artist,* ed. Rowland Abiọdun, Henry Drewal, and John Pemberton III (Washington, D.C: Smithsonian Institution Press, 1944), p. 193.
2. See S. O. Biobaku, *Sources of Yoruba History* (Oxford: Clarendon, 1973).
3. See Sally Price, *Primitive Art in Civilized Places* (Chicago: University of Chicago Press, 1989), p. 5.
4. Susan Vogel, "Known Artists, but Anonymous Works: Fieldwork and Art History," *African Arts* 32 (spring 1999): 40–55, quotation p. 40.

5. Ibid.

6. Ibid.

7. Gene Blocker, "Is Primitive Art Art," *Journal of Aesthetic Education* 25, 4 (winter 1991): 91.

8. Vogel, "Known Artists."

9. Quoted in Mohammed Abusabib, *The Aesthetics of African Art* (Uppsala: Uppsala University, 1995), p. 128.

10. Olabiyi Yai, "In Praise of Metonymy: The Concepts of 'Tradition' and 'Creativity' in the Transmission of Yoruba Artistry Over Time and Space," in *The Yoruba Artist,* ed. Abiodun, Drewal, and Pemberton, p. 108.

11. See Biobaku, *Sources of Yoruba History.*

12. Bolanle Awe, "Notes on Oriki and Warfare in Yorubaland," in *Yoruba Oral Tradition,* ed. Wande Abimbola (Ile Ife: DALL, University of Ife, 1975), pp. 267–292.

13. See Biobaku, *Sources of Yoruba History.*

14. Roslyn Walker, *Olowe of Ise* (Washington, D.C: Smithsonian Institution Press), 1998.

15. See Henry Drewal, *African Artistry* (Atlanta: High Museum of Art, 1980).

16. See Wande Abimbola, "Lagbayi, the Itinerant Wood Carver of Ojowon," in *The Yoruba Artist,* ed. Abiodun, Drewal, and Pemberton, pp. 137–142.

CHAPTER 2

1. Adaptation mine. In the late 1950s at Ahmadu Bello University, Zaria, educational authorities attempted to have European art teachers teach Nigerian students, but the students rebelled against the teachings of their professors.

2. Paul Bohannan and Philip Curtin, *Africa and Africans* (Prospect Heights: Wavelength, 1988), p. 357.

3. Nkiru Nzegwu, "Contemporary Nigerian Art: Euphonizing the Art Historical Voice," in *Contemporary Textures: Multidimensionality in Nigerian Art,* ed. Nzegwu (Binghamton, N.Y.: International Society for the Study of Africa, 1999), p. 11.

4. Vincent B. Khapoya, *The African Experience* (Englewood Cliffs, N.J.: Prentice-Hall, 1994), p. 156.

5. Kevin Shillington, *History of Africa* (New York: St. Martin's, 1989), p. 310.

6. Ola Oloidi, "Hindrances to the Implantation of Modern Nigerian Art in the Colonial Period," *Kurio Africana: Journal of Art and Criticism* 1, 1 (1989): 15–24.

7. C. T. Lawrence, "Report on Nigerian Section, British Empire Exhibition," *West Africa* 9 (November 1, 1924): 1212–1216.

8. J.R.O. Ojo, "Epa and Related Masquerade," unpublished ms.

9. Rowland Abiodun, "Ife Art Objects: An Interpretation Based on Oral Tradition," in *Yoruba Oral Tradition,* ed. Abimbola, pp. 450–451.

10. Other photographs have shown him wearing a totally Yoruba outfit.

CHAPTER 3

1. See Ola Oloidi, "Modern Nigerian Art: The Implantation, Development, Direction, and Analysis, From 1900 to 1960," Ph.D. diss., University of Nigeria, Nsukka, 1981, p. 93.

2. Conversation with Lasekan, Ile Ife, 1971.

3. Kojo Fosu, *Twentieth Century Art of Africa* (Zaria: Gaskia Corporation, 1986), p. 8.

4. Ibid.

5. Ibid., p. 7.

CHAPTER 4

1. Beier, *Contemporary Art in Africa,* p. 109.
2. See Marshall Ward Mount, *African Art: The Years Since 1920* (Bloomington: Indiana University Press, 1974), p. 133.
3. See Uche Okeke, "History of Modern Nigerian Art," *Nigeria Magazine,* nos. 128–129 (1979): 114.
4. Mount, *African Art,* p. 132.
5. Sharon Pruitt, "Zaria Artists: Over Thirty Years After the Revolution," in *Issues in Contemporary African Art,* ed. Nkiru Nzegwu (Binghamton, N.Y.: ISSA, 1998), p. 147.
6. Okeke, "History of Modern Nigerian Art," p. 114.
7. Eddie Chambers, "Introduction," in *Hybrid: Uche Edochie, Knechi Nwosu-Igbo* (Lagos: Galeria Romana, 2000), p. 2.
8. Yoruba elders say "half a word is enough for the wise. When s/he digests it, it becomes a whole."
9. Beier, *Contemporary Art in Africa,* p. 109.
10. FESTAC 77 stands for the 1997 International Festival of Black and African Cultures, which was celebrated in Lagos, Nigeria.
11. *Abiku* are mysterious children who die young. They belong to a society, or *egbe,* midway between this world and the other world. Before they leave their place of abode for this world, they pledge a specific time when they will return to their playmates. Thus they conspire to come to this world to tease expectant mothers by being born as normal children. When their pledged time comes, they die suddenly, sometimes without even being sick.
12. Beier, *Contemporary Art in Africa,* p. 115.
13. Ibid.
14. I will call her Nikẹ because she once said at a conference that it is the only stable name she has. She said, "I seem to be changing husbands rather frequently, and I am tired of changing names."
15. Pruitt, "Zaria Artists," p. 147.

CHAPTER 5

1. Yai, "In Praise of Metonymy," in *The Yoruba Artist,* ed. Abiọdun, Drewal, and Pemberton, p. 108.
2. Ibid.
3. All quotes by Campbell found in this book are extracted from interviews with the author at several places in the United States from 1997 to 2001.
4. All quotes by Ogundipẹ found in this book are extracted from interviews with the author from 1987 to 2001.
5. Rotimi Fani-Kayọde, "Traces of Ecstasy," in *Reading the Contemporary: African Art From Theory to the Marketplace,* ed. Olu Oguibe and Okui Enwenzor (Cambridge: MIT Press, 1999), p. 279.
6. Although Audu was not born to Yoruba parents, he was raised in Yorubaland with Yoruba language and culture. He is married to a Yoruba woman, a fellow artist, and Yoruba is his first language.

CHAPTER 6

1. All interviews with Michael Harris were recorded in 1998 in Gettysburg, Pennsylvania.
2. The artists mentioned are all important names associated with the arts of the civil rights movement.

3. Interview by author, 2000.
4. For a fuller discussion, see Rowland Abiọdun, "Understanding Yoruba Art and Aesthetics: The Concept of Ase," *African Arts* (July 1994): 68–78.
5. This book has focused on the Yoruba revival, even though it is possible to trace some of the other ethnic notions in the bigger African renaissance.

CONCLUSION

1. Obiora Udechukwu, quoted in *The Poetics of Line: Seven Artists of the Nsukka Group* (Washington, D.C.: National Museum of African Art, 1997), p. 8.
2. I am grateful to Christine Nogaki who helped conduct the interview with Chris Vondrasek on March 4, 1999. Nogaki is Asian American, which may be significant in the context of the multiethnic potpourri in this conclusion. All quotations attributed to Vondrasek are from the interview.

BIBLIOGRAPHY

Abimbola, Wande, ed. *Yoruba Oral Traditions.* Ile Ife: Department of African Languages and Literatures, Obafemi Awolowo University, 1975.

Abiọdun, Rowland. "Understanding Yoruba Art and Aesthetics: The Concept of Ase." *African Arts* (Los Angeles) (July 1994): 68–78.

Abiọdun, Rowland, Henry Drewal, and John Pemberton III, eds. *The Yoruba Artist: New Theoretical Perspectives on African Art.* Washington, D.C.: Smithsonian Institution Press, 1994.

Adenaike, Tayo. "The Osogbo Experiment Sixteen Years Later." B.A. thesis, University of Nigeria, Nsukka, 1979.

Adepegba, Cornelius. "Modern Nigerian Art: A Classification Based on Forms." *Kurio Africana: Journal of Art and Criticism* (Ile Ife) 1, 2 (1989): 111–137.

———. "Nigerian Art: The Death of Traditions and the Birth of New Forms." *Kurio Africana: Journal of Art and Criticism* (Ile Ife) 1, 2 (1989): 2–14.

Aniakor, Chike. "Contemporary Nigerian Artists and Their Traditions." *Black Arts* (Jamaica, N.Y.) 4, 2 (1980): 40–55.

Aradeon, Susan. "Contemporary Nigerian Art, Tradition, and National Identity." *Nigeria Magazine* (Lagos) 55, 1 (January-March 1987): 1–10.

Audu, Osi. "Monoprint *Juju*." In *Africa: Arts and Culture,* ed. John Mach. London: British Museum, 2000.

Babalola, Daniel. "The Awo Art Style: A Synthesis of Traditional and Contemporary Artistic Idioms in Nigeria." Ph.D. diss., Ohio State University, 1981.

Baxandall, Michael. *Painting and Experience in Fifteenth-Century Italy.* Oxford: Oxford University Press, 1988.

Beier, Ulli. *Contemporary Art in Africa.* London and New York: Pall Mall and Frederick Praeger, 1968.

———. "Contemporary Nigerian Art." *Nigeria Magazine* (Lagos), no. 68 (March 1961): 27–51.

———. *Thirty Years of Oshogbo Art.* Bayreuth: Iwalewa-Haus, 1991.

Biobaku, Saburi. *Sources of Yoruba History.* Oxford: Clarendon, 1973.

Blocker, Gene. "Is Primitive Art, Art." *Journal of Aesthetic Education* 24, 4 (Winter 1991): 91.

Bohannan, Paul, and Phillip Curtin. *Africa and Africans.* Prospect Heights: Wavelength, 1988.

Chambers, Eddie. "Introduction." In *Hybrid: Uche Edochie, Kenechi Nwosu-Igbo.* Lagos: Galeria Romana, 2000.

Crowder, Michael. "The Contemporary Nigerian Artist: His Patrons, His Audience, and His Critics." *Presence Africaine* (Paris), nos. 105/106 (1978): 130–145.

Delaquis, Ato. "Dilemma of the Contemporary African Artist." *Transition* (Accra) 9, 50 (October 1975-March 1976): 16–30.

"Design in Nigeria." *Design Journal* (Seoul), no. 26 (April 10, 1990): 70–92.

Drewal, Henry. *African Artistry.* Atlanta: High Museum of Art, 1980.

Drewal, Henry, John Pemberton III, and Rowland Abiọdun. *Yoruba: Nine Centuries of African Art and Thoughts.* New York: The Center for African Art in association with Harry N. Abrams, Inc., 1989.

Eze, Justene. "The Zaria Art Society." B.A. thesis, University of Nigeria, Nsukka, 1978.

Filani, Kunle. "Art as Transmitter of Socio-cultural Values: The Metamorphosis of Form and Content in Contemporary Nigeria Art." *Kurio Africana: Journal of Art and Criticism* (Ile Ife) 1, 1 (1989): 57–72.

———. "Contemporary Printmaking in Nigeria: Its Growth and Glory." *Kurio Africana: Journal of Art and Criticism* (Ile Ife) 1, 2 (1989): 25–41.

Fisu, Kojo. *Twentieth Century Art of Africa.* Zaria: Gaskiya, 1982.

Guez, Nicole. *L'art Africaine Contemporain* (Contemporary African Art), edition 1996. Paris: Association African en Creation, 1996.

The Ife Art School: 1974–1984 (exhibition at the Exhibition Center, National Council for Arts and Culture, Lagos, April 27–May 19, 1984; Instituete of AAAfrican Studies, University of Ibadan, June 1–15, 1984; and Concord Hotel, Owerri, August 20–25, 1984). Introduction by Frank Aig-Imoukhuede. Lagos: National Council for Arts and Culture, 1984.

Jegede, Dele. "Patronage and Change in Nigerian Art." *Nigeria Magazine* (Lagos), no. 150 (1984): 29–36.

————. "Trends in Contemporary Nigerian Art: A Historical Analysis." Ph.D. diss., Indiana University, 1983.

Kasfir, Sydney. "Art From Africa." *African Arts* (Los Angeles) 14, 44 (August 1981): 76–78.

————. *Contemporary African Art.* London: Thames and Hudson, 1999.

Kelly, Bernice. *Nigerian Artists: A Who's Who and Bibliography,* ed. Janet Stanley. London and New York: published for the National Museum of African Art, Smithsonian Institution, Washington, D.C. by Hans Zell, 1993.

Kennedy, Jean. *New Currents, Ancient Rivers: Contemporary African Artists in a Generation of Change.* Washington, D.C.: Smithsonian Institution Press, 1992.

Khapoya, Vincent. *The African Experience.* Englewood Cliffs, N.J.: Prentice-Hall, 1994.

LaDuke, Betty. *Africa Through the Eyes of Women Artists.* Trenton, N.J.: Africa World Press, 1991.

Laṣekan, Akinọla. "Problems of Contemporary African Artists." *Kurio Africana: Journal of Art and Criticism* (Ile Ife) 1, 1 (1989): 25–37.

Lawrence, C. T. "Report on Nigerian Section, British Empire Pavilion." *West Africa* (London), no. 9 (November 1, 1924): 1212–1216.

Mount, Marshall. *African Art: The Years Since 1920.* Bloomington: Indiana University Press, 1973.

Neue Kunst in Afrika: Das Buch zur Ausstellung. Curated and text by Ulli Beier. Berlin: Reimer, 1980.

Nigerian Art: Kindred Spirits (video), narrated by Ruby Dee. Washington, D.C.: WETA, 1990.

The Nucleus: A Catalogue of Works in the National Collection of the National Gallery of Modern Art. Lagos: Federal Department of Culture, 1981.

Nzegwu, Nkiru, ed. *Contemporary Textualities: Multidimensionality in Contemporary Nigerian Art.* Binghamton, N.Y.: International Society for the Study of Africa, Binghamton University, 1999.

————, ed. *Issues in Contemporary African Art.* Binghamton, N.Y.: International Society for the Study of Africa, Binghamton University, 1998.

Odutokun, Gani. "Art in Nigeria Since Independence." In *Nigeria Since Independence: The First Twenty-Five Years, Volume 7: Culture,* ed. Peter Ekeh and Garba Ashiwaju. Ibadan: Heinemann Educational Books (Nigeria), 1989.

Oguibe, Olu. *Crossings: Time-Space Movement.* Tampa, Florida: University of South Florida, 1997.

Oguibe, Olu, and Okui Enwenzor, eds. *Reading the Contemporary: African Art From Theory to the Marketplace.* London: INIVA, 1999.

Oguntona, Toyin. "The Oshogbo Workshops: A Case Study of Non-formal Art Education in Nigeria." Ph.D. diss., University of Wisconsin, 1981.

Ojo, Bankole. "Two Decades of Ori Olokun Art: The Years 1969–1989." In *Oritameta: Proceedings, 1990,* ed. Moyọ Okediji. [Ile Ife]: Department of Fine Arts, Obafemi Awolowo University, 1991.

Okediji, Moyọ. "Onaism in *The Nucleaus.*" *Kurio Africana: Journal of Art and Criticism* (Ile Ife) 1, 2 (1990): 88–99.

Okeke, Uche. "History of Modern Nigerian Art." *Nigeria Magazine* (Lagos), nos. 128–129 (1979): 100–118.

————. "The Search for a Theoretical Basis for Contemporary Nigerian Art." *Nigerian Journal of the Humanities* (Benin City) 1, 1 (1977): 60–66.

Okoro, Godwin. "African Contemporary Art in Nigeria." Ed.D. diss., Columbia University.

Oloidi, Ola. "Art and Nationalism in Colonial Nigeria." In *Seven Stories About Modern Art in Africa,* ed. Clementine Deliss. Paris: Flammarion, 1995.

———. "Elitism and Modern African Artists." *Nigeria Magazine* (Lagos), nos. 134–135 (1981): 71–84.

———. "Growth and Development of Formal Art Education in Nigeria, 1900 to 1960." *Transatlantic Journal of History* (Nairobi) 15 (1986): 108–126.

———. "Hindrances to the Implantation of Modern Nigerian Art in the Colonial Period." *Kurio Africana: Journal of Art and Criticism* (Ile Ife) 1, 1 (1989): 15–24.

Oyelola, Pat. *Everyman's Guide to Nigerian Art. Nigeria Magazine.* Lagos: Cultural Division, Federal Ministry of Information, 1976.

Price, Sally. *Primitive Art in Civilized Places.* Chicago: University of Chicago Press, 1989.

Pruitt, Sharon. "Perspectives in the Study of Nigerian Kuntu Art: A Traditional Style in Contemporary African Visual Expression." Ph.D. diss., Ohio State University, 1985.

Sillington, Kevin. *History of Africa.* New York: St. Martin's, 1989.

Vansina, Jan. *General History of Africa, Volume 8: Africa Since 1935.* London and Berkeley: Heinemann and University of California Press, 1993.

Vogel, Susan. "Known Artists, But Anonymous Works: Fieldwork and Art History." *African Art* 32 (spring 1999): 40–55.

Walker, Rosalyn. *Olowe of Ise.* Washington, D.C.: Smithsonian Institution Press, 1998.

Wangboje, Solomon. "Western Impact on Nigerian Arts." *Nigeria Magazine* (Lagos), nos. 122–123 (1977): 100–112.

Wewe, Tola. "Thematic Growth in Nigerian Contemporary Paintings: 1920–1964." *Kurio Africana: Journal of Art and Criticism* (Ile Ife) 1, 2 (1989): 80–88.

Wolford, Jean Kennedy. *Contemporary African Art, Painting, Sculpture, Drawing, Graphics, Ceramics, Fabrics* (exhibition at the Otis Art Institute, Los Angeles, March 13–May 4, 1969). Los Angeles: Otis Art Institute of Los Angeles County, 1969.

Zaria Art School, 1955–1990: Catalogue of an Exhibition by the Students and Lecturers of the Department of Fine and Industrial Design, Ahmadu Bello University, Zaria. Lagos: National Council for Arts and Culture, 1990.

INDEX

Page numbers in italics indicate illustrations.